T0345673

LE CORBUSIER

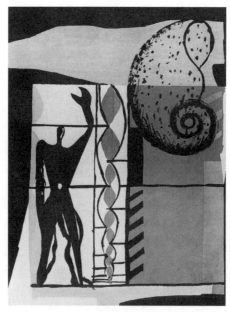

Le Corbusier, 'Modulor, spiral and seashell',
illustration in *Le Poème de l'angle droit*, 1955

NIKLAS MAAK

LE CORBUSIER

The Architect on the Beach

HIRMER

CONTENTS

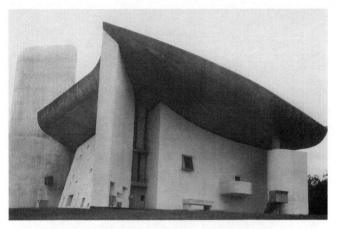

The pilgrimage church at Ronchamp, constructed in 1955

FOREWORD

The controversy over Ronchamp

Until the summer of 1955 Ronchamp was completely unknown, a mining village in the foothills of France's Vosges Mountains with only a few low houses, a neo-Gothic parish church and the rusty tower of an old mine that was closed a few years later. Just before the bend, an unpaved road leads up the hill to the site of the ancient *oppidum* Bourlémont. A small chapel that had once stood here was destroyed in bitter fighting during the retreat of the German Army in 1944. In the early 1950s Le Corbusier replaced it with something that looked like anything one cared to imagine – only not like a church (ill. above).

Writers attempting to describe what the architect had created in this hilly landscape after five years of construction struggled to find the appropriate terms. On 17 September 1995 Niels von Holst

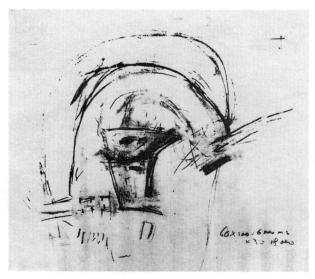

Le Corbusier, sketch of ground plan for Ronchamp, 6 June 1950

wrote in the *Frankfurter Allgemeine Zeitung* of an 'baffling alien form' that could not really be 'called a building'.[1] And, as always when new forms challenge conventional language, they grasped at all manner of metaphors: it was a tent; a concrete sail, something that looked as if it had been flung up onto the beach from the depths of the sea, an otherworldly emanation whose forms could have been derived either from the future or from a long-forgotten past.

The new structure surged up out of the hill, it seemed to billow as if it were mostly made of cloth. At the same time it looked as solid as a rock. Its walls and roof curved every which way, light trickled into the interior through small openings that one could hardly call windows; instead of providing a classic nave with an apse the ground plan appeared to respond to the topography of the hill; and in place of a church tower the structure thrust three ship funnels into the sky. The building employed neither the classic basilica layout nor any other known church-shape; the Church had commissioned it – but had a church been delivered?

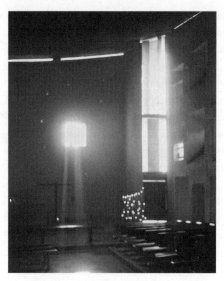

Ronchamp, interior, view of altar wall

Few of the numerous controversial buildings of the twentieth century have initially so polarised both visitors and the architectural profession as Ronchamp. Criticism from Germany was particularly aggressive: the art advisors to the Paderborn archdiocese published a declaration in which they noted 'with dismay that the pilgrimage church built by Le Corbusier in Ronchamp is for the most part being met with an altogether positive response in the press.' Nevertheless, 'this church is the height of innovation for its own sake, capriciousness, and disorder'; with it, Le Corbusier has 'broken with the tradition of Catholic church architecture with an unprecented radicalism, and in many ways even violated the standard rules of architecture.' The affronted committee was particularly concerned that 'this church completely lacks the air of sanctity that must be demanded at all costs.'[2]

Church representatives criticised the architect above all for challenging the notion of a basic form that every church structure should adhere to one derived from altogether different sources.

This departure from classic church architecture is already evident in his earliest sketches.

The traditional ground plan was replaced by what Le Corbusier referred to as a 'réponse au site'. The first sketch for Ronchamp follows the situation of the small hilltop and orchestrates the view of the surrounding landscape as a natural spectacle (ill. p. 8).

The church was built around the shapes of the hill, around sightlines and vantage points, the features of the site imprinted into the design as though by frottage. The classic church inventory of apse, altar and chancel was obliged to adapt itself to the resulting form. It is as though, in siting his structure, the architect set out to choreograph various effects. The building's south wall curves outward toward the approaching visitor and the curves of the north wall screen the chapel from the Vosges foothills. Le Corbusier's first design has nothing to do with mathematics or conventional construction plans it being, above all, a reflection of the specific topography, with the bordering mountain formation enfolding the viewer to the north and, to the south, opening out onto the valley. The building becomes a stage for a natural extravaganza, the architecture intensifying nature.

Almost all modern church buildings before Ronchamp, from Auguste Perret's Église Saint-Joseph du Havre, planned in the 1940s,[3] to Luigi Figini's Chiesa della Madonna dei Poveri in Milan[4] to Rudolf Schwarz's curving St. Michael's Church in Frankfurt, had retained or only slightly varied the traditional symbolic shape of the basilica or rotunda. Le Corbusier broke with this tradition altogether in Ronchamp, abandoning the traditional symbols of faith. The shape of the chapel's roof, lifting higher in the direction of the altar, describes an upward sweep from the sheltering vault toward the light and the horizons. Within the spiral shapes of the north and west walls are three narrow side chapels, only dimly illuminated by light from above, their grotto-like walls covered with a mixture of sprayed concrete and whitewash that looks like the rough surface of a rock (ill. p. 12). The structure's darker niches are reminiscent of caves and early Christian catacombs – as if the church were liberating itself from confinement within a traditional

corset of forms and rituals and, instead, returning to the first Christian meeting places.

The altar wall is equally unusual (ill. p. 9). Where the south and east wall meet the nave is dramatically opened up by a shaft of light the full height of the structure. The benches face the light in this opening. The altar itself, the cross and the actual object of veneration, the statue of the Virgin, are moved off-centre and, from within the semi-darkness of the chapel, are bathed in morning light that enters from the side. The ray of light that falls through the shaft of windows especially in the morning must be familiar to worshippers, for it evokes the lighting in classic pictures of the Annunciation. Christian symbols are underplayed in Ronchamp in favour of the manipulation of light, the effect of an epiphany staged without intermediary metaphors.

On either side of the large shaft of light the heavy concrete roof floats above the walls as though it here, miraculously, weighed no more than a sail. Le Corbusier placed a great deal of importance on this effect, noting with satisfaction: 'The shell sits atop thick, plain, but serviceable walls inset with reinforced concrete pillars. The shell rests on these pillars here and there but does not touch the walls; a horizontal strip of light ten centimeters wide will elicit astonishment.'[5]

Le Corbusier had always justified the *pilotis* (stilts) of his residential structures by insisting that, with them, open traffic areas were created beneath his structures, no unhygienic corridors were created and one could stroll beneath the buildings as though through a large park – an explanation that was criticised by contemporaries like Hans Sedlmayr as 'highly specious.'[6] The Munich art historian declared such filigree architectural substructures to be an expression of a rootless culture, but even if one does not agree with him, his criticism hits upon something that Le Corbusier denied for a long time. In Ronchamp the architect admits that here the actual goal of his structure was its theatrical effect: the modern concrete pillars are employed solely to produce a baroque effect of surprise – they are meant to 'elicit astonishment'. In a lyrical text Le Corbusier goes even further, defining architec-

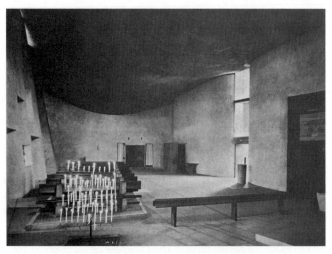

Interior view of the church at Ronchamp,
looking towards the west wall

ture – as opposed to a mere building meant to offer shelter and
mark a specific place – as the ability 'to create excitement / through
the play of proportions / the unexpected, the mystifying.'[7]

Le Corbusier's unconventional building also had supporters
within the Church. Abbé Ferry found in it something that he
missed in modern architecture – namely the sense of space and
'mystical atmosphere of early Romanesque churches'. In the mid-
dle of the twentieth century, Ferry wrote: 'this chapel incorporates
all the Christian mysteries. It is no surprise that in it one feels as if
one were once again encountering the evocative aura of the early
years that one finds in the catacombs, the old basilicas.'[8] The archi-
tect's manipulation of Christian iconography familiar to pilgrims
from paintings and from pictures of early Christian catacombs was
clearly a success. This may be one of the reasons why the structure
quickly captured the popular imagination and, despite heated crit-
icism, became a favourite pilgrimage site.

Although pilgrims clearly had few problems with Ronchamp
the structure led to a momentous schism within modern architec-

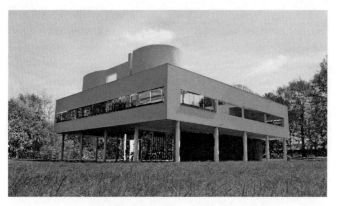
Le Corbusier's Villa Savoye, constructed 1928-31

ture, for it represented not only an obvious break with the classical tradition in church architecture but also a departure from the white buildings floating atop slender reinforced concrete pillars for which Le Corbusier was known. His early villas, most notably the Villa Savoye (ill. above) and the Villa Fallet La Roche, were the very antithesis of Ronchamp. They belonged to a determinedly rational, mechanistic modernism largely free of mystery and exuded a relatively aseptic, sporty air. One could imagine their enlightened inhabitants sunbathing on their numerous terraces, changing into their tennis clothes, studying catalogues of cars and leading altogether modern, active lives.

The Villa Savoye was one of the ideological showpieces of this way of life. Visually floating atop *pilotis* as though on tiptoe, it was elevated above the ground and independent of its configuration. It could theoretically be erected anywhere and thus took seriously the notion of internationalism. It ignored its surroundings, held itself aloof from its site and could be imagined resting on its stilts in an Arctic bog just as well as on a Moroccan sand dune or a meadow in Normandy. Such rootlessness was important to Le Corbusier. In 1930 he wrote that the house stood perfectly 'in Poissy's rural surroundings, but it would also look splendid in Biarritz. Or I can picture it in the gorgeous Argentinian landscape.'[9]

It was virtually unthinkable that a Le Corbusier structure should be kneaded out of the earth and evoke mysterious grottos, the mystical darkness of early Christian catacombs, Indian cave dwellings or Arab alleyways. The ultra-modernist had taken a next step and – in the eyes of a number of confused contemporaries, at least – had landed in some unsettling Archaic era. To them the little pilgrimage church was a twofold sacrilege, an affront both to more dogmatic churchmen and to modern architecture.

The allusive concrete grotto shocked the adherents of rationalism most of all. A writer for the journal *Die Kunst und das schöne Heim* declared in bewilderment that of all people 'the protagonist of straightforward building forms that reflect their method of construction and their function has here, in a kind of counterpoint, wholly distanced himself from the right angle and turned toward the spatial prototype of the cavern.'[10] Le Corbusier of all people – with this piece of seemingly irrational, overblown and overpowering theatricality, the man revered by a whole generation of architects as the pioneer of rational living machines appeared to have sold out and placed himself in the service the Catholic Church.

In his essay 'Le Corbusier's Chapel and the Crisis of Rationalism' the architect James Stirling, at that time still a young man who doubled as a critic, lamented that the structure required no intellectual involvement, that with its shaft of light and other visual effects it appealed exclusively to the viewer's emotions, for which reason, unlike the architect's early villas, it found 'ready acceptance among the local populace'[11] – to Stirling an obviously negative point. In his view Ronchamp related to Modernism in the way that Mannerism related to the Renaissance.[12] Rationalism was in crisis, it could no longer produce any new forms and, for that reason, traded on mere torsion as such. The critic Rudolf Müller-Erb also fulminated against what Le Corbusier had claimed gave the building its special quality, namely its rootedness in nature and history.[13] 'The swept-up roof', Müller-Erb writes, 'appears to one person like a mushroom, to another a pillow, to a third a brownish hat, to a fourth a monolith, to a fifth a sail, to a sixth a wave'.[14] In reality, the presumed crab shell was all of these, and yet it wasn't. 'The

cavern is intentional. Diffuse light penetrates through gaps, gashes and holes and illuminates the space's incommensurable recesses and crevices, swellings, angles and hollows ... Ronchamp is constructed magic; not the magic of primitives, but sentimental twentieth-century magic.' Whereas 'all historical religious structures', he continues, even those of the Baroque, 'pretended to be a reflection of and foretaste of heaven', the Ronchamp space is no 'vessel of the mystery', but rather 'like some obscure, encrypted, inscrutable word; it sings out in an allusive, compelling music, is the numinous itself, the great, enigmatic, scintillating id'[15] that drives believers away from the faith into dreary spiritual isolation.

His criticism is typical of the way Ronchamp was perceived in Germany. It was influenced by Hans Sedlmayr's general mistrust of Modernism, his lament for the 'Verlust der Mitte,' or loss of the mean, and also made use of his rhetoric calling for a world 'wholly dominated by order', one in which art is supposed to provide a logical confirmation, not some conflicting aberration. But even in France Paul Doncoeur complained about Le Corbusier's 'desire to confuse and unsettle ... Everything is unresolved dissonance, there is no recognizable axis.'[16]

The perplexity both of Le Corbusier's critics and adherents was so considerable that they gratefully pounced upon the story the architect related as a way of explaining the structure.

In 1946 and 1947 Le Corbusier travelled to New York where he headed the commission on the building of the United Nations headquarters on the East River. On those trips he also managed to drive to the ocean and along the beaches of Long Island (ill. p. 27). In various writings he describes how, while walking along a beach at the edge of the surf, he came upon a crab's shell (ill. p. 16). He stepped on it with all his weight and, astonished by its resilience, took it with him. Later, he relates, it was the sight of that found object that gave him the inspiration for the chapel's design.

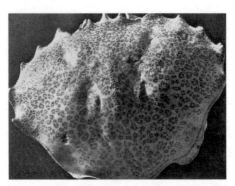

Crab's shell found by Le Corbusier
on Long Island in 1946

'On the drafting table lies a crab's shell that I picked up on Long Island near New York in 1946. It becomes the roof of the chapel: two connected concrete skins six centimeters thick, between them a distance of 2.26 meters ... hand me pencil and paper!

It begins with a response to the site. Thick walls, a crab's shell, so as to enliven the too static plan with curves. So I pick up the crab's shell and place it on top of the walls.'[17]

The anecdote was immediately circulated and would, henceforth, colour the way people wrote about the chapel. The exterior façade would remind the reporter for *Le Parisien* of 'the movement of waves',[18] and Abbé Bolle-Reddat would write of a 'vessel of still-ness, filled with the murmur of the sea'.[19] When discussing the chapel's roof, writers would be sure to add that, as is known, 'its design was inspired by a crab's shell' – an assumption that persists to this day.[20]

From beach find to blurb and biomorphism:
a misunderstanding

Also thanks to this anecdote about the crab's shell that – enlarged – became a roof, Ronchamp has again and again been described as the first structure in a new, 'organic' Modernism.[21]

But above all Ronchamp has become a point of reference in the context of today's biomorphic architecture.

Interest in Ronchamp on the part of this trend in contemporary architecture is all the greater inasmuch as the design was created at a time when chaos studies were trying to comprehend natural phenomena by way of mathematics and describe seemingly lawless chaotic systems – a crucial endeavour for the development of computer-generated forms. In Ronchamp Le Corbusier attempted to expand a mathematical concept still based on Renaissance notions of ideal geometry by means of a mathematics of natural forms. Only five years after Ronchamp the meteorologist Edward N. Lorenz demonstrated in a computer-generated weather model how a relatively simple system of equations produces infinitely complex patterns – precisely what interested Le Corbusier with regard to shell surfaces and flow patterns – phenomena that evade a strictly geometric description. By different routes they both led to an architecture that hopes to simulate chaotic structural processes in nature and exploit them in the production of form.

The pioneers of computer-aided design were already referring to Ronchamp with some frequency, for example Frank Gehry, who became famous in the eighties and nineties with his biomorphic structural forms and at that time erected a number of structures closely imitative of patterns in nature (ills. p. 18).

Meanwhile, phenotypical, nature-like source forms have developed into a stylistic trend often circumscribed with the term 'biomorphism'. It is particularly concerned with fractal structures arising from a potentially infinite sequence of stretching and folding processes. Complex spatial geometries in endless permutations have been developed on the screens of ever more powerful computers, fusing natural forms with computer-generated products

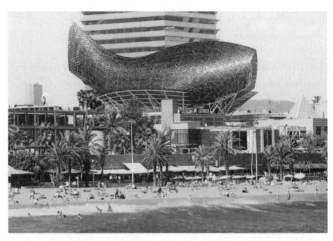

Frank O. Gehry, 'Peix' (fish) sculpture, Barcelona, 1992

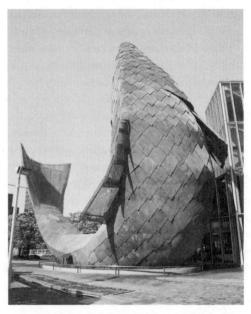

Frank O. Gehry, Fish Dance Restaurant, Kobe, 1986

like ergonomically designed athletes' shoes or car bodies – objects whose forms are likewise indebted to natural laws like fluid dynamics or load distribution and that have not been designed in the two-dimensionality of the drawing table but in the three-dimensional space of the computer.

Among the structures that imitate non-linear, chaotic, 'natural' processes are Greg Lynn's oyster-like 'Embryological Houses' (ill. p. 20) which, although never built, have inspired any number of theories in which one sees the misunderstandings that arise from the numerous, visually compelling linkages of natural and computer-generated forms. Biomorphic architecture, of which Ronchamp is claimed to be an analogical precursor, provokes misconstructions similar to those that had appeared some years before in the course of the image-making techinques of chaos studies.

The visualisation of chaos formulae, among which the Mandelbrot Set mutated into the 'Apple Man' is the best known, has produced countless images reminiscent of clouds, ferns, squid arms and other forms. Such stunning visual likenesses soon lead the associative eye to conclude that there are analogies, insisting on essential relationships where there is simply a phenotypical similarity. Some of the new biomorphicists do much the same, presenting mutating forms that have surfaced out of the obscure depths of the computer in their lectures, forms that sometimes recall corals, at other times organisms. Their creations are promptly misunderstood as part of a new bionics that carries nature's construction methods into the field of architecture and deluded partisans celebrate an architecture in harmony with natural forms. This misunderstanding is fueled by the evocative sequences of pictures from the realm of nature with which architects like Ben van Berkel embellish their books. There the intricately perforated metal screen of a building's façade is compared to the eyes of an insect,[22] though it has no biological function; one has to assume that here the natural form at most served as a source of sculptural inspiration.

Like Greg Lynn, Lars Spuybroek also attempts to imitate the temporal dimension of chaotically growing forms in his computer design work. Among the few structures from this genre ever built

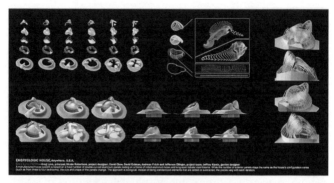

Greg Lynn, Embryological House, 2000

is his Son-O-House (ill. opposite page), completed in 2004 – a glass jellyfish that is also a clear homage to Le Corbusier's sound sculpture *Poème électronique*, erected together with the composers Iannis Xenakis and Edgar Varése in the Philips Pavilion in Brussels in 1958. In Spuybroek's structure sound patterns developed by Eric van der Heide respond to the visitors' movements.

Much the same happens in the project 'Biomorph' lounge, whose architects took 'the phenomenon of the swarm' as their model. The visitors' heartbeats are registered by electrodes and transmitted by way of an armband to receiving stations where the data is processed and 'various musical and visual effects' are generated.[23]

Once again these are attempts to make a structure appear to be a collective organism. By this method, which tries to reproduce the complex processes by which forms are developed in nature, an ideology of metaphysical totality is also accorded new respect. For example, it is said of the designs of Hernán Alonso Diaz that his 'revolutionary concept of architecture' operates 'at the interface between architects like Greg Lynn and Hani Rashid and architectural theorists like Jeffrey Kipnis, who are considered to be the pioneers of an amorphic architecture. Like the genetic mutations of a cell, his individual projects refer to each other and in their sum total produce an organic whole. His brilliant architecture is devel-

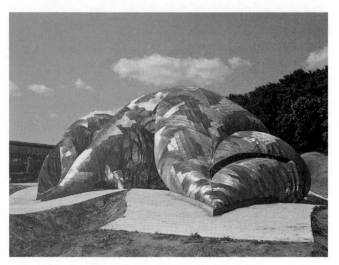

Lars Spuybroek, Son-O-House, 2004

oped out of patterns of evolutionary movement that extend from abstract forms to hybrid structures.' In this paean to his 'holistic concept of architecture'[24] a whole arsenal of terms – from 'mutations' to 'evolutionary' to 'hybrid' – is served up to make architecture seem like a second nature and the architect a veritable *alter deus in terris*.

Not all biomorphic forms in architecture are explained with such essentialist totality rhetoric – many, like Peter Cook and Colin Fournier's Kunsthaus in Graz (ill. p. 22), which is reminiscent of a glass cuttlefish, take biological forms as the starting point for sculptural form in only a vague way.

This is also true of the shimmering blue Selfridges Building in Birmingham, completed in 2003 by Future Systems. Its exterior is also suggestive of flotsam or some aquatic creature, but inside it houses a more or less conventional department store (which is why we are almost always shown only exterior photos).

More than a decade ago, with regard to the esoteric connections being made between architecture, bionics, computer-generated

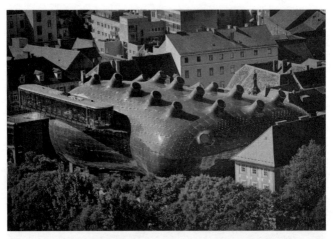

Peter Cook and Colin Fournier, Kunsthaus Graz, 2003

blobs and images from chaos studies, the zoologist Werner Nachti-
gall remarked that it was to be hoped that such architecture, only
phenotypically nature-like, is 'not be misunderstood as a way back
to nature, to the point of assimilating actual natural forms.'[25]

A glance at the historic example of Ronchamp also helps to
clear up several misunderstandings that characterise the relation-
ship between natural form and design to this day. To choose to see
in Ronchamp merely the beginning of a reorientation towards
nature in modern architecture or a consciousness of 'natural'
design principles would be one such misunderstanding.

The materials Le Corbusier used in the planning of the roof at
Ronchamp are preserved in the Fondation Le Corbusier in Paris.
Anyone who takes a look at them soon recognises that the sand-
wich construction of aeroplane wings was at least as important as
the crab's shell. In the 1950s there was considerable discussion in
professional journals about the possibility of applying the wing
design developed for aircraft to reinforced concrete construction
and Le Corbusier kept clippings of such wing diagrams (ill. p. 23).[26]

In 1923, in his collection of essays *Vers une Architecture*, Le Cor-
busier had already insisted that architecture needed to take into

Le Corbusier, model for roof construction at Ronchamp based on aeroplane wing sandwich construction

account the construction of modern ships, automobiles and aeroplanes and, even with his nature-inspired roof at Ronchamp, he had remained truer to his old enthusiasm for modern technology than most critics recognised (ill. p. 24). Archbishop Dubois of Besançon was one of the few who saw to what degree the chapel owed its design to contemporary aeroplane technology. In his dedication speech on 25 June 1955, he spoke of the church as 'arche et avion' – an ark and an aircraft – an apt description of the structure's idiosyncratic juxtapostion of the Archaic and the ultra-modern.[27] Yet why did Le Corbusier fail to mention aeroplane technology with a single word? Why did he repeatedly emphasise the importance of the natural form, his find while strolling along a beach?

In French literature there is a striking parallel to Le Corbusier's anecdote about an architect who, in a moment of crisis, strolls along a beach and finds an unusual object that provides him with infinite new ideas.

In 1921 the poet and philosopher Paul Valéry published his architectural-philosophical dialogue *Eupalinos* (ill. p. 25), which takes up his thinking from earlier essays like 'The Paradox of the Architect' and 'Introduction to the Method of Leonardo da Vinci'. In *Eupalinos* Socrates and Phaedrus, as shadows of the dead, discuss the 'great business of building'.[28]

Le Corbusier, sketch for roof at Ronchamp

Valéry's Socrates tells of an experience that is astonishingly reminiscent of the story Le Corbusier later told in connection with his find. He 'was walking along close to shore', Socrates relates, and there he 'found one of these things that the sea has cast up; a white object of the purest white, smooth, hard, delicate and light … its peculiar shape caused me to abandon all my other thoughts. Who made you? I wondered. You remember nothing and yet you are not formless.'[29]

He had thrown the thing – which he calls an 'object ambigu' – back into the sea and puzzled about it instead of keeping it and studying it as an architect might have done. Thus, after throwing the object away, Valéry's Socrates became a philosopher who sought the truth in ideas rather than the world in sensual forms.

In his *Arcades Project* Walter Benjamin explains that the main distinction between the flaneur and the collector is that the flaneur responds to the world visually, the collector tactilely.[30] In Valéry

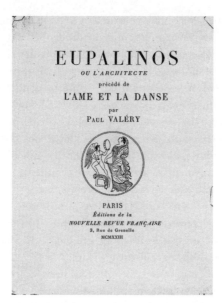

Le Corbusier's personal copy of Paul Valéry's
Eupalinos, Paris, 1923

this distinction separates the thinker from the architect – and it is one of the anti-Platonic ironies of the text that, in retrospect, Valéry's Socrates greatly regrets his decision to throw away his find and become a philosopher.

Le Corbusier owned this book and had read it. He was personally acquainted with Valéry; he read his works closely and carefully annotated them. There is much to suggest that Le Corbusier's theory of architecture was greatly influenced by Valéry's thought – especially by his *Eupalinos* (ill. above), which Hans Blumenberg called one of the fundamental texts, not only for Valéry, but for twentieth-century architectural and art theory in general, one that with the example of the 'objet ambigu' called into question the distinction between natural form and work of art promulgated in classical metaphysics – a subject that had occupied Le Corbusier well before Ronchamp.

Le Corbusier's library consisted of some 1,600 volumes, the majority of which are preserved in the Fondation Le Corbusier in Paris. From the abundant commentaries, insights and observations with which he annotated these books it is possible to study how the architect read, how he would take up ideas, ponder them and incorporate them in his own theories. He would often write whole essays between the lines of a book in a swift, scratchy hand, curling words into the empty spaces until his annotations became more and more indistinguishable from the printed words and ideas. Of all his books, Valéry's stand out – Le Corbusier read them and annotated them with the greatest concentration.

Le Corbusier and Valéry's common interests were by no means limited to architecture. Since the mid twenties Le Corbusier had collected flotsam that he found on the shore, old bits of wood, eroded stones and above all shells – seashells and crab's shells like the one from Long Island. He called his finds 'objets à réaction poétique'. They would come to fill whole shelves and ultimately whole sheds.

Valéry had a gigantic shell collection, he too was perennially fascinated by shells and the odd, fragmented shapes that he found on the shore and that turned up in his writings again and again as *objets ambigus*. For Blumenberg, the 'objet ambigu' is 'something for which there is no designation within a Platonic ontology. Socrates sees it immediately – it is an object that is reminiscent of nothing else and yet is not without form.' It 'also fails to find a place in the ultimate classification of ancient metaphysics, into the distinction between the natural and the artificial.'[31]

Whereas ancient ontology considered that it was always possible to decide whether an object was of natural or artificial origin, with the 'objet ambigu' Valéry introduced a new category: a surreal hybrid that erased the distinction between nature and art. Le Corbusier's objects are precisely that – especially the fragments of bricks that the architect tended to collect along with shells were always representative of both: cultural products formed from clay, a natural material, which, after being 'processed' by natural forces, tides and waves, have taken on a new shape.

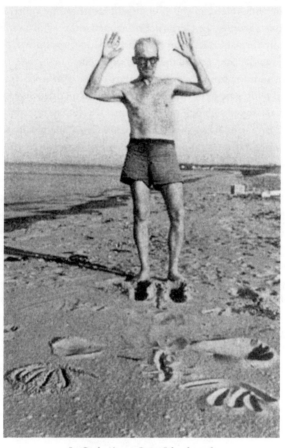

Le Corbusier on Long Island, 1946

While Le Corbusier was working on his 'Modulor' and *Poème de l'angle droit* he read Valéry's *Man and the Seashell*.[32] So it is perhaps no coincidence that the pattern of thought developed by Valéry with regard to the shell and the 'object ambigu' can be read as the theoretical blueprint for the new ways of thinking about architecture and design that Le Corbusier was envisioning in the late 1940s through study of his 'objets à réaction poétique'. In his theoretical

debate with Valéry, as well as in his still insufficiently appreciated work as a painter, Le Corbusier developed a theory of form that literally turned on its head the kind of Modernism of which he was even then considered the classic exponent.

In addition to shells and crab carapaces Le Corbusier also collected photographs of current patterns left in mudflats by ebbing tides, of eroded soils and polished stones. In what he referred to as 'nature' – as distinguished from the sphere of mathematics and technology in a way that at first strikes one as obsolete – he was primarily interested in the evolution of form – a process that in contrast to the mathematical model that describes it, cannot be deterministic in the classical sense. What kind of architecture arises from the study of the pattern of a shell or of a piece of driftwood in which endless permutative, random processes are reflected? This was a question Le Corbusier asked himself in the light of his finds. What we now fashionably refer to as nonlinear design systems had here an early precursor.

Through his meditations on Valéry and his object theory Le Corbusier developed a new concept of design that went beyond the incorporation of chance finds in his architecture.

It is curious that the collecting of shells would lead Le Corbusier and Valéry in much the same direction. On the basis of shells and other flotsam they both sought to develop a theory that not only questioned how natural form and culture are related, but also the ways in which architecture had been understood up until then. Ronchamp and the thinking that led to it also questioned what it means to design something. What is 'invention' and how does it function? How does a new form arise? What happens when the artist 'designs'? What roles are played by things he has read or remembered? How much is unplanned? Is it possible to imagine forms and spaces that open up a new freedom beyond the classical distinctions 'interior' and 'exterior', 'nature' and 'art'?

The flotsam that both Valéry and Le Corbusier piled up in their workrooms and that again and again resurfaces in their writings and images like some masonic lodge symbol was central to their thinking: in Valéry the object of a new phenomenology, in Le Cor-

busier a ground plan, decor and design accompaniment and painting motif.

The architect, who is still today regarded as the inventor of the 'living machine' and proponent of a technocratic-mechanistic Modernism[33] was, at the same time, the one who would steer that Modernism in a wholly different direction, one that is not fully appreciated to this day.

It is another history of modern architecture that can be told taking these objects as a starting point.

This history began on a beach.

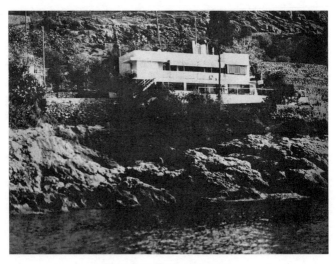

Eileen Gray, E1027, built in 1929

I.

THE BEACHES OF MODERNISM

When Le Corbusier travelled to Cap Martin the first time, it was not to be beside the sea. He wanted to look at a house. In Roquebrune, a small village on the Côte d'Azur, the Irish interior designer Eileen Gray had erected her first building, a villa among rocks and pine-trees with a view of the open sea and the bay of Monaco (ill. above). Le Corbusier and Gray knew each other from Paris. She was nine years his senior and one of the best-known furniture designers of her time; her partner, the Romanian architect Jean Badovici, edited the periodical *L'Architecture vivante* and was a close friend of Le Corbusier. Badovici and Gray had looked for a plot of land on the French Riviera since 1925, eventually finding

one near the Italian border, half way between the railway line and the beach. In the intervening years Gray had spent much time on the coast overseeing the construction work, whereas Badovici dropped by Roquebrune only occasionally, preferring to go on holiday with Le Corbusier to Arcachon or occupy himself in other ways.[1]

Gray's house was finished in 1929. The extended white building with a flat roof and long horizontal windows lies above a small beach. Viewed from the sea, it resembles a white yacht anchored behind red-brown rocks. In designing the house Gray adopted a number of precepts formulated by Le Corbusier in the mid-1920s. The structure stands on thin iron stilts (*pilotis*), the floor plan is open and the windows form a horizontal band. Le Corbusier's influence is so obvious that until quite recently Gray's villa sometimes featured as his work in specialist periodicals.[2] However, it can be read differently, as a development or critique of Le Corbusier's tract *Vers une Architecture* (*Towards a New Architecture*).[3]

Even the name Gray gave her seaside house, E1027, suggests an ironical commentary on the cult of the machine, espoused by the avant-garde to which Le Corbusier was thought to belong since publishing *Vers une Architecture*. Although it resembles a neutral record, like the serial number of a technical apparatus or the date – October 1927 – when the building was begun, it in fact harboured a romantic secret. The 'E' stood for 'Eileen', the '10' for the tenth letter of the alphabet ('J', as in 'Jean'), the '2' for the second ('B', as in 'Badovici') and the '7' for the seventh ('G', as in 'Gray'). In this way, her name bracketed his in that of the house: Eileen-Jean-Badovici-Gray.[4] Gray was fifty-one years old, Badovici thirty-five, when the house was ready. They separated a few years later.

Gray left E1027 to Badovici in 1932 and built herself a new house, in Castellar, where she owned some land. At Badovici's invitation, Le Corbusier visited the coast several times. He holidayed in E1027 with his wife, Yvonne, and in 1938 painted some of its interior walls. Le Corbusier intended the murals as a gift for his hostess, but she saw his intervention as an 'act of vandalism'. Much has been written about this physical appropriation,[5] which brought to

a head a conflict that had been smouldering since 1929 and led to a final break between Le Corbusier and Gray. For E1027 was only ostensibly a homage to Le Corbusier. Unlike his Villa Savoye, created in the same year and, as described above, elevated on stilts amid grass (ill. p. 13), Gray's house is built into the landscape and structured around vistas. The harbour and bay of Monaco can be seen from the living area; the bedrooms are arranged so that the morning sun shines into them. Gray decided not to raise the ground artificially, but to design the house in accordance with the natural givens.[6]

A modernist like Le Corbusier admired ships for their rational organisation of space within a severely limited area[7] and for their perfect accommodation to aquadynamic and aerodynamic laws. By contrast, Gray cited the ship aesthetic in E1027 in a proto-postmodern way. The house is *architecture parlante*: she hung a life buoy beneath the long window on the seaside elevation, mounted a white mast on the roof and gave the stairs, which lead from the exposed, visible rocks to the roof, the shape of a seashell.[8] The spiral of the stairs was important to Gray both as a physical form and as an image and metaphor. She used it as a basis for criticising Le Corbusier's notion of the house as a 'machine for living in', a phrase he had coined in *Vers une Architecture*.[9] A house, Gray wrote, is 'not a machine to live in. It is the shell of man, his release, his spiritual emanation.'[10]

Such criticism must have hit Le Corbusier very hard indeed. In the 1920s he had begun to collect vast amounts of flotsam and jetsam and to study the shapes, textures and markings of seashells. How important these forms were to his architectural theory and practice would not emerge until much later. In fact, these 'objets à réaction poétique', as he called them, constituted nothing less than the key to his new concept of architecture. They were the central focus of his theory of design and form, generating an intellectual model that would eventually lead to a far-reaching break with some basic ideas about architecture.

The architect and the sea:
self-depiction in the sign of the shell

Le Corbusier's huge collection of flotsam and jetsam was long explained away as a fad. Just how seriously he took the objects became clear at the latest on 18 June 1950. That day the architect interrupted his work on the Ronchamp plans to sketch a medal in honour of himself (ill. p. 34, top).[11] Carried out by the sculptor Jean-Charles Lallement, the design was subsequently issued by the French mint (ill. p. 34, bottom) – to the chagrin of Le Corbusier, who in October 1955 complained to Lallement in a letter of thanks that his face on the medal was 'not very beautiful, but if that's how you see me, so be it'.[12] Lallement did at least reproduce exactly the symbols that Le Corbusier had included in his sketches, even though they departed completely from the attributes traditionally associated with architects, such as pairs of compasses, rolled plans and personifications of geometry.

What do the symbols on the medal signify? It is not difficult to identify the section through Le Corbusier's Unité d'Habitation, the tall residential block erected as a pilot project in Marseilles from 1947 to 1952. On the reverse, a square divided in accordance with the architect's Modulor system of proportion appears behind his self-portrait. Beneath the portrait, in place of the bow tie customarily used by Le Corbusier as his architect's mark, is a seashell. Le Corbusier here inscribes himself programmatically into a twin system. Two worlds meet, that of linear geometry and that of a mathematically more complex natural form whose helix is as easy to calculate as its textures and markings are chaotic, alleatoric and difficult to describe in mathematical terms. A measurable system of calculable harmonies, rationally explicable in every detail, encounters the immeasurable mutations of nature.

The seashell is a borderline product: its textures – the irregular shapes and chipped areas – arise by chance, but the genesis of its basic form, like that of many plants and molluscs, can be explained in terms of the 'Fibonacci numbers', an endless sequence of numbers discovered in the Middle Ages in which each consecutive

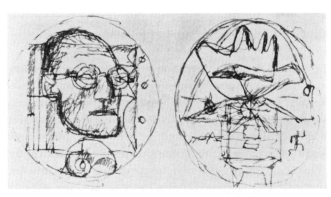

Le Corbusier, Sketch for a medal in honour of himself, 18 June 1950

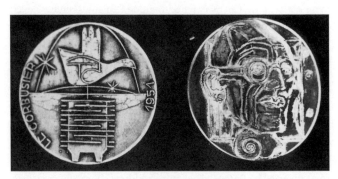

Jean-Charles Lallement after a design by Le Corbusier,
Le Corbusier medal, 1955

number results from the sum of the two previous ones. Johannes Kepler later established that the quotient of two successive Fibonacci numbers approximates to the Golden Section, in which the smaller part is to the greater as the greater is to the whole. The logarithmic spiral of the shell can be represented as quadrants forming a link between the corners of a 'golden' rectangle divided into a square and a smaller rectangle. In the nineteenth century this spiral was therefore considered to be an ideal form and the embodiment of a natural aesthetic law.[13]

The forms of nature as the key to a new architecture: those were the terms in which Le Corbusier promoted his Unité d'Habitation, which, following its first realisation in Marseilles in 1947–52, was erected in Nantes and, in an altered form that took account of inflexibly bureaucratic German building regulations, in Berlin. The first Unité was 138 metres long and 56 metres high. Its eighteen floors contained 337 apartments, most of them two-storey, and a separate floor housing shops, a small hotel and a laundry. On the roof was a terrace with a kindergarten, climbing facilities, a swimming pool, a gymnasium and a running track – all adding up to a kind of public square on top of the building. Le Corbusier said of the design that it aimed to re-establish 'the rapport man – nature' by supplying 'in silence and solitude, in the light of the sun and amid space and green, a dwelling that would be the perfect receptacle for a family.'[14]

Finally, the medal features an open hand enclosed by two parabolas clearly representing paths of the sun. At the time he designed the medal, Le Corbusier was designing a hand of this type as a monument in the centre of the new city of Chandigarh in India. Nehru, the country's prime minister, had commissioned the architect to design a new seat of government for the Punjab in the summer of 1947, after India and Pakistan had gained independence from British rule and Lahore, India's north-western capital, had become part of Pakistan. The site chosen for this ideal city, named after a nearby village, lay at the foot of the Himalayas. Le Corbusier had the hand erected house-high in concrete in the grand public square, the Fosse de la Considération. It remains the city's landmark to this day.

The hand possessed a double significance: firstly, it formed part of Le Corbusier's private cosmology, in which it symbolised life lived 'in harmony with all men, animals and inanimate things'. 'Since 1948', he wrote, 'I have been obsessed by the principle of the open hand.'[15] This hand, a 'sign of peace and reconciliation, must be erected at Chandigarh. This sign, which is something that I have carried in my subconscious for many years, must come into existence in order to provide a testimony of harmony. Before I find

myself some day ... in the celestial spheres amid God's stars, I shall be very happy to see this "open hand" which ... marks a fact, a stage accomplished.'[16]

The second meaning of the hand relates to a turning point in Le Corbusier's architectural theory. In 1955, not long after the consecration of Ronchamp, he published *Le Poème de l'angle droit*, a picture book that juxtaposed fragmentary poetic phrases relating to his architecture with drawings of superimposed shells, landscapes, human bodies and modern architecture. This 'Poem of the right-angle' aimed to popularise his theory of architecture through evocative combinations of words and images. Not bothering unduly about the borderline between pathos and kitsch he wrote in it: 'Tenderness! ... The hand kneads, the hand caresses, the hand smooths. The hand and the shell love one another.'[17] As already suggested, the text seeks to describe in easily comprehensible terms how architecture is created and how it might affect the lives of people in the modern age. In *Vers une Architecture* of 1923 Le Corbusier had invoked mathematics, the 'pure creation of [the] mind', as the well-spring of all design. Now that function was performed by the tactile experience of a natural spiral with a rough exterior and a smooth interior. The hand on the medal, then, symbolised a theory of design that accorded the tactile element, the exploration of form by means of touch, just as much importance as the pure geometry evoked by the classic attributes of the architect.

As a student Le Corbusier had engaged intensively with the occult theosophical theories of Edouard Schuré, seeing himself as a 'grand initié' (grand initiate) capable of understanding the laws of the cosmos.[18] Now, in the iconographical programme on his medal, he aimed to represent nothing less than a harmonious synthesis of nature and human creation. Yet the natural form of the seashell, its inexplicable shapes and tactile sensations, figure as a central architectural symbol not only on the medal. The seashell emblazoned there like a personal emblem beneath Le Corbusier's head is the same as that in the drawing that hung above his desk (ill. opposite page). It is the shell whose abstracted logarithmic spiral formed the basis in 1928 of his plans for the Mundaneum, a

Le Corbusier in his study. On the wall is a drawing
of his Modulor and a seashell

museum devoted to knowledge of the world, and, a few years later,
for the Musée à Croissance illimité. A decade later the shell con-
stituted the starting point for one of the most influential architec-
tural systems of proportion in the modern age: Le Corbusier's
Modulor, developed by taking a natural form (the seashell), sub-
jecting it to mathematical abstraction (a sequence of numbers
similar to Fibonacci's) and projecting the resulting mathematical
figure onto the human body.[19]

Shells, snails, flotsam and jetsam crop up everywhere in Le Cor-
busier's work. The seashell shape runs through his entire oeuvre
like a hidden leitmotiv, like some spiralling underground thought.
It thus comes as no surprise to find that the tiny *studiolo* he erected
on the coast in 1952 in close proximity to Gray's E1027 takes the
form of an abstract snail's shell.

Living in a snail's shell:
Le Corbusier's Cabanon at Cap Martin

In the early 1950s Le Corbusier pursuaded the former plumber Thomas Rebutato of Nice to let him erect a small structure on a plot of land Rebutato owned next to Gray's house. Rebutato had opened a seaside restaurant called the 'Etoile de mer' and Le Corbusier had become acquainted with him during holidays spent on the coast. They had already worked together on a number of projects. From 1949 to 1951, for example, Le Corbusier had designed developments for Rebutato consisting of mini-sized holiday homes. This included a project named 'Roq', which featured thirty to eighty units for tourists but did not get off the ground owing to Rebutato's financial difficulties, and another called 'Rob', which comprised 'cells' for campers.[20]

On 30 December 1951 Le Corbusier sketched plans for a similar unit, which he called 'Le Cabanon' (the cabin or hut). With a ground plan measuring 3.66 by 3.66 metres, and a room height of 2.26 metres, the Cabanon was the smallest house Le Corbusier ever built. This room by the sea, constructed like a log cabin from rough-hewn pine trunks, was tucked away on a slope between Menton and Monaco. Its dimensions were arrived at with the help of the Modulor system, which Le Corbusier had recently published in book form (*Le Modulor*) and which he hoped architects would use to calculate harmoniously and practically proportioned details (ill. p. 39). The system was founded in a length of 2.26 metres – the average height of people in his day with their arms raised – and in a sequence of numbers derived from a seashell's logarithmic spiral, which was to form the basis of every detail's proportions and position. In the Cabanon Le Corbusier first realised his ideal measurements for a unit of accommodation as proposed in *Le Modulor*: 2.26 × 2.26 × 2.26 metres. He packed everything he needed into this space: a folding table, two storage chests that also functioned as seats, a bed, a bath, a lavatory and a window from which it was possible to see the spot where he would drown while swimming in the sea in on 27 August 1965. The Cabanon demonstrated the mini-

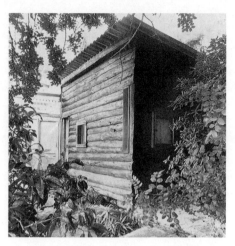

Le Corbusier's Cabanon at Cap Martin
on the Mediterranean, 1952

mum space needed to contain everything essential for living. But it was more than that. It was a kind of built manifesto, designed to show how materials generate spatial effects in combination with ground plans and it can be no accident that walking inside the Cabanon resembles moving round the spiral of a seashell.

In his *Poétique de l'espace* (*The Poetics of Space*) Gaston Bachelard traced the literary history of 'day-dreams of refuge'[21] as embodied in the notion of human-sized shells enfolding the body like a cross between a second skin and a house. Le Corbusier himself spoke in interviews of his wish to 'give the human being its shell'.[22] In a sense, the Cabanon is just such an artificial shell. It is entered via a 3.6-metre-long corridor, which in view of the house's tiny dimensions represents a curious waste of space. From the corridor one turns sharp right and, as Bruno Chiambretto has noted in his analysis of the Cabanon, continues in a spiral motion, as though moving inside a shell.[23] Even the small, hatch-like windows offering views of the sea only strengthen the feeling of intimacy and security. Significantly, Le Corbusier abandoned the broad window bands here with which he otherwise liked to open up his buildings.

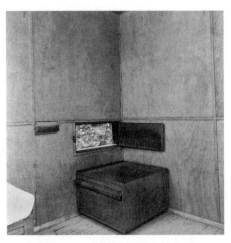

Le Corbusier's Cabanon at Cap Martin;
interior view

It is not only the spiral organisation of space in the Cabanon that brings to mind an abstract shell. The materials arouse similar associations. Made from smooth, light-toned wood, the interior walls and the furniture form a seemingly organic unity and contrast with the rough wood of untreated pine trunks on the outside. This was an unusual feature for Le Corbusier, who was widely known for antiseptically smooth exteriors of white plaster and who now upset his friends and associates by building something resembling a lumberjack's cabin.[24] He was presenting a physical contrast of the kind characteristic of shells, with their external roughness and their interiors as smooth as porcelain. Along with their strict mathematical construction, it was the tactile qualities of these 'objets à réaction poétique' that fascinated him. 'They are caressed by your hands, your eyes gaze upon them, they are evocative companions,' he said of objects that 'speak the language of nature'.[25] In the Cabanon he magnified the tactile opposition between rough exterior and smooth interior to the size of a building. The structure amounts to a prototype for architecture no longer predicated exclusively on proportion and measurement, but also embracing

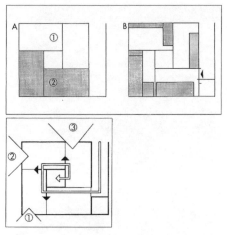

Analytical ground plan of Le Corbusier's
Cabanon at Cap Martin

the effect of materials. The eye, the visual element, loses its primacy: lacking large windows, the house is virtually 'blind', and the sense of touch, little regarded in the age of the Bauhaus, comes into its own.

In the 1950s the Cabanon provided the setting for a change in the image Le Corbusier promoted of himself. It formed a most effective stage on which to present himself to guests as a noble savage who had escaped decadent civilisation and, within sight of the sea and its generative powers, was developing a new kind of architecture nourished directly by the forms of nature.

The architect in his beach hut:
Le Corbusier's new self-image

In the summer of 1955 correspondents of the magazine *Science et vie* were among those received by Le Corbusier in the Cabonon, rather than in his Paris studio. He led the journalists to the hut next to the Cabonon, in which he housed his collection of objects. His appear-

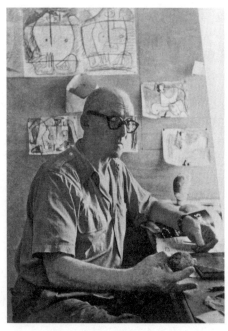

Le Corbusier in the Cabanon,
press photograph, 1955

ance surprised them: he was wearing an open-necked, khaki-
coloured shirt and summer trousers, and that is how he let them
photograph him, holding a pebble from the beach in his right
hand (ill. above).[26]

It was not the first time Le Corbusier had invited photogra-
phers to the seaside. In 1946 he had presented himself to them on
the beach on Long Island in swimming trunks, his hands raised as
though he has just performed a handstand, posing in front of some
usual marks in the sand (ill. p. 27). Later, Lucien Hervé, a 'court
photographer' of sorts to the architect, took a picture of him on the
pebble beach at Cap Martin, again wearing just swimming trunks
and again with his hands raised, as though Hervé had snapped him
just as he was finding something very important (ill. p. 46). For

Brassaï he posed among palm leaves like a native whom a chance encounter with another civilisation had equipped with a pair of spectacles and some swimming trunks (ill. p. 115). Finally, he also showed himself painting in the nude. Unlike the pictures of him taken during seaside holidays in the 1920s and 1930s, these photographs were not for private consumption. They formed part of a large-scale image campaign. What had happened to induce the architect to be photographed in his shirt sleeves, in swimming trunks or even completely naked?

Le Corbusier was a professional self-advertiser. Few architects have worked harder at their image and few have been so rigorous in their choice of outfit – suit, bow tie, heavy-rimmed spectacles. This get-up initiated a sort of sartorial dogma that would later be seen as a caricature of the entire profession. The way Le Corbusier dressed underscored his love of the modern Machine Age: his narrow-cut suits seemed like tubes in some apparatus, his black, circular glasses and bow tie like the cogs in a human machine. In contrast to the corpulent Ludwig Mies van der Rohe, Le Corbusier, gaunt and clothed in technological-style garb, literally embodied his dogma: his physical appearance echoed the radical, technoid modernism of which he was a well-known and acclaimed representative. He wore the clothes to be expected of a designer of white houses like the Villa Savoye of 1929, in which even the remotest corner is proportioned strictly in accordance with the Golden Section. His fashionable exterior suited the image of a rampaging demiurge who in 1925 had proposed to demolish half Paris and substitute the severe grid and ultra-modern highrise city of his Plan Voisin.

If Le Corbusier's designs of the 1920s share anything it is a certain bodilessness. The Villa Savoye, for instance, hovers above the ground on the thinnest of reinforced concrete stilts like a vision in white paper. Or again, the Plan Voisin aimed to tear apart the body of the city, with its tightly-knit traffic network, and replace it with airy islands of residential accommodation amid a loosely arranged urban landscape. Le Corbusier embodied this aesthetic in his strictly formal, almost mechanical appearance. It was thus perhaps

no accident that he presented himself to the press quite differently in the Cabanon.

The *Science et vie* reporters were impressed. 'A wooden hut', they wrote after their visit, 'with three drawings on the wall, a project for a carpet and a few coloured sketches. Light from two windows falls on a large rectangular table covered with paper and on shelves full of variously coloured stones, pieces of bone eaten away by the sea and a lobster shell. A man in his shirt sleeves is sitting upright at the table: the architect of happiness, Le Corbusier. The wooden hut is his workshop.'[27]

The article was headed 'The man who can give all French people a home.' And indeed, the journalists' chief concern was to report not on the holiday pursuits of celebrated artistic figures, but on the future of France's cities. Le Corbusier still spent most of his time in his Paris studio, but the reporters pictured him as a lonely thinker, dreaming up a new architecture in a simple hut made of plain logs, far removed from urban civilisation. The message of the photograph is clear: here, within sight of the sea and amid the forms it generates, among lobster shells, stones and bones, the architect, pebble in hand, will have ideas that would never occur to him in the stifling atmosphere of the city. Le Corbusier, still seen by many as a leading representative of rational, machine-orien-tated modernism, presents himself as a visionary seeker after form, outside society, on the border between nature and culture. 'Objets à réaction poétique', not mathematics and systems of measurement and proportion, now lie at the heart of his architectural theory.

The press eagerly accepted Le Corbusier's new image. 'In his hand', wrote the correspondents of *Science et vie* under the photo-graph, 'he holds "natural structures" – shells, pebbles – he has col-lected on the beach. In Le Corbusier's opinion a bone gave birth to the Eiffel Tower and a crab's shell to the church of Ronchamp.'[28]

The picture in *Science et vie* proclaimed to a wider public a para-digmatic change in Le Corbusier's view of architecture. This is reflected in his writings. Mathematics, proportions and concepts no longer figure as the starting point for creating architectural form. Their place is taken by the tactile exploration of stones, bro-

ken bones and chipped bricks. Le Corbusier now looks for formal and structural models in the collision zone between land and sea. He systematically described this rejection of the culture of pure stereometric volumes, of deliberately antiseptic rationalism, in favour of the fragmentary, aleatoric forms of flotsam and jetsam for the first time in 1935, in his tract *La Ville radieuse*. Here he had already abandoned the image of himself as a rationalist believer in technology and became a self-styled 'homme de la mer' (man of the sea) who preferred the unspoiled, archaic life of fishermen to the decadence of the big city. He wrote: 'I go where order is coming out of the endless dialogue between man and nature, out of the struggle for life, out of the enjoyment of leisure under the open sky, in the passing of the seasons, the song of the sea.'[29]

The image of a man who turned from the difficulties of national reconstruction to the eternal cycles of nature, however, clearly hit the spot in the post-1945 period. Time and again his claim was reiterated that 'the shell of a crab inspired [Ronchamp's] design.'[30] No one bothered to check this 'fact'. Just as no one took the trouble to ask why an active participant in architectural policy was now presenting himself as a semi-naked shaman of spatial wisdom who clothed the forms of modernist architecture in natural laws. During the Second World War Le Corbusier had tried very hard for commissions from the collaborationist Vichy régime (and, as letters preserved at the Fondation Le Corbusier in Paris show, shared with many architects of the time a naive enthusiasm for Nazi ideology). As for Ronchamp, its roof was made possible by technological innovations like the sandwich construction of aeroplane wings. Le Corbusier had studied such forms closely, but played down their influence in favour of a romantic account of the chapel's birth from the waves of natural forces.

This mystification of the design process represented a clever ploy in defending modern architecture from the accusation that it produced soulless, inhospitable, machine-dominated buildings. Criticism of modern city architecture was rife. Voiced at the conferences of the Congrès Internationaux d'Architecture Moderne (CIAM) ever more strongly after 1951, it culminated in 1961 in

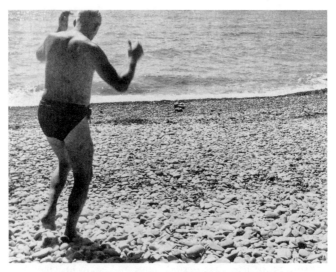

Le Corbusier on the beach, photographed by Lucien Hervé

Jane Jacobs's full-scale attack in her book *The Death and Life of Great American Cities*. For that reason alone, it could do no harm if in the popular imagination nature replaced technology as modern architecture's chief point of reference – regardless of the fact that contemporary mathematicians were associating both aspects to a virtually unprecedented degree.

The strategy worked. Le Corbusier's anecdote about what he found on the beach was so convincing that even his opponents ceased to accuse him – as the art historian Hans Sedlmayr had still done – of trusting blindly in technology and of tearing people from their roots; now, it was his glorification of nature, heaving and swelling, unrestrained and unstable, as at Ronchamp, that they deplored.

It is tempting to leave it at that – to interpret Le Corbusier's self-promotion as the architect in swimming trunks and his attractive blend of natural forms and contemporary architecture simply as a propaganda measure. When protests about the mass accommodation of people like hens in concrete batteries mounted and

dissatisfaction with severely plain, sober forms of architecture began to find expression in kidney-shaped tables and neo-Expressionist curves, Le Corbusier will not have wanted to be ranked among the exponents of an outdated and inhumane architectural ideology and so opted instead to present himself as a pioneer of a synthesis of nature-based architectural principles and mass-produced components. Yet his love of the sea amounted to more than a propaganda subterfuge on the part of an inveterate self-publicist eager to shake off his reputation as an inflexible builder of machines for living in. The cracked, broken flotsam and jetsam he had been collecting since the mid-1920s – especially the shells – constituted the raw material and intellectual basis of a new theory of architecture. This theory led him to reject the primacy of abstract ideas and traditional categories in the genesis of designs and would eventually result in quite new architectural forms.

What the architect on the beach was looking for: 'objets à réaction poétique'

What did the architect do on the beach?

First of all, what most people do. There are photographs showing Le Corbusier behaving like any tourist. He went swimming, lay on the sand, smoked a cigarillo. In the summer of 1933 he carried on smoking a pipe while boxing with his cousin Pierre Jeanneret on the beach at Le Piquey (ill. p. 48). He played tag with friends, read while floating in a life buoy (ill. p. 49) and collected shells and stones.

But he also took photographs, of splintered wood, of ripples formed in the sand by the outgoing tide, of boulders hollowed out by the sea. There are pictures of footprints in the sand, of a woman's bare legs sinking into the wet sand near the water, taken against the light. Then there are the shells, casting bizarre-looking shadows when lit from the side or acquiring a surreal plasticity. Almost like an Impressionist, he took pictures of the moment when a wet piece of wood sparkles in the sunlight, as though it were not

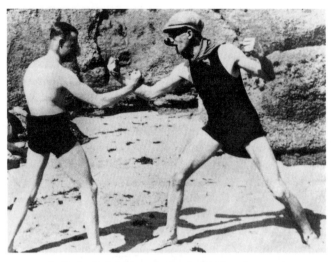

Le Corbusier boxing on the beach with Pierre Jeanneret

enough for him to take *objets trouvés* home with him and he must also prevent fleeting impressions from vanishing forever. He thus appropriated an object in two ways, by keeping it and by taking its picture. It would seem that Le Corbusier feared the kind of disappointment felt later by the man in in Italo Calvino's story 'Collezione di sabbia' (Collection of Sand) who collects sand from various beaches, only to discover that its evocative power evaporates when removed from its original locations.[31]

In the 1930s Le Corbusier began amassing a collection of 'natural objects' that soon came to number several hundreds.[32] In his tract Entretien avec les étudiants des écoles d'architecture (Le Corbusier Talks with Students from the Schools of Architecture) of 1942 he calls them 'objets à réaction poétique' for the first time. 'A pebble polished by the ocean ... a broken brick rounded by lake or river waters, or bones, fossils, tree roots or algae, sometimes almost petrified, or whole shells smooth as porcelain or carved in Greek or Hindu fashion ... [b]roken shells [that] reveal their amazing spiral structure ... seeds, flints, crystals, pieces of stone and wood': they 'form the vast panoply of spokesmen who speak the language of

48

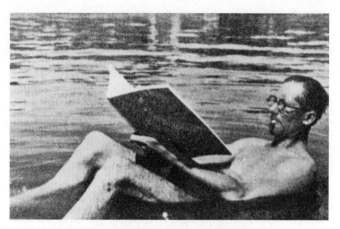

Le Corbusier reading in the bay of Saint Tropez

nature.'[33] All these things he 'gathered at the waterside, at lakes, at the sea', things that, 'tortured by the elements, demonstrate physical laws – wear and tear, erosion, splintering etc. They possess not only plastic qualities, but also exceptional poetic potential.'[34]

Le Corbusier sometimes even kept cow and chicken bones left over from meals.[35] He stored all these things in no apparent order on tables and in boxes and chests of drawers. His 'objets à réaction poétique' differed from the *objets trouvés* collected by other artists of his time principally in that they did not include any of the detritus of civilisation, the 'old tins, mattress springs and rusty bicycle parts',[36] that sparked the Surrealists' imagination. Very occasionally he might keep something like a dented lamp, but as a rule the forms that interested him were notable for an ambivalent combination of generative nature, human activity and destructive natural forces. They were either natural objects that somehow looked 'treated' or 'constructed' or they were distorted artefacts that, cracked, eroded or washed smooth, seemed to be passing back into the realm of amorphous matter.

Le Corbusier was intrigued by sawn cow bones, by pieces of split wood, by bricks that, having been fired by human hand, fell into the sea and were transformed by the action of the water from

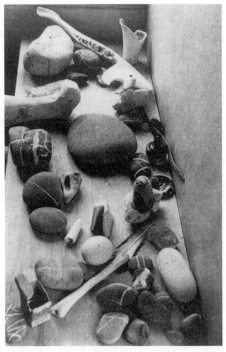

'Objets à réaction poétique': flotsam and jetsam
kept by Le Corbusier in his Cabanon

a rectangular block into a smooth ovoid shape – and by the broken seashell whose helix appears turned inside out so as to reveal its construction. When split open, spirals like this present particularly bizarre spaces. It is impossible to say exactly what is interior and what exterior: established categories for describing space dissolve in the face of such objects. Almost everything that Le Corbusier collected had been subjected to a formal metamorphosis that undermined familiar categories in this way. A strangely curved red-dish object, for example, might be a pebble that had been sand-wiched between two rocks for a long time or a brick that had been swept away by water, rounded, split and washed smooth again.

Neither its origins – whether natural, in water, or cultural, in a brickmaker's kiln – nor its initial function is immediately apparent. What Le Corbusier called the 'poetic potential' of the objects lies in these ambiguous origins. They raise questions and prompt speculation, engaging the mind while delighting the eye. These 'objets à réaction poétique' opened up a world of forms that lay outside the architect's accustomed intellectual categories, and thus outside the scope of his powers of invention. They acted as generators, mobilising previously inconceivable forms.

Le Corbusier expected constantly new inventions of himself. In this, he was the opposite of Mies van der Rohe who once declared that he saw 'no reason to invent a new architecture every Monday morning'[37] and developed his own architecture slowly, with dogged perseverance. Le Corbusier was a far more restless spirit and the 'objets à réaction poétique' helped him in his incessant search for fresh ideas. They were works of art that had come about by chance: their shapes had no recognisable purpose and no recognisable origins, and their presence did not represent anything. In a sense these found objects were to Le Corbusier as his architecture was to his contemporaries. The British critic Fourneaux Jordan once wrote that from somewhere up in the clouds Le Corbusier sent down hieroglyphs to earth that no one could decipher.[38] To the architect himself, *objets trouvés* seem to have resembled such hieroglyphs.

Le Corbusier described some natural objects in his collection, especially the seashells, as though they were works of art made by human hand. They were, for example, as 'smooth as porcelain'[39] – a statement that embodies a kind of etymological switchback, since the word 'porcelain' comes from the Italian *porcellana* (literally 'little sow'), which denotes a cowry and was applied to a particular type of ceramic ware when it reached Italy from China in the fourteenth century because its perfectly smooth surfaces recalled the inside of a seashell. For Le Corbusier, seashells were also 'sculptés à la grècque ou à l'hindoue'[40] which can signify 'meander or wave-shaped' as well as 'sculpted in the Greek or Hindu fashion'. Either way, he speaks of them as though they were ancient sculptures.

In the course of his life Le Corbusier drew more seashells than he designed buildings. Why this almost manic interest? Why collect, photograph, paint and draw shells for decades on end? Some writers have explained this obsession in psychological terms. For instance, Charles Jencks, in all seriousness, interprets the sudden increase in bulbous, swelling, sculptural forms in Le Corbusier's painting and collection of found objects as a late awakening of the sex drive.[41] Others believe that Le Corbusier at first wished merely to distance himself from the art of his fellow exponent of Purism, Amadée Ozenfant, who, like him, was both an architect and painter and with whom he founded the magazine *L'Esprit nouveau*.[42] In this view he was on the lookout for new approaches after years of exploring Purist architecture on paper to the point at which its combinatory possibilities had been exhausted. Following buildings in the 1920s, in which he largely ignored material characteristics and physical weight, he now designed a summer home for Hélène de Mandrot at Le Pradet in southern France with walls of unrendered stone and a house at La Celle, Paris, that featured hand-finished brick, untreated stone and exposed concrete. In their tactile qualities alone, both buildings seem to echo the rough, multi-coloured surfaces of some of the architect's found objects.

In the 1930s Le Corbusier's architecture became increasingly physical. Unrendered brick appeared, then board-marked concrete. At the same time, his thin white *pilotis* grew in width and roughness. The surfaces, coarse, pre-modern and craft-like, generated associations that had been banished from the tactile vocabulary of steel-and-glass architecture. After the Second World War, at a time when buildings became even more immaterial, glassy, shiny and smooth, as seen in Mies's programmatic Farnsworth House at Plano, Illinois, Le Corbusier drew on his *objets trouvés* to develop the material qualities of his architecture. Tactility of the kind apparent in the massive, untreated concrete stilts of the Unité d'Habitation and in the amorphous concrete hill on its roof plays an important part in Ronchamp. The walls there, roughly rendered and as thick as a human figure, resemble cliffs or ancient masonry. This satisfied the nostalgic longings of many visitors and the

chapel soon became popular. In its use of materials alone it marks a turning point, the end of the clinical, emotionally neutral, functional spaces of the first period of modernist architecture and the beginning of the second period.

Le Corbusier's outstanding historical achievements include the application of capitalist principles to architecture. This entailed, for example, optimising the exploitation of resources by separating functions. Walls in earlier times had to be thick because they simultaneously divided up space, provided protection from the cold and supported the building and its roof. Le Corbusier did away with such walls. With him, a reinforced-concrete skeleton supported everything, interior walls could be arranged flexibly and a much thinner and lighter membrane of glass or stone offered protection from the elements. He broke down architectural construction into separate stages the way that Henry Ford had broken down car manufacture. This compartmentalised modernism harboured the threat of monotony and emitted a whiff of the conveyor belt. Its inventor was one of the first to recognise this. And, unlike many exponents of the Bauhaus ideal, who persisted much longer in their grim, decidedly bloodless pragmatism, Le Corbusier moved on to something different. His aim now was to create buildings that were all of a piece, to produce architecture as a *gesamtkunstwerk*, that merged nature, humankind and technology into one entity. His drawings and paintings show him embracing this idea long before it emerged in his architecture and they reveal the part played in it by his collection of flotsam and jetsam.

Le Corbusier, drawing of an
'objet à réaction poétique'

Le Corbusier, drawing of a pine cone and shells
from his collection of found objects

THE OTHER OEUVRE

Le Corbusier as a draughtsman and painter

Le Corbusier's drawings are immediately recognisable. The archi-
tect throws lines and marks onto the paper violently, as though the
hand were trying to be as quick as the thought that he wished to
record. This sudden, impulsive way of sketching formed part of the
young Le Corbusier's anti-academic pose. 'Je dessine comme un
cochon' (I draw like a pig), he once noted contentedly,[1] and the
wildness of his drawings, which look like stunned ideas, belonged
to an aesthetic programme. The point of his sketching was not to
record things seen, as the academy taught: for that purpose he
used the modern medium of photography right from the time of
his early travels. He drew tirelessly. Sometimes he appears to be
scratching chance images out of the paper as he circles restlessly
with his drawing implement and scrapes away with it. At other
times the drawing metamorphoses seamlessly into letters: a sketch
becomes a word and vice versa, and the drawing seems to repro-
duce the process of thought, images mingled with concepts. Word
and image amalgamate to form an entity in which things just seen
and things just thought freeze as they switch back and forth, gen-
erating a very wide variety of associations.

An exception to this precipitous graphic manner is Le Cor-
busier's drawings of shells, stones and pieces of wood (ill. p. 54):
these he records slowly, hesitantly, meticulously, wielding the
pencil with a surgical precision reminiscent of photorealism. Two
different tempos thus inform his oeuvre of drawings: the swiftness
of sketches committed instantly to paper, scratchy and blurred,
and the leisurely pace of finely executed, highly detailed images
of 'objets à réaction poétique'. In the latter works Le Corbusier
resembles a scientist or a painstaking academic artist. Like a sur-
geon dissecting a body with the scalpel, he draws the helix of a

seashell with the sharpest of pencils and shades the curving volumes carefully, instead of indicating them roughly with a few lines.

In some drawings Le Corbusier seems to be exploring the mathematical principles underlying the construction of the natural objects he has found. He 'geometrises' nature. A pine cone, for instance, is shown as consisting of pyramidal elements. With seashells he focuses on the spiralling helix and the ramp-like end of the curve. In fact, he had an almost obsessive interest in spirals and ramps. Virtually all his residential buildings, from the Villa Savoye to the Villa La Roche, Paris, and the Unité d'Habitation, include a ramp. This penchant has generally been traced to mechanical models, for example to the ramps in Fiat's Lingotto car factory in Turin, which Le Corbusier admired and visited on several occasions. With regard to his sketches of spirals, however, it is conceivable that snail's shells influenced his employment of this unusual architectural motif, not least because the ramps often lead to intimate, enclosed, welcoming spaces, as in the Villa La Roche. He used shells to study such fundamentals as the opening and enclosing aspects of space. At the same time they were to him 'poetic' objects, not in a diffusely affective or lyrical sense, but in the classic Greek meaning of *poēisis* as 'producing' or 'calling forth'.

Drawn stones: aleatoric images and architecture

A photograph shows Le Corbusier holding a stone and a sheet of paper bearing a drawing (ill. p. 57 bottom).[2] The stone is of a kind found on the seashore or in mountain streams, round, dark, with light markings reminiscent of chalk lines. At one point it is chipped. Carefully recording the stone, Le Corbusier's pencil has transformed the marks almost imperceptibly into figurative signs. The whole resembles a head. Nose, eye and mouth are easily identifiable, perhaps, too, on a smaller scale, the figure of a man with one arm raised.

The type of vision that recognises anthropomorphic elements in chance forms had a long history in art before it was adopted by

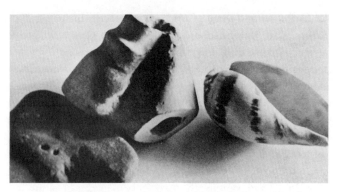

Lucien Hervé, photograph of some 'objets à réaction poétique'

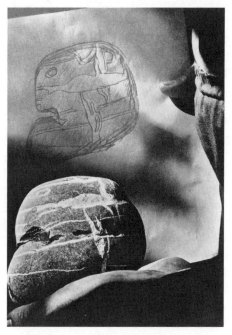

Le Corbusier holding a stone 'objet à réaction
poétique' and his drawing of it

Le Corbusier and some of his contemporaries, including Max Ernst and the Surrealists and, not least, Pablo Picasso, who took an almost manic delight in transforming a bicycle handlebars and saddle into the head of a bull and, in his paintings, women into stones and stones into women. The tradition goes back even further than Andrea Mantegna's *St Sebastian*, painted around 1470 and now in the Kunsthistorisches Museum, Vienna, in which a cloud has the form of a rider.[3] According to Sabine Blumenröder, the 'idea of giving clouds recognisable shapes relates to a *topos* familiar since Antiquity which, among other things, addressed the origins of sculpture and painting, the occurrence of images in nature and artists' inspiration by chance forms'.[4]

In the Middle Ages Albertus Magnus described images inscribed in pieces of stone.[5] Later, Alberti discussed fortuitous shapes in *Della pittura* and *De statua*, as did Leonardo in his treatise on painting. Alberti wrote: 'It is evident that nature herself delights in painting, for we observe that in marble she fashions hippocentaurs and bearded faces of kings.'[6] In Alberti's view the first sculptures arose when artists, perceiving the outlines of objects in stone or wood, began to add to or take away from these found forms so as to disclose the objects with greater clarity. The spontaneous discovery of chance formal constellations played a major part in the art of Dada and Surrealism – René Magritte's countless formal ambiguities are merely the best-known examples. When the chapel at Ronchamp was being built, the notion that art had originated in the elaboration of chance forms found in nature had again become a serious subject of discussion, recently discovered cave paintings apparently supporting the theory.[7] Le Corbusier may well have been aware of this debate. Certainly, interpreting his design for a chapel in terms of a grotto or cave would seem to be a continuation of this associative strategy.

Classic theories of the creative process have always welcomed fortuitous images when conscious strategies fail. Artists will attempt to do something and, when it does not work out, chance comes to their aid. Pliny the Elder tells the story of the painter Protogenes who tried in vain to depict the foam on a dog's mouth. In

his frustration he performed a piece of Action Painting *avant la lettre* and threw a sponge angrily at his picture, promptly achieving the very effect he had been unable to arrive at by painting what he had envisaged in his mind's eye. In this way, the successful work of art emerged from the symbiosis of an accident of nature with the artistic will: 'thus did chance represent nature in a painting'.[8] This almost seems to anticipate the Surrealist strategy of formal invention. Pure invention expands to encompass found objects and the promptings of fortuitous images, extending the range of forms conceivable to the human mind to include the interpretation of vague outlines. Belief in the idea as the well-spring of artistic invention yields to an encounter with a chance find as the starting point of formal exploration.

Classical antiquity was familiar with two opposing concepts of formal invention. One held – and holds – that it consists in releasing into the world an idea or a construct based on knowledge of mathematical laws; the other, that it entails discovering, interpreting, reviewing, recombining, redeveloping and relocating existing forms. The one school of thought trusts to mathematical harmonies and laws, to the existence of unchanging archetypal Platonic ideas; the other to observation of the fleeting and transitory, to ephemeral, unfixed, ambiguous forms that appear suddenly – the kind of phenomena that feature repeatedly in Antique writing, from Ovid's *Metamorphoses* to Pliny the Elder's description of chance images in passing cloud formations.[9] Even at that time, emphasis on a metamorphic view of the world and on fortunate finds occasioned criticism. Cicero, for instance, railed against the cult of chance in art. Writing of Praxiteles' *Venus of Cos*, on display in the Templum Pacis, he declared: 'Do you imagine that an accidental scattering of pigments could produce [this] beautiful portrait? ... No perfect imitation of a thing was ever made by chance.'[10]

In his essay on aleatoric images in Antiquity and the Renaissance H. W. Janson suggests that when Alberti claimed the first images of gods consisted of roots and pieces of wood that happened to possess anthropomorphic features – in other words, that

they were evocative *objets trouvés* – he was basically reversing Ovid's tale of Daphne, the divine nymph who was transformed into a laurel tree. Le Corbusier's work re-enacted the age-old conflict between regulated aesthetics and chance forms. By the time he drew up his legendary Plan Voisin in the 1920s, he had adopted a *tabula rasa* attitude to urban planning, countenancing historical references only when they embodied linear mathematical schemes of proportion (as did the Parthenon, for example). On the other hand, he took an interest in deformed, fractured and strangely mis-shapen objects found on paths in the countryside and on the seashore. The simultaneous implementation of both approaches was inconceivable in historical terms. This explains the alienation caused by Le Corbusier's proclamation of found objects as the model for a new type of architecture and his definition of invention as the combining, dismantling, enlarging and 'translating' of such objects. In the 1950s James Stirling, for example – who later became well-known for his postmodern Staatsgalerie building in Stuttgart, the entrance to which pays homage to the convex wall of Ronchamp – did not really know what to make of the chapel and its sources of inspiration. In his view Le Corbusier's curious turn-about resulted from a shift of emphasis from inventing to adapting forms. Stirling was convinced that 'Le Corbusier's incredible powers of observation are lessening the necessity for invention, and his travels around the world have stockpiled his vocabulary with plastic elements and *objets trouvés* of considerable picturesqueness.'[11] His method of architectural invention, Stirling claimed, had switched from abstract mathematical constructs to the observation and imitation of objects.[12] Stirling was not far wrong (though he intended his analysis as a reproach). Scrutiny of the objects that Le Corbusier had collected on his travels clearly replaced systems of measurement and tables for calculating harmonious proportions as his primary focus.

The architect appears to be 'translating' his found objects as he depicts them, interpreting their forms in the language of drawing. If his image of a stone resembles a face, it also evokes a town plan, a map and a perspective space bounded by the edges of the object.

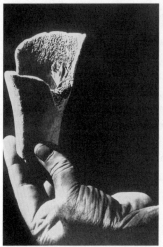

left: An 'objet à réaction poétique' held by Le Corbusier;
right: Detail of the exterior of Ronchamp chapel, 1955

Activated by this ambiguity, the eye of the viewer seeks to bring the
drawing's content into focus. Zooming back and forth between
'face' and 'town plan', for instance, it begins to operate in the same
way as Le Corbusier's own eye, with its capacity for discovering
other possible forms in virtually every shape – a body in a stone, a
building in a shell.

A microcosmic world:
formal discoveries through the zoom

'Pebbles, crystals, plants and all their parts extend their meaning
even to the clouds ... to the fabulous sights airplanes have revealed
to us.'[13] The surrealistic effect of microscopic enlargement that
Le Corbusier describes here, from the small to the large and back
again, is primarily a strategy of metamorphosis and reinterpreta-
tion and is one of the most important methodological keys to his

world of form. Enlargement and diminution can turn any shape into another, a bone into a wall, for example, or a splintered stone into a house. Modernism's rationalist genesis of form is here opened up to encompass forms disovered by chance, which, in Le Corbusier's opinion, cannot be invented by constructive intelligence and are of a 'richness which the mind alone cannot discern'.[14] In a sense, then, Ronchamp is the application of Surrealism to architecture. Stirling wrote that the chapel resembles 'an unnatural configuration of natural elements'.[15] The roof is like a hugely magnified crab's shell, but it also contains elements of an aeroplane wing. It thus represents a monstrous, supranatural instance of hypertrophy: a shell enlarged a thousand times that has been attacked by technology.

If Le Corbusier's design process revolved around sparking off clashes between classic determinist mathematical systems and chance, then the objects he found on the beach functioned both as sources of inspiration and as embodiments of this procedure. The shape of a pebble, for example, results from the effects of hydrodynamic laws and from such unforeseeable factors as where it had been driven by a storm and the way in which it came to rest in the water. In Le Corbusier's writings the sea thus figures as a gigantic generator of form subject both to laws and to chance. 'I love the sea, the flat coasts and the plains more than the mountains', he declared. 'How much deeper is my feeling for the admirable clock that is the sea, with its tides, its equinoxes, its daily variations according to the most implacable of laws, but also the most imperceptible.'[16] Time and again he photographed the traces left in the sand by the outgoing tide. The tiniest shifts in the initial situation would induce even the strictest of laws to produce wholly inexplicable mutations. This paradox lies at the heart of the relationship between mathematics, aleatoric forms and Surrealism in Le Corbusier's work.

The architect's interest in seashells and other beach finds had some well-known predecedents. In the seventeenth century Francesco Borromini, for instance, cut open seashells in order to examine the regular mathematical construction of their spiral

shape. Le Corbusier himself stated in a TV interview: 'I've a weakness for seashells. They're marvellous forms which have astonished me ever since I was a young boy. There's nothing more beautiful than seashells: they're harmony itself, the law of harmony. They develop inside and out in a quite extraordinary way, radially or spirally... These objects harbour the laws of nature and express them.'[17]

'Inside and out... extraordinary': in the early 1930s the architect who had designed walls so smooth and unreal-looking that his buildings resembled large-scale paper models began to draw rough surfaces with almost obsessive regularity. Vibrant, undulating surfaces, coloured only once, started to spread over the strictly mathematical shapes in his sketches to form unexpected textures that apparently obeyed no other logic than that of chance. The textures, too, were copied painstakingly from reality. A few years later the outer skins of Le Corbusier's buildings lost their glassy smoothness: the masonry of the holiday homes he designed in the 1930s consists of rough-hewn stone; the Unité d'Habitation stands on stilts of rough-cast concerte that look like rock; and walls of exposed and sprayed concrete at Ronchamp turn the chapel, in tactile terms at least, into an oversized seashell.

Matter and maths: modernism's tactile revolution

The aim was to breathe new life into modern architecture. The beach finds – the objects – were to form a model that would awaken architecture from the coma of rationalism's eschewal of the senses. Le Corbusier never tired of insisting that architects should understand 'objets à réaction poétique' in two ways.[18] He encouraged his students to concern themselves with such objects and thereby 'replace the dreary studies of ancient plaster which have so dulled our image of the Greeks and Romans... I would have you sketch these plastic events in pencil, these proofs of organic life, these expressions which, though limited by natural and cosmic principles, speak so eloquently,'[19] Here the Greeks and seashells –

history and complex natural forms – find their way into a theory of formal invention previously governed principally by rigorous geometry and machine art. The importance of this methodological shift should not be underestimated: the very modernist who had promoted more consistently than most the transformation of houses into machines for living in, and who had propagated the rationalist demystification of architecture, was now invoking the tactile experience of form, rather than formulas and pure mental constructs, as the wellspring of design. In some strange, animistic way forms were to become partners in a dialogue, the objects mutating into 'evocative companions' as they 'speak the language of nature'.[20] Architecture now starts out not from the eye or an idea, but from the hand that strokes and carresses, from the immediate, sensuous, physical perception of volume and space.

Le Corbusier enjoyed exaggerated polemics, had a weakness for esoteric cosmology and possessed a distinct liking for implicitly sexist kitsch, as when he clothed his criticism of modernism's approach to objects in the words 'I believe in the skin of things, as in that of women'.[21] His new cult of tactility brought him close to certain contemporary thinkers who might be reckoned among the opponents of modernism. In campaigning against the rationalism of the pure idea and in favour of sensuous engagement with forms and their incorporation into the reality of everyday life, he evinced a scepticism that also informed Martin Heidegger's critique of modern notions of the object.[22] In several writings, including *Sein und Zeit* (*Being and Time*) and 'Der Ursprung des Kunstwerks' ('The Origin of the Work of Art'), Heidegger insisted on the difference between the 'thing' and the pure object. In his view, things acquired value through daily use. The thing-in-itself (*Ding an sich*) did not exist for him: a thing has first to be made and then constantly reinvented by people activating it as they perceive and use it. Behind this philosophical notion there clearly lay an intellectual rejoinder to Plato. The concept of the thing as existing only through use, through concrete experience, and not as an abstract idea, substitutes continuous becoming and development for the notion of ideal, immutable being divorced from the world. (A

much later echo of this can be found in biomorphic designs that emphasise the processual and amorphic, the constant flux, of a computer animation in relation to the concept of a finished form to such an extent that the choice of an individual form for realisation in concrete and glass no longer appears desirable.) Heidegger thus conceived of the work of art and its genesis in terms not of ideal being, but of making (*techné*) and use, as an act of 'production' – rather as Le Corbusier did when placing the 'objet à réaction poé-tique' at the centre of his theory of formal invention. The shell was to him what the jug was to Heidegger: it was not the idea of the object, detached from its physical presence, that mattered, but the direct experience of it on a daily basis. Only then would the object disclose the principles underlying the construction and erosion manifested in its particular form; only then, through the syn-aesthetic experience of looking and touching, would knowledge be gained from the object. For Le Corbusier, 'understanding' involved the twin aspects of technique and feeling. Addressing stu-dents, he noted that this 'sensitive pair' formed the 'foundations of architecture'. He wished that 'architects would now and again take up their pencil to [record] the innate harmony of a seashell, cloud formations and the eternal coming and going of waves.'[23] In doing so, they would be describing not the everlasting laws of nature, but the energies that constantly bring forth astonishing new forms and chance images.

Le Corbusier told the history of architecture as his personal his-tory of tactile exploration. At the Parthenon in Athens he realised that he could not find a true school in the academies, but 'here, with my hands feeling the marble'.[24] He stressed the unusual con-trast between the insides of shells, smooth as porcelain, and their rough exteriors. A posed photograph shows him holding a broken cow bone with the light falling on it so as to reveal the rough inte-rior and the smooth exterior surface (ill. p. 61, left). In a book Le Corbusier reproduced this photograph alongside a detail of the exterior of Ronchamp (ill. p. 61, right), as if to suggest that the chapel's contrast between smooth concrete and rough limewash had been taken over directly from the tactile qualities of the natu-

ral object. One reason for his interest in stones and bones was that they provided textbook examples of solutions to constructional problems. 'A bone', he said in an interview, 'is a wonderful thing, created to withstand a jump, a punch, the impact of a kick, to support dynamic loads. Each part of a bone is architectonic in a subtle way. And when you contemplate a piece of bone and think about it you'll realise that a lot can be learned from it. A builder in concrete looks at a bone with open eyes.'[25] Le Corbusier appears here as an exponent of bionics long before the term was invented, as someone for whom no formal analogy is so vague as not to reveal every basic principle of construction in nature. In his collection of objects he discovered 'every shape (sphere, cone, and cylinder, and their varied sections)'.[26] In this way the seashore became a place of revelation with regard to cosmic laws of construction. In his characteristically grandiloquent way, he describes how he discovered geometry and the right-angle on a beach, the 'point of all dimensions' and the 'key to architectural poems': 'a vertical rock ... its vertical makes a right angle with the horizon ... This is a place to stop, because here is a complete symphony, magnificent relationships, nobility. The vertical gives the meaning of the horizontal. One is alive because of the other. Such are the powers of synthesis.'[27]

Ur-impulses in place of rationalisation: How to ground ideology in nature

This description is interesting primarily because it shows Le Corbusier deriving the 'magic' of nature from a mathematical configuration. As invoked here, the beach is not a refuge from over-regulated city life but a place in which mathematical laws become manifest, a place of the right-angle. The seashore has become a locus of philosophical reflection and the objects found there nothing less than potential sources of knowledge about the world. Indeed, Le Corbusier presented himself as a combination of scientist, missionary and early Romantic who, rather like Benôit de Maillet's Telliamed, examined rocks and sands in order 'to be

able to infer the mechanisms that had presided over the history of the earth'.[28] On one occasion he told a mass audience on French television that he wished 'to return people to their natural conditions'.[29] On another he responded to a journalist's enquiry as to whether he had 'dug down into origins' when designing Ronchamp by claiming to be closer to Voltaire's and Rousseau's 'savage', someone who seeks a little truth in an affected society.[30]

Rhetoric of this kind can be seen as an attempt to remove modern architecture from the firing line at a time of mounting criticism from its opponents. If architects obey the eternal laws of nature and return to basics then, firstly, they cannot be held responsible and, secondly, theirs is the only possible way forward – indeed, any other way would automatically be unnatural. By grounding his architecture in nature and its manifestations, rather than in a historical sequence of human acts, decisions and inventions, Le Corbusier accomplished two things: he undermined the accusation that modern architecture was destroying nature and he drove his adversaries into a maze of contradictions from which they would find it difficult to escape. Brandmarked for failing to recognise that rectangular concrete living-machines were created in the spirit of nature, they found themselves on the defensive again: the onus now lay on them to prove that they, and not Le Corbusier, were the true critics of modernist rationalism and formalism. With enviable energy, he continued to promote the image of himself as a noble savage: 'Only the architect', he wrote, 'can strike the balance between man and his environment', between man on the one hand and 'nature and [the] cosmos' on the other.[31] It is only through concrete that humanity recovers its original harmony. By redefining his work as a development willed by nature and as a force of nature of his own invention, Le Corbusier sought to present his controversial modernism as the embodiment of an unavoidable return to mythical *ur*-impulses.

Modernists in the post-war period commonly claimed – with essentialistic pathos – that architects were engaged in a search for 'origins', '*ur*-impulses' or ancient wisdom. The historian and critic Sigfried Giedion, for instance, had recourse to this essentialist

pathos when in 1956 he wrote: 'After a long rationalist interval the modern movements, inasmuch as they are genuinely constitutive, are attempting again to engage with the *ur*-phenomena of human nature. We are enquiring again into eternal relations. Thus it has come about that attempts are once more being made to do justice to cosmic and earthly movements.'[32] The drift of such statements is clear. On the one hand, they divorce modern architecture from purely functional rationalism and invoke it as something more comprehensive and holistic. On the other, they promote it not as anti-historical, but, on the contrary, as ante-historical, as plumbing the *ur*-depths of 'human nature'.

It is worth remembering just who the author of the words just quoted was. As the first Secretary General of the Congrès International des Architectes Modernes (CIAM), Giedion acted as a sort of chief international press officer of modern architecture. He voiced his view of history in terms of nature and his approval of an aesthetic theory that revolved around immutable cosmic laws. Faced with accusations of an anti-historical and inhumane belief in technology, he took the bull by the horns and claimed that modernist architecture was anchored not in technology and cost-effective mass housing, but in nature and, indeed, in human nature.

Such vindicatory efforts form the context within which to see Le Corbusier's self-stylisation as a 'man of the sea' and his constant invocation of the interrelations between the human body, the volumes of architecture and the forms of nature. Yet explaining his cool, rationalist architecture of the 1920s and the gargantuan demolition fantasies that accompanied it as the unavoidable outcome of the workings of natural law was not his sole aim: he was genuinely concerned with discovering new modes of invention and architectural culture. This had become apparent in his paintings long before it did in his architecture – they became an arena in which to explore concepts of space that would later figure in his buildings.

Painting as an arena for architectural experiments: the paintings *Harmonie périlleuse*, *Léa* and *Femme, homme et os*

Le Corbusier's paintings were long underestimated. Either they were classified as bad imitations of Picasso or their barely decipherable iconographical mixture of natural forms, geometrical constructions and body fragments caused them to be associated with the work of the Surrealists, especially Salvador Dali.[33]

The architect suffered from not being taken seriously as a painter. In Paris he spent several hours every morning in his studio in the rue Nungesseret-Coli before leaving for his architectural office. Writing to the Swiss architect, artist and writer Alfred Roth in 1955, he called his painting the 'key to my existence' and complained that everybody ignored it[34] and, elsewhere, he described 'painting, architecture, sculpture [as] a unique phenomenon of plastic nature'.[35] Giedion hastened to his defence by claiming that at 'the present state of development no truly creative architect or planner can exist who has not passed through the needle's eye of modern art'.[36] This has not prevented critics from viewing what Le Corbusier did in the eye of that needle with a lack of comprehension at best respectful.

But, in fact, his architectural theories can scarcely be understood without taking a close look at his paintings.

In a groundbreaking text Stanislaus von Moos has noted that painting enabled Le Corbusier to keep his head above water 'financially and morally' during the long period in Paris in which he failed to make a living as an architect.[37] At a supper in May 1918, organised by the group Art et Liberté, the architect Auguste Perret had introduced his younger and considerably less successful colleague to Amédée Ozenfant, a painter and critic who owned a small boutique and was a respected member of Parisian society. Ozenfant and Le Corbusier founded the review *L'Esprit nouveau*, in which they both published theoretical articles on art before Le Corbusier began working as a painter. Just as in architecture, he thus started out from theory and only subsequently moved on to

Le Corbusier, *La Lanterne et le petit haricot*, 1930

practice. Accordingly, his first paintings embodied an anti-Cubist theory of art called 'Purism' that had already been described in published texts. It was through his painting that he came into contact with the industrialist Raoul La Roche and other patrons who subsequently commissioned his well-known villas and continued painting, after attaining an international reputation as an architect, in the mid-1920s.

Le Corbusier painted the picture *La Lanterne et le petit haricot* (Lantern and small haricot bean) in 1930 (ill. above). It consists of a collection of geometrical and organic forms. One configuration of lines, multi-view and Cubist-looking, perhaps represents the lantern. Beneath this, at the lower edge, is a white bean and a yellowish seashell. Two further round-volumed organic shapes appear in the blue lid of the 'lantern'. On the lower right-hand side, in a complex series of overlaps, a small steep pyramid rests on a cone-shape in front of which, or inside which, is an object that could be

either an implement made of corrugated iron or a stylised scallop. Since this object's fluting could be either machine-made or natural, it has a foot in both camps represented in the picture, the organic and the constructed. The seashell binds these two realms, encapsulating the mixture of construction and chance, rationalism and Surrealism, technology and nature that typifies Le Corbusier's painting as a whole.

The picture can be read in Cubo-Surrealist terms. Its title recalls Surrealism's constellations of disparate objects and their paradigmatic basis in Lautréamont's dictum relating to the 'chance encounter between a sewing machine and an umbrella on an operating table'.[38] Le Corbusier insisted that on entering his paintings objects were subjected to a kind of metamorphotic magnetism that transformed them into other shapes. Of his series of bull paintings *Les Taureaux*, which he exhibited at Pierre Matisse's New York gallery in 1956, he wrote: 'The key to it are a dead tree root and a pebble, both of which I found in a deep pass in the Pyrenees. Ploughing oxen passed by my window every day. By being drawn and redrawn the oxen of root and pebble turned into bulls.'[39] A line can be traced from here to Le Corbusier's later buildings. From a certain perspective, the chapel of Ronchamp seems like built Surrealism, like the chance encounter between a cow bone, an aeroplane wing and a crab's shell, a Madonna and a hand crank. But the translation of found objects into architecture was not that simple.

La Lanterne et le petit haricot encompasses a kind of evolutionary narrative, starting with the amorphous natural form of the bean and leading via the seashell to the 'lantern' and the strange geometrical shapes that twist and tilt in it. Again, the spiral of the seashell forms a link between the measured, constructed world of industrial products and the unpredictability of nature and chance. Le Corbusier has invented a space with hints of perspective and a sense of depth, yet it is difficult to say where 'front' and 'rear' are. This space cannot be described in traditional geometric terms. Like the 'objets à réaction poétique', it subverts established categories. Is something behind or in front of something else? Is it

natural or man-made? Such questions must remain open or be answered with 'both'. Experiments like this were to have repercussions far beyond the picture planes on which they were conducted, for Le Corbusier's paintings show him feeling his way towards a freer, more open kind of space previously inconceivable, let alone realisable, in concrete terms.

Harmonie périlleuse

One year later, in 1931, Le Corbusier painted *Harmonie périlleuse* (*Dangerous harmony*; ill. opposite page). It is a strange work, almost entirely devoid of pictorial depth: forms are stacked one above the other like props stored for use in some future painting and, in common with virtually all Le Corbusier's pictures, it juxtaposes biomorphic with geometrical forms, the found with the invented and the constructed with the organic. An indefinable green configuration winds its way upwards on the far left, partly covered by a flat area containing a white, fluid biomorphic form – perhaps a stylised shell with holes. Some regular shapes appear: a twisted rectangular solid, a band and an angled structure. Alongside these is a grey sculpture, its sightless eyes reminiscent of those in Antique statues. Finally, on the far right, five flesh-coloured elements recall torsos, hips, arms and legs.

What is the significance of these forms? The question is difficult to answer in iconographical terms but they share one striking formal characteristic: torsion. The rectangle, the band, the grey statue, the 'legs', the 'torsos' and so forth comprise rotational movements, they all twist in accordance with the same mathematical principle, 'Möbius band', a figure created by giving a long strip a 180° twist and attaching the two ends to each other. The band has fascinated scientists and artists ever since its discovery in 1858. Its most remarkable properties include the fact that if it is cut along its centre it doubles in length rather than dividing in two. If the strip is cut lengthwise into three parts it does divide in two, such that both strips are entwined and one of them is the Möbius band, now twisted twice. It is hardly surprising that this interested

Le Corbusier, *Harmonie périlleuse*, 1931

Le Corbusier, for the Möbius band, like his 'objets à réaction poé-
tique', undermines conventional philosophical and spatial cate-
gories. The band erodes distinctions between top and bottom,
inside and outside, as anyone knows who has tried to colour one
side of it and has ended up with the whole thing coloured. It con-
tinues to intrigue architects. As recently as 1998, Ben van Berkel
erected the Möbius House near Amsterdam, its basic form varying
the idea of the endless band (ills. pp. 173, 174).[40]

Why 'Dangerous harmony'? The painting could equally well
be called 'Turning', for it shows forms pushed to the limits of
recognisability by Möbius-type torsion. What happens when a
clearly demarcated form like the straight-edged solid in Le Cor-
busier's painting comes into contact with the dynamic, endless
rotation of the Möbius band? Its geometrical structure is deformed
almost to bursting point. If twisted any further, it would split into
two irregular pyramids, just as the statue would collapse into its
component parts (which would then probably look like the skin-
coloured elements piled next to it). The picture addresses the same

issues that intrigued Le Corbusier in the objects he collected: at what point does something become a shape and for how long? How far is it possible to go before a shape metamorphoses into a new and interesting one? Which processes alter a shape and which simply destroy it? *Harmonie périlleuse* once more shows Le Corbusier painting his way to the invention of a new arsenal of forms.

Léa: Image and word construction

Some items from Le Corbusier's collection of 'objets à réaction poétique' turn up in readily recognisable form in his paintings. The cut cow bone in *Léa* is an example. This picture

immediately brings to mind the Purist painting propagated by Le Corbusier und Ozenfant after the First World War. The space is perspectival, with an open door at the rear on the far left and a table – or folding bed – in the middle. Above the bone a closed shell hovers, painted in an unusually rich manner for Le Corbusier. The strip at the top is emblazoned with the name 'Léa'.

Interpreting Surrealist images in psychological terms is unfortunately a habit that dies hard. Commentators apparently assume that the artists have provided coded messages easy enough to decipher with a little help from Freud. For Freudians, the open door, the closed shell and the folding bed in *Léa* speak an uniquivocally sexual language and they will doubtless be encouraged in their view by Le Corbusier's statement that the objects in general express 'the male and the female'. But what about the name 'Léa' hovering at the top? In his book *Les Mots dans la peinture* (Words in Painting) Michel Butor writes: 'At the time of Cubism the extreme distance between the accustomed aspect of the object taken as model and the result in the work made the title very important for preserving traces of the path travelled.' The title is 'witness to a lost appearance, a ladder that permits us to return slowly, and perhaps with pleasure, up to [that appearance]'.[41]

It may be doubted whether 'Léa' forms a ladder leading back to a specific source. Ultimately, this 'signature' can only be the subject of speculation. Maybe Le Corbusier knew someone called Léa;

Le Corbusier, *Léa*, 1931

maybe he was thinking of an actress or of the eponymous sports car, popular at the time. We simply do not know. Each of his paintings harbours idiosyncrasies, secrets and allusions, yet any attempt to construct a coherent personal iconography from them must remain hypothetical.

In formal terms the picture is notable for its inclusion of script and painting in a single image, a combination that had already featured in Le Corbusier's sketchbooks, where word and image, sign and representation, merge seamlessly into one another. Later, the architect was to inscribe letters into his buildings, turning elevations into legible texts. The words 'Je' (I), 'vous' (you) and 'salue' (greet) appear in separate panes in the southern elevation at Ronchamp which contains a large number of small windows. As visitors walk past a fragmented text they gaze through the individual words to the landscape beyond. One pane bears the name 'Marie'.

Le Corbusier, *Femme, homme et os*, 1931

At this point, if not before, it becomes clear that Le Corbusier has broken down the French text of the 'Ave Maria' ('Je vous salue Marie, pleine de grace; le Seigneur et avec vous') into its constituent parts and spread them across the wall. This, then, is built text, rendering the building legible in a quite literal way and, conversely, transforming script into sculpture. Among other things, Ronchamp is physically accessible text. This intermingling of form and script is heralded in *Léa*.

Two objects in the painting manifest two different modes of representation. The shell, with its profusely organic, voluptuous volumes, recalls Dali's neurosis-based objects, whereas the bone, sharply contoured with incisive lines, evokes the precise cut of the butcher's cleaver. Once more two disparate worlds of form are juxtaposed: the gently bulging, organically proliferating realm of nature and the sharply defined realm of culture, with its clear-cut delineation of space and objects. *Léa* presents two differing formal

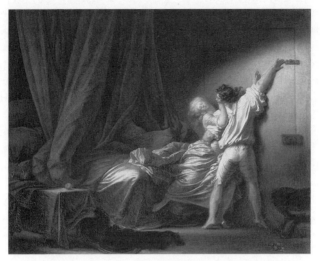

Jean-Honoré Fragonard, *Le Verrou*, 1778, Musée du Louvre, Paris

principles, the amorphously rampant and the precisely delimited. A form that grows slowly from within through calcium secretion confronts an object generated suddenly by an exact cut. Both kinds, contrasted to equally striking effect, will appear later in Le Corbusier's architecture.

Man–woman and bone

The sawn cow bone puts in an appearance in several canvases by Le Corbusier, including *Femme, homme et os* (Woman, man and bone) of 1931 (ill. p. 76). The sparse literature on this painting cannot agree on whether the full title is *Femme grise, homme rouge et os* (Grey woman, red man and bone) or *Femme rouge, homme gris et os* (Red woman, grey man and bone). Sometimes both versions are used in one and the same text.[42] In fact, the best title would be *Homme-femme et os* (Man–woman and bone), because it is difficult to tell which figure represents the man and which the woman. The bone from Le Corbusier's collection of objects is seen in the left half of

the painting, slightly modified and coloured blue. A seashell over-laps it. On the ground lies an amorphous object, a cloth covering, perhaps, or a split shell or even an item of clothing. Stones and a red, boldly zigzagged form appear behind the bone. Two figures, one grey, the other red, are embracing in front of a door frame. The grey figure gestures 'stop!', but it is not clear whether this is directed at the viewer or at the red figure.

The composition brings to mind a well-known eighteenth-cen-tury French painting: Jean-Honoré Fragonard's *Le Verrou* (*The Bolt*; ill. p. 77). This, too, features a male and female in front of a door on the right. Stirred by a stormy wind the draperies surge towards the couple as though depicting natural forces, seething emotion or both. The enigmatic zigzags in Le Corbusier's painting recall the folds in the red cloth in Fragonard's canvas, and the colour of the shell, like advocaat, resembles that of the woman's dress in the earlier work. Space in Fragonard's painting is defined in two ways, by the wall and by the canopy. The space clearly delimited by the wall contrasts with the more complex, labyrinthine space evoked by the canopy. Wall and door firmly separate the interior from an imagined exterior: whoever opens the door can leave the room. The tornado of red cloth on the left moves towards and subverts this unambiguity: it sweeps down onto the bed, changing from curtain to bedspread; it collapses in folds and forms cavities; it shields and reveals. Multi-layed, intertwining, changeable space confronts sharply defined space; the soft and the fleeting oppose the hard and the clear-cut. A similar juxtaposition occurs in Le Corbusier's painting: geometric clarity on the right faces bulging, fluid, vegetative shapes on the left, twisting and turning in a for-mal labyrinth.

Ambiguous form: confusion of the sexes

But which figure in this curious version of a Rococo painting is the man and which the woman? If Le Corbusier followed Fragonard, the grey figure would have to be the woman. Much speaks in

Le Corbusier, in women's clothes, with August Klipstein, *c.* 1910

favour of this view. A female breast is recognisable, and the genitals are rendered in the same way as in the painting *Nu feminin* (Female nude) of 1932, which obviously represents a woman. In the latter work Le Corbusier depicted a cross between a human body à la Aristide Maillol and a concrete sculpture, a hybrid of corporeal and architectural volumes. The breasts resemble rocky seaside cliffs, the legs recall menhirs and the hair looks as though it was made in a concrete mixer. In *Femme, homme et os* the naked grey figure exhibits a similar tendency towards the massive which supports its identification as the woman.[43] But then why is this figure larger and more muscular than its red counterpart? Why is there a suggestion of long hair in the red figure? And why does the shape of the grey figure's head approximate more closely to that of a man? Moreover, the movements of the grey figure are decisive, whereas its red companion throws its arms round the grey person's neck rather hesitantly – an act reserved almost exclusively for women by (generally male) painters throughout the history of art.

The indeterminacy of the sexes may not be fortuitous. Ambiguity, openness of form, was what fascinated Le Corbusier about shells, chipped stones and eroded or splintered pieces of wood. And just as the borders between cultural product and natural form,

between inside and outside, are fluid in the objects he collected, so distinctions of sexual identity are fluid in his paintings, and not only in them. An early photograph of Le Corbusier, taken during a trip to the Middle East, shows him with his friend August Klipstein, an art historian and expert on Cézanne who later became a dealer of international standing (ill. p. 79). Klipstein sits cross-legged on an armchair like a fakir while the twenty-four-year-old Le Corbusier, dressed as a woman, approaches him with a theatrical gesture. It would be foolish to attach too much significance to occasional photographs of this kind, but there can be little doubt that the games Le Corbusier played with sexual and spatial characteristics in his art were anything but accidental.

Spatial hermaphrodites:
Le Corbusier, Rothko and formal ambivalence

Abolishing traditional notions of space went hand in hand with overturning conventional ideas about volume. To understand this interrelation and interdependence it is worth taking a look at the work of a painter who developed a new concept of space, starting, like Le Corbusier, from images of bodies. At first sight Le Corbusier might seem to have little in common with Mark Rothko. They would appear to be linked by nothing more than an interest in the work of Picasso, an influence felt by many painters in the 1930s and 1940s. Yet, however different stylistically, their painted oeuvres share one thing: a development away from volumes as the focus of images towards concepts of space that corresponded to Hans Blumenberg's notion of 'anti-platonic irony'. For both of them, painting constituted a means of presenting spaces, forms and states that could be neither constructed nor conceived in any other terms.

Rothko was born Marcus Rothkowitz in Dvinsk, Russia, in 1903. His family fled to Portland, Oregon, in 1910. Rothkowitz studied psychology at Yale before moving to New York where he illustrated a bible, wrote pamphlets about child creativity and

painted subway scenes that vaguely recally Edward Hopper's images of city life. The pictures show women standing alone in the subway while other people huddle together in groups so that the individual bodies merge into a single, rust-coloured volume that surges into the tunnel with a multitude of legs and heads. Rothko's work at this time is figurative, yet these city scenes contain the seeds of his later colour-field painting. Planes and people collide; there is a constant pushing and pulling, overlapping and abutting. Against the background of these early canvases, the well-known colour-field paintings that Rothko began producing in 1948 appear like a continuation of his earlier concerns, exploring at a basic formal level the mechanisms and principles of touch, finely poised states of equilibrium and brief, unexpected moments of harmony.

Like Le Corbusier, Rothko turned increasingly to mythological subjects, doubtless influenced by Picasso. He painted Syrian bulls, but also surreal images that took their cue from the treatment of space in Giorgio de Chirico's pictures and Max Ernst's *Loplop*. Then, at some point, the narrative, the figure, disappeared from his painting. Colours now touched or collided in complex ways, intermingled unexpectedly or repulsed one another – the way people had in the subway pictures. Yellow might emerge from steaming white or red might bump into blue and produce a stunned sliver of bright green. The *comédie humaine* was being played out by colours. As with the architecture Le Corbusier was designing at this time, Rothko's games with colour aim to convey a direct experience that goes beyond iconographical intelligibility. Anyone following the artist's injunction to view his paintings close-up will not simply register their intensely glowing colours, but have the sensation of gazing into light. Clement Greenberg and other critics acclaimed the new, physical immediacy of painting that transcended activation of viewers' iconographical knowledge to engage directly with their bodies. There was no meaning beyond the work itself, no allusions to things outside it: the images strike the eye and stimulate the body here and now. After focusing on one of Rothko's red pictures for a few minutes and then turning to look at a white wall next to it, viewers think they see a green spectre. This

Mark Rothko, *Teiresias*, oil and charcoal on canvas, 1944

is the after-image of the red painting, a kind of mirage casts on the wall by the brain as if by a ghostly slide projector.

Post-war writers on art long dismissed Rothko's early paintings as inferior exercises along the road to mastery, as necessary stop-overs in the company of Hopper und Picasso. Yet the mythological figure of Teiresias that he drew and painted several times – both as a recognisable figure as well as in the form of an abstract colour-field painting with only the title refering specifically to the mythi-

Mark Rothko, *Teiresias*, drawing, *c.* 1944

cal figure – may well play a key role in Rothko's work (ills. oppo-
site page and above). According to Hesiod, Teiresias was a priest of
Zeus who, finding two snakes copulating on Mount Kyllini, killed
the female and was punished by the gods by being turned into a
woman. His divisive intervention, his destructive separation of
male and female forms, resulted in the dissolution of his own
identity. Later he is blinded as well, thereby losing the capacity
for objective differentiation. Rothko depicted Teiresias as a sexual
hybrid, as a woman–man, repeatedly painting the figure as a her-

maphrodite with male and female sexual organs and a head that is all eye but has no eyes. What was it about this figure that fascinated him to an almost obsessive degree?

Teiresias – the blind seer who 'leaps ... across sexual differences'[44] – is the mythological image for the loss of unequivocal identity. Being both man and woman and no longer able to differentiate among the things of this world, he can only sense what will happen and what he 'sees' are things that do not exist. This paradoxical motif informs Rothko's entire oeuvre. His canvases, whether figurative images of Teiresias or colour-field paintings, amount to an attack on the kind of thinking that operates with firm categories and sharp distinctions, that decrees that someone must be either inside or outside, for instance, or a man or a woman. Rothko explored the potential of a third sex, the hermaphrodite, the monstrosity who refuses to decide, who swims on in the sea of possibilities and who answers the questions 'Who are you?' and 'Where are you?' with 'Everything' and 'Everywhere'. This monster lived on in Rothko's non-respresentational pictorial spaces. The American painter was clearly interested in figures and spaces that countered conventional ideas by rejecting such opposites as 'man/woman' and 'foreground/background' as false premisses.

Rothko's 'multiforms' of 1947 presaged a new kind of pictorial space. In these, figuration dissolved into a haze of glowing, burning colour. What then happened in his painting approximates to a zoom focus, with the artist apparently taking from the 'multiform' paintings transitional areas in which two colours meet and enlarging them. This resulted in the well-known colour-field paintings, the space of which evokes a flight through psychedelic realms. Colours overlap luminous red blocks, abysses open up, areas fade into one another like steam, a garish pink smoulders behind a harsh orange, a Matisse blue spreads diffusely into a green reminiscent of Monet's water lilies and sinks into a dull black. Traditional perspective is abolished completely, as dark areas of colour float above or below lighter ones and overlap like clouds. The paintings generate space, but it is impossible to distinguish between front and rear, to say whether a dark area is a plane or a hole

or to establish whether a brown stroke is a bar or an opening. This is the world of reversible images, a dizzying realm of constant metamorphosis. Perhaps the elements floating in and out of each other in these paintings can best be likened to objects wandering aimlessly in a weightless space.

It comes as no surprise to find that the period of Rothko's greatest success coincided with the beginnings of post-modern theories that opposed exclusive, 'either/or' logic with an inclusive 'as well', demanding a non-hierarchical reordering of the world and calling into question supposed ontological constants. Around the same time that Rothko was 'hermaphroditing' the world, others were working on a type of architecture that operated in the same way as his paintings, with overlapping and indeterminacy, with hard and soft edges, hot and cold areas, 'hermaphroditic' spaces rather than rooms marked off clearly by walls.

Architecture and Surrealism

Like Rothko, Le Corbusier engaged with Surrealism and its spaces. Indeed, his collection of beach finds in some ways recalls Surrealism's *objets trouvés*, those semi-destroyed objects that had lost their functional value and were prized by the Surrealists for embodying what Christian Kellerer has called a 'basic level of sensuous experience' and for the fruitful promptings of their bizarre deformations.[45] Such objects appeared for the first time in Le Corbusier's work in his painting. Here, too, he used the medium to experiment with things that would later feature in his architecture. Curved shapes had figured in his early buildings – in the roof of the Villa Savoye, for example (ill. p. 13) – but were derived primarily from geometrical figures and stereometric forms. These are controlled, calculated curves, not organic implants. Allusions to technology and to classical Antiquity in fact dominated Le Corbusier's early architecture. For him, Antique buildings inhabited a world governed by a geometrical system of proportion, as his clipped, almost military-style description of the Parthenon in *Vers une Architecture*

(1923) shows: 'The Parthenon – Here is something to arouse emotion. We are in the inexorable realm of the mechanical. There are no symbols attached to these forms: they provoke definite sensations; there is no need of a key to understand them ... The fraction of an inch comes into play. The curve of the echinus is as rational as that of a large [artillery] shell.'[46]

Much has been written about the influence of theosophy and other esoteric teachings on Le Corbusier.[47] In his youth he read work by several esoteric cosmologists and his early writings accord fully with these in their assumption that harmony between buildings and the cosmos can be achieved by precisely calculated proportions. 'If we are brought up short by the Parthenon, it is because a chord inside us is struck when we see it; the axis is touched.' Or again, in front of buildings erected in accordance with 'universal' systems of harmonious proportions there is 'a moment of accord with the axis which lies in man, and so with the laws of the universe – a return to universal order.' And yet again: 'The objects in nature and the results are clearly and cleanly formed; they are organized without ambiguity. It is because *we see clearly* that we can read, learn and feel their harmony'.[48] ... 'without ambiguity': it is one of the paradoxes of Le Corbusier's thinking and formal invention that shortly after he wrote this text – perhaps even while he was doing so – he became interested in ambiguity, presenting in his painting forms that countered and undermined static concepts of nature.

Theodor W. Adorno described Surrealism as a reaction against the elimination of history and chance from modern architecture. In his view Surrealism revealed the other side of the objectivity coin: the 'horror' felt by an Adolf Loos at the 'crime' of ornament is 'mobilized by Surrealist shocks. The house has a tumor, its bay window. Surrealism paints this tumor: an excrescence of flesh grows from the house ... Surrealism gathers up the things the *Neue Sachlichkeit* denies to human beings; the distortions attest to the violence that prohibition has done to the objects of desire.'[49] Applied to Le Corbusier, this would mean that his painting constituted a refuge for everything that he had deliberately excluded from his architecture: such things as the cruelly twisted stereometric vol-

umes in *Harmonie périlleuse*, the proliferating shells and the colour-ful, amorphous springs, then appear as 'compensation' for the rationalist striptease that Le Corbusier had forced on traditional buildings. Compelled to cast off their roofs, bay windows, mul-lions, volutes and caryatids, they deposited them in his painting, where they accumulated like objects thrown away in haste.

That is one way of looking at it. But it might also be that paint-ing, rather than constituting a repository for things Le Corbusier had suppressed, was an arena for experimenting with everything that as yet had no place in his architecture. It was here that he probed overlapping and ambiguity, wove together natural forms, artefacts and history, combined calculation (represented by con-struction lines and indications of ground plans drawn across the picture plane) with chance (embodied in broken and damaged objects). For once, the rather hackneyed idea of the painter's stu-dio as a 'laboratory' seems appropriate.

In his painting Le Corbusier took his cue from Cubism. He dis-sected the picture plane, tilting and folding it so as to form an unreal space in which objects could be viewed from more than one angle at a time. Although Ozenfant's influence in the early 1920s soon caused him to move to the anti-Cubist, Purist camp, Le Corbusier retained his personal mode of Cubist dissection (thus perhaps prompting his break with Ozenfant). The dissolution of space that he investigated in collages, montages and prints was to appear a short while later in his architectural work. Structures like the Villa Savoye represented an attempt to keep abreast of tech-niques used outside architecture and incorporate them in build-ings. Beatriz Colomina has shown how Le Corbusier used long windows and ramps in the Villa Savoye to turn the structure into a kind of built film, with spatial cuts, flashbacks and close-ups (and the ribbon windows with their supports actually look like a film negative): 'The house is no more than a series of views choreo-graphed by the visitor, the way a filmmaker effects the montage of a film.'[50] The aspects of his painting that seem Surrealist are also best explained as experiments with space, in which he drew on Sur-realist strategies only as aids.

Similarly, Le Corbusier's 'objets à réaction poétique' are not the kind of *objets trouvés* collected by the Surrealists. Along with items divorced from their original function, the Surrealists valued bizarre, inexplicable, 'crazy' forms like the spoon described by André Breton in *L'amour fou*, which he bought while strolling round a flea market and the handle of which metamorphosed into a woman's slipper: 'Some months earlier, inspired by a fragment of a *waking sentence*, "the Cinderella ashtray" [*le cendrier Cendrillon*] and the tempation I had had for a long time to put into circulation some oneiric and para-oneiric objects, I had asked Giacometti to sculpt for me, according to his own caprice, a little slipper which was to be in principle Cinderella's lost slipper ... In spite of my frequent reminders to him, Giacometti forgot to do it for me. The *lack* of this slipper, which I really felt, caused me to have a rather long daydream, of which I think there was already a trace in my childhood. I was impatient at not being able to concretely imagine this object, over whose substance there hangs, on top of everything else, the phonic ambiguity of the word "glassy" [*verre* = glass, *vair* = ermine] ... It was when I got home and placed the spoon on a piece of furniture that I suddenly saw it charged with all the associative interpretative qualities which had remained inactive while I was holding it. It was clearly changing right under my eyes.'[51]

Le Corbusier always insisted that everyone should be able to 'read' the shells and bits of wood he collected. Breton's shoe-spoon is quite different. It is accessible only to the narrator and acquires meaning only in the context of his pyschological being. The intensely personal wish, founded in his biography, for a physically constructed pun, the 'cendrier Cendrillon', the form of which he cannot imagine, was aroused by the sight of a found object at a flea market. The *objet trouvé* is here a maieutical object, one that calls forth unconscious desires from the depths of an individual's pysche. Its attractions and its significance remain hidden from other viewers. In the spoon, for instance, Breton saw a symbolic figuration of the male sexual apparatus', this rather overheated view leading him to recognise a barely concealed sexual meaning in the Cinderella story. That is how objects work in Surrealism:

they initiate a subjective train of thought, triggering a series of personal associations. In certain situations any object – spoon, battle mask or whatever – can acquire a significance comprehensible only to the individual concerned. The 'réaction poétique' they bring about is thus different from that invoked by Le Corbusier. His objects must be intelligible to everyone everywhere, and in that they are very much part of the internationalist movement in architecture.

'Our intellectual field of enquiry must henceforth be different', Le Corbusier declared, 'as will be the choice of our companions. I mean all the objects with which we love to surround our daily lives ... which might also be poetic objects ... By means of them friendly contact between nature and ourselves is woven. I have on occasion used them as themes for my paintings and murals. Through them, characters emerge: male and female, vegetable and mineral, bud and fruit (dawn and noon), every shading (the prism giving off its seven acid colors, or the muted tones of earth, stone, wood), every shape (sphere, cone and cylinder, and their varied sections).'[52] Unlike the Surrealists, then, who used objects as points of departure for generating individual associations, Le Corbusier sees in them a manual for understanding the universal laws of nature. In a kind of methodological reverse thrust, the rationalist architect also derives mathematical basics from them ('sphere, cone and cylinder, and their varied sections'). White modern boxes with big wide windows are now to admit real nature, in place of bay windows, scrolls and ornaments, which to Le Corbusier are merely Platonic plaster shades of the nature curving and burgeoning outside the dark domestic cave. Beach finds, kept on the living-room table instead of knick-knacks, will tell of what is outside. Le Corbusier first elucidated the role he envisaged for 'objets à réaction poétique' in modern life in 1925, in a place where shells existed only as cast-gold decoration: the Exposition des arts décoratifs in Paris which proved to be one of the most important exhibitions in his career as an architect.

89

3·

SHELL PASSAGES

The invention of modern architecture out of the spirit of
flotsam and jetsam: the 'Exposition des arts décoratifs'

The 'Exposition internationale des arts décoratifs et industriels
modernes' took place in Paris from April to October 1925. Attract-
ing over one thousand visitors a day, it was one of the most
successful world exhibitions. Stylistically, it was dominated by a
decorative variant of Cubism: Art Deco, which determined the
appearance of countless luxury objects with which manufacturers
sought to prove that in the immediate post-First World War period
Paris had maintained its position as the world's leading producer
of such wares. Le Corbusier displayed a 'Pavillon de l'esprit nou-
veau', which cemented his reputation as a builder of 'machines for
living in' and a preacher of industrialised living. He explained that
the pavilion, a two-storey, generously glazed structure, was a mod-
ule for the 'Immeuble-Villa', which would consist of 120 such units
stacked together to form a large building. The architect realised
this project a quarter of a century later in altered form in the above
mentioned Unité d'Habitation in Marseilles, a block of flats that
basically constitutes a miniature city, like some compressed, mould-
cast village comprising hundreds of houses mounted on top of
each other.

This idea alone served to provoke the organisers of an exhibi-
tion expressly devoted to the 'decorative arts'. Le Corbusier and
his close associate of the day, Amadée Ozenfant, showed an indus-
trially reproducible building with standardised furniture that must
have looked very spare and mechanical to eyes accustomed to
ornate, sumptuously upholstered furniture. Demanding the
'purification of architecture through emptiness',[1] Le Corbusier
spoke of 'objets types' responding to 'bésoins types': objects with
shapes perfectly suited to essential requirements such as lying

down, sitting and storing, but lacking all decoration.[2] The exhibition organisers reacted quickly to the provocation and erected a six-metre-high hoarding around Le Corbusier's pavilion. It was removed only after vociferous protests from the architect had prompted the intervention of the Minister of Culture, Anatole de Monzie.[3]

Sigfried Giedion reports that visitors were also disconcerted because Le Corbusier had laid out 'strange flotsam and jetsam' on the tables and window-sills in place of the knick-knacks and *objets d'arts* – small porcelain figures, over-elaborate table clocks and so forth – featured in the other pavilions.[4] The beach finds were harbingers of the same stripped-down ideology that had occasioned the 'objets types' and their embodiment of a return to basic needs that were being ignored by manufacturers concerned to create a cushioning aura of cosy well-being. Unlike the knick-knacks and *objets d'art* which only pretended to be hand-made and individual, the shells and stones were truly unique. They encapsulated a different relationship between the general and the specific: the shape of every shell, for example, was based on the same strictly mathematical spiral, yet chance had given each one of them varying markings and textures by placing them differently among stones and splitting or smoothing them in different ways.

With its steel furniture in place of period furniture, its shells in place of *objets d'arts*, its real nature in place of sentimental historicity, Le Corbusier's pavilion formed a counter-model to the world of commercialised decorative art that was the exhibition's *raison d'être*. This was the first time that the architect had displayed his 'objets' in public as components of a new lifestyle. Although his pavilion may be seen as a highpoint of rationalist living-machine culture, he presented his found objects there as 'evocative companions', long before he wrote those words.

Like painting, exhibitions seem to have provided Le Corbusier with a forum for reformulating ideas. Indeed, one little-regarded exhibition can be said to hold the key to his theory of architecture and at a time before he accorded the seashell central symbolic importance in his first *Modulor* book of 1948.

Le Corbusier's exhibition 'Les Arts dits primitifs':
the blueprint for a theory of assemblage

In 1935 Le Corbusier organised an exhibition with the Paris art dealer Louis Carré who represented Fernand Léger and Picasso among others. It took place in the architect's studio and bore the title 'Les Arts dits primitifs dans la maison d'aujourd'hui' (The so-called primitive arts in the home of today). 'So-called' was a remarkable qualification at a time when modern ethnological practices had yet to be introduced and allegations of Eurocentricity had yet to achieve widespread acceptance in connection with non-European art. Le Corbusier's article about his exhibition in the specialist periodical *Architecture d'aujourd'hui* contained a programmatic illustration (ill. opposite page). It showed a Greek statue of the Alexandrian period, a sixteenth-century bronze from Benin on top of a brick and a large pebble from his collection of found objects. The architect wrote: 'The primitive arts are those from the creative period in which a society invented its implements, language, thinking and gods, in which civilisation seemed to be bursting with dynamism ... Today a new world is arising; everything is beginning afresh,'[5] This statement, and the exhibition title, appear odd in view of the objects displayed in the illustration. The pebble was not a product of art, while the brick and the Antique sculpture resulted from long processes of adaptation and improvement of a basic type, not from a creative *ur*-phase of some kind. Even the bronze scarcely testifies to an early cultural flowering, since it dates from the highpoint of Benin culture. Only when taken together do the objects evoke a new start – a draft theory of architecture formulated with objects as conceptual building bricks.

The evocative collection of objects recalls the juxtaposition of motor cars, steamships and Greek temples in Le Corbusier's tract *Vers une Architecture*. All the items exemplify shapes created in series and refined through constant repetition. In the 1935 exhibition cultural products were combined with natural forms evincing comparable material and associative qualities. The human-made Antique statue, for instance, possesses the same immaculately

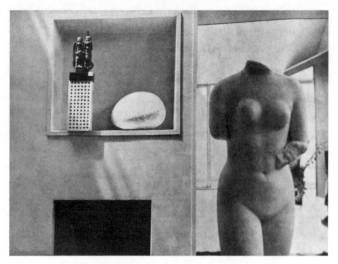

Le Corbusier's exhibition 'Les Arts dits primitifs'
in the architect's studio, 1935

rounded surface as the stone shaped by nature. Another systematic
development was also presented in the exhibition: the progression
from a stone formed by nature to a human figure carved in stone
and thence to a machine-made 'stone'. The latter – the brick –
embodies an inverted sculptural process: whereas human hands
shaped a natural material to produce the statue, the brick smoothed
by water is a material made by human hands that has been formed
by nature in accordance with aquadynamic laws (and with the
intervention of chance). These transitions from natural to artistic
shaping clearly fascinated Le Corbusier and dominated his exhi-
bition.

The 1935 collection of objects had a predecessor in sixteenth-
century cabinets of curiosities which included Antique items
among fossils because the antiquities, too, had been discovered in
the earth. They thus figured as a link in a chain that led from nat-
ural forms to Antique art and from post-Antique works of art to the
machine, which represented the final stage in human domination
of nature.[6] This sequence recurs both in Le Corbusier's exhibition

and in his painting. In *Harmonie perilleuse* (ill. p. 73), for example, a proliferating green shape, an Antique statue and a mathematically simplified, potentially endless loop of industrial forms appear alongside one another.

Le Corbusier's juxtaposition of nature, classical antiquity, Benin and brick is not a surreal assemblage. Neither does it revolve around various beginnings in cultural history. It seeks instead to evoke a new mental and emotional attitude. This he defined shortly later in terms of a revised notion of contemporaneity: 'We may feel like collecting [such objects], and they will seem to us to be contemporary, although in actual time, they certainly are not. This anachronism must not be measured by the scale of time. It arises only in the gap between things utterly different in spirit. What we mean by contemporaries, at this level of perception, are objects with sister souls. So objects originating in any time and place whatsoever may aspire to this brotherly communion.'[7]

The four objects encapsulate associative viewing. As in Le Corbusier's painting, the chain of associations embodies not an individual's desires, but the theosophical notion of a 'cosmic axis' linking people and their bodies with the objects of nature and culture. Here is further evidence of how deeply Le Corbusier was influenced by turn-of-the-century esoteric writing, not least by Henri Provensal's *L'Art de Demain, Vers l'Harmonie intégrale* (The Art of Tomorrow, Towards Universal Harmony, 1904) and Edouard Schuré's *Les Grands Initiés* (*The Great Initiates*, 1889).[8] In his writings the esoteric philosopher Schuré had already invoked an *ur*-harmony that connected humans, nature and the universe. Le Corbusier adopted both Schuré's high-flown style and his penchant for 'initiations' and 'crossing thresholds'. 'The teachers who supervise your education', he stated 'should not do more for you than to *open the doors* on vast, utterly limitless horizons. The diploma crowning your studies should grant you only one right: to cross the threshhold.'[9]

Once over the threshold, Schuré discourses endlessly on Nicholas of Cusa's concept of 'coincidentia oppositorum' (the union of opposites), tying himself in ever more complicated knots.

Cusa's idea of 'docta ignorantia' (learned ignorance) claims that humanity can develop more and more precise categories for classifying things – 'nature' and 'artefact', for example – but can never comprehend the coincidence of such artificial opposites in the divine One. Humanity can only conceive of that possibility, prompted by a contemplation of the world of objects in terms of symbols ('symbolice investigare') that encourages speculation on the cosmic laws underlying appearances. Le Corbusier's interest in hybrids, in ambivalence, in forms occupying an indefinable place between nature and artefact might have been fired by this approach, even though he will doubtless have been familiar with medieval theological concepts only in the still more confusing form of Schuré's theosophy. This sufficed, however, to arouse in him a feeling for the 'unity of being' behind the manifold forms of external appearance. He here adopts a position as a Schuré-style initiate who, unlike the technocratic rationalists of avant-garde architecture, seeks to accommodate mathematics to nature rather than opposing the two. Accordingly, he stated with reference to the auditorium in his competition entry for the Palace of the Soviets in Moscow that the task had required a solution 'closer to biology than to statics' and that this explained why his structure was 'designed [to resemble] the double curve of a half-open shell' and thus embodied 'pure mathematics, the key to pure harmony'.[10]

Le Corbusier used his collection of objects to develop a passage towards knowledge that comprised three stages. He began with the direct sensuous experience of, say, a shell in the hand. Then he uncovered the basic mathematical figure underlying its structure, the spiral. Finally, he identified its individual features – cracks, chips, rounding and smoothing caused by its falling into the water, being dragged around the sand and buffetted by the wind or current – as evidence of 'cosmic laws' that, although operating through erosion and aquadynamics, do not result in predictable shapes. Thus, however regular an object, attention focuses chiefly on its special history at the hands of chance, on its particularity.

Le Corbusier, Plan Obus for Algiers, 1931

Algiers: people, history and nature
return to architecture

Early in 1931 Le Corbusier journeyed to Algeria to deliver a lecture on urban development to the 'Amis d'Alger'. A few months later he returned to Algeria for his summer holiday.[11] He travelled through the Sahara, studied traditional architecture and drew the inhabitants.[12]

In the M'Zab valley in southern Algeria he sketched traditional buildings,[13] their irregular, markedly sculptural façades pierced by small windows seem like a blueprint for the light wall at Ronchamp. Indeed, the complete break with technology-based design practices accomplished by Le Corbusier in his response to the Ronchamp site appears to be heralded in a plan for rebuilding Algiers that he drew up in 1933. Here, the architectural design no longer constitutes a pure idea projected onto an empty surface against all opposition in an exclusive Cartesian act (ill. above). Comparison with the Plan Voisin, makes the change clear. That is not to say that

Le Corbusier, Musée à croissance illimitée, 1939

the Plan Obus did not possess brutal, almost megalomaniac traits; it entailed demolishing the old Quartier de la Marine, for example, and the suburbs of St Eugène and Hussein-Dey were to be linked by a 'main road' erected 'in front of a steep slope' on a reinforced concrete structure harbouring 'dwellings for 180,000 people'.[14] On the other hand, the Algiers plan does respond to the site. The architecture curves round the terrain, skirts the remains of history (the ancient Qašbah fortress is untouched) and flows past views and historic buildings into the surrounding landscape like the contents of an overturned snake basket. In the Plan Voisin Le Corbusier had wanted to raze half Paris to the ground. Now the new did not destroy the old as a matter of course, but inscribed its forms in and around what was already there.

Concrete snails: esoterics and theosophy, the Mundaneum and the Musée à croissance illimitée

Le Corbusier designed two large museums in the 1930s. In Zurich in 1939 he produced a drawing showing how he developed the architecture of the Musée à croissance illimitée (Museum of Unlimited Growth) from constructional principles present in

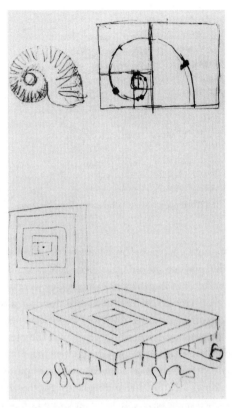

Le Corbusier, Musée à croissance illimitée, 1939

nature (ill. above and p. 97). He started by depicting a coiled
seashell. This formed the basis of the design. The next stage was a
mathematical analysis of the snail's shape. A vertical line divided
a rectangle at a point corresponding to the Golden Section; the
smaller rectangle thus created was then divided at the same point,
and so on. The centre of each larger rectangle was marked with a
dot and the dots joined with a curved line. In this way the architect
generated the spiral shape in the rhythm of the Fibonacci sequence
of numbers. This structure underlay that of the museum as a whole

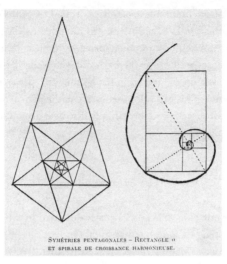

Matyla Ghyka, Spiral constructed in accordance
with the Golden Section, 1931

which the drawing shows to be essentially geometricised nature
raised on *pilotis*. In a letter Le Corbusier explained how the museum,
designed in 1931 for the periodical *Cahiers d'art*, might grow grad-
ually like the seashell, with galleries added to the spiral as required.[15]
Hence the design possesses no final, definitive form: the building
was to expand like the shell of a mollusc which increases in size
imperceptibly through the secretion of calcium.

Among the books that Le Corbusier read while working on
the designs for the Musée à croissance illimitée and for another
museum, the Mundaneum, was Prince Matyla Costiesco Ghyka's
Le Nombre d'or (The Golden Number, 1931). The great-grandson of
the last reigning prince of Moravia, this writer, philosopher and
mathematician was born in Moravia in 1881. Employed as a
Romanian diplomat in Paris, he included the writers Paul Morand
and Marcel Proust among his friends. His theoretical writings
sought to establish the importance of mathematics to poetry. In *Le
Nombre d'or* he finds the Golden Section just about everywhere, in

everything from buildings to actresses' faces. Le Corbusier worked a lot with this book.[16] Its illustrations included two X-ray photographs of the Nautilus pompilius species of mollusc – the kind that Le Corbusier would use as the basis of his museum design, as his personal mark on the medal in his honour (ill. p. 34) and as the starting point of his Modulor theory. Its mathematical description as a series of rectangles increasing in size also occurs in Ghyka's book (ill. p. 99).

The Mundaneum

The other museum that Le Corbusier designed in the 1930s likewise consisted of a monumental spiral (and was also never built). It was commissioned by the pacifist Paul Otlet, today celebrated as a pioneer of documentation management and as the founder of modern information science. Born in Brussels in 1868, he had set up the Office International de Bibliographie with Henri La Fontaine in 1895 and sought thenceforth to establish a universal library, the Mundaneum. After the First World War, in which his son fell, he became a committed pacifist and increased the scope of the Mundaneum to encompass not only a world-wide repository of knowledge, but also a monument to international understanding and a museum of world history. The latter aimed to show the development of life from the 'primeval matter of the universe' to the achievements of modern art and science.[17] Le Corbusier designed a building for Otlet in the shape of an Assyrian stepped pyramid (ill. p. 101). A 2,500-metre-long ramp spirals round the structure from the bottom to the top. From the ramp, the architect explained, visitors would see nature as a kind of first exhibit in the museum: 'The loftiest Alps, the smoothest lake [and] the Rhône, that great world river which thrusts its way into the sea.'[18]

Le Corbusier's accommodating attitude towards pedestrians was thus not restricted to the traffic engineering in his urban plans: visitors reached the entrance to the museum only after observing nature on a walk of two-and-a-half kilometres. From here, another

105. World Museum. Main façade on the esplanade.

106. Rear façade seen from the halls of modern times.

107. Cross-section of the pyramid.

Le Corbusier, Three sections through the Mundaneum, 1930

spiral led back down. As Elisabeth Blum showed in her study of
the Mundaneum, Le Corbusier reconstructed more or less exactly
the 'path of knowledge' described by Schuré in his book on the
'great initiates'.[19] For at the very end of the evolutionary path,
beyond the latest achievements in art and science, metaphysical
illumination was to await the visitor in what Le Corbusier called
the Sacrarium, which contained statues of the 'great initiates'
Rama, Krishna, Hermes, Moses, Orpheus, Pythagoras, Plato and
Christ. The architect took over Schuré's choice of outstanding his-
torical figures, although he did not especially admire them: neither

Krishna nor Plato, for instance, plays a notable role in his work, and indeed he would soon adopt a philosophy of the object markedly different from Plato's.

The greatest interest of the Mundaneum is methodological: Le Corbusier translated a book into architecture. Metaphorical 'paths of knowledge' metamorphosed into ramps, while evolution and knowledge became a matter of storeys and distances. Transformation is enacted physically as the visitor progresses. The Mundaneum differs fundamentally from Vladimir Tatlin's well-known design for a *Monument to the Third International*. Built to a height of four hundred metres, the monument was to take the form of a gigantic spiral housing three deputies' chambers that, like stars, were to complete one rotation about their axes every day, month and year respectively. For Tatlin, the spiral was principally a symbolic form, representing cosmic harmony,[20] but for Le Corbusier it was something that must first be explored physically. After this beginning in sensuous experience, it is subjected to abstract explanation in rational terms, before eventually acquiring a symbolic dimension. Those are the three stages undergone by the 'objet à réaction poétique' in Le Corbusier's theory of formal invention and they correspond to the three stages in the 'path of knowledge' embodied in the Mundaneum. Physical reality is experienced immediately in the effort of ascending to the entrance, as fatigue and the natural laws governing gravity, cold and heat register as bodily sensations. Only at the top is the visitor vouchsafed an overall view of nature. On the way up, the view expands gradually, each turn in the spiral opening up new perspectives, which unite in a single one at the summit. This 'staging' of nature functions as a metaphor of the step-by-step acquisition of knowledge, the spiral as a built representation of thought processes. Inside the museum, the downward spiral path then elucidates what has been experienced mainly in physical terms outside: the relationship between nature and humanity. The Mundaneum is thus an epistemological model and a contribution to the theory of perception (though one with considerable theosophical padding). Hence it belongs among the ambitious projects in modern architecture once described by

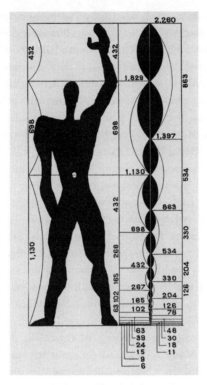

Le Corbusier, The Modulor, 1948

Walter Gropius as 'recasting transcendent thoughts in sensuously perceptible form'.[21] The spiral construction emerges both as a method and a metaphor of knowledge acquisition.

The mathematics of nature: measure and Modulor

The links between natural forms, mathematics and humanity that Le Corbusier repeatedly expounded in his paintings and exhibitions ultimately became the lynchpin of a design theory that ranks among the twentieth century's most influential. In 1948 he pub-

lished *Le Modulor*, which describes an anthropometric system of proportion used both by Le Corbusier himself and subsequently by many other architects. The architectural historian Rudolf Wittkower saw in the Modulor a revival of the Renaissance belief that 'man-made objects, such as architectural structures, can only be attuned to universal harmony if they follow man's proportions.'[22]

Essentially, the Modulor repeats Ghyka's ideas about the Golden Section.[23] Le Corbusier evoked the contents of his book on the cover. Inserting a spiral figure, half red, half blue, between the images of a shell and a measuring scale, he announced his view of the spiral as a mathematical link between nature and humanity. The Modulor itself consists of a male human figure proportioned entirely in accordance with the Golden Section. The man is 1.83 metres tall, 2.26 metres with his arm raised. His navel is inscribed at a height of 1.13 metres – that is, forming a Golden Section in relation to his head height.[24] A sequence of measurements on a Y-axis, calculated in accordance with the Golden Section from the values 226 and 183, forms the basis of the blue and red spirals. A spiral emerges when these points are linked by curved lines, increasing at the same exponential rhythm as the spiral of a seashell. The Modular condenses the perceived inner connection between natural forms, mathematics and human beings into a neat visual formula that the architect hung above his desk (ill. p. 37) and immortalised in his medal.

His sequence of numbers, Le Corbusier claimed, generated forms that would reunite humankind and nature. He had already formulated the mathematical basis of this idea in earlier writings: 'Man ... has been created according to the laws of nature. He must ... understand the spirit of [those laws], then apply them to his environment in order to create out of the cosmos something *human* ... Nature is wholly mathematical in substance, but our eyes perceive it as a series of chaotic spectacles ... in order to save himself from this chaos ... man has projected the laws of nature into a system that is a manifestation of the human spirit itself: *geometry*.'[25]

For Le Corbusier, however, geometry is merely a means to an end: it forms only the 'key' to 'solutions'.[26] The decisive prompt-

ing for the Modulor came from sensuous form, from the spiral – 'a material phenomenon that can be grasped by the eye, dazzling in its scope'.[27] 'I had not realized at the time', he writes, 'that I was, in fact, creating something: I placed the man in the centre of the drama, his solar plexus being the key to the three stages... But in my hands, the hands of a plastic artist... the mathematical relationship became embodied – spontaneously – in a harmonious spiral, an ideal shell. That is where my invention comes in... not scientific in character, but a spontaneous product of a passion for poetry and the plastic arts.'[28]

Objective rules versus sudden 'transformation': Le Corbusier developed his theory of formal invention from the state of tension that exists between these two poles. From the abstract diagram of a human body broken down into a set of mathematical relationships there arose a form that he interpreted as an idealised variant of another familiar form, that of the seashell. 'Invention' is here presented as a metamorphotic process facilitated by mathematics, a process in which suddenly, without the designer intervening, a form emerges from a numerical jungle. Le Corbusier describes designing as a twofold metamorphosis. A natural form – the human body – is reduced to its mathematical structure; then the eye, thinking associatively in terms of formal analogies, fashions from this structural scaffolding an object with its own sensuous properties. In other words, one structure is translated into another: a building's mass is distilled from a body's build. That is how the architect had proceeded in his plan for Algiers, deriving the organically curving lines of his design from drawings of the human body.

The process just described resulted in a figure that is both mathematical construct and sensuous object. Thus the Modulor constitutes not only a practical design aid, but also an actual method of designing. It is the instrument into which Le Corbusier channelled what he saw and collected. For he translated these things seen and collected far less directly into architecture than is often claimed – not least in the wake of his own popularisation of his work in statements like 'I placed a crab's shell on top of thick walls.'[29] Nowhere is this better exemplified than in his Cabanon

which embodies the three stages of Modulor design by creating architecture in the form of abstracted, hypertrophic nature from the mathematical reduction of a natural form – the seashell (ill. p. 41).

Affective formulas: mathematics and poetry

Two concepts unrelated to pure calculation appear repeatedly in Le Corbusier's theory of formal invention: the 'sudden' – or 'spontaneous' – and the 'poetic'. In *Le Modulor 2* (1955) he writes: 'The secret of my quest must be sought in my painting ... My painting was creative and not imitative in nature.' The 'lightning clarity and originality of relationships' in his painting generated what the architect terms the 'poetic moment' or 'lyricism'.[30] To explain this he illustrates one of his paintings alongside a diagram of its hidden compositional structure. All the elements are arranged in the shape of a spiral. The precision of the composition, he says, generates an effect that 'moves' viewers without their knowing why.

Whether one believes this or not, the theory is of special interest because it defines architecture as a machine for producing effects. Accordingly, the goal of building must be to produce a moving effect. What really mattered in building was not the abstract 'star-shaped icosahedron and dodecahedron' arrived at by 'humanist geometricians', but 'the eye's vision', 'the medium of visual perception'.[31] It is this that makes architecture poetic in the Greek sense of *poëisis*. For Le Corbusier, construction and mathematics are means of 'producing' emotions. His concept of poetry comprises three stages. First, an object – a seashell, a stone, a photograph of an old wall and so forth – arouses sensations. With his penchant for emotionally charged verbal expression, Le Corbusier says that a 'sounding-board ... vibrates in us'.[32] This aesthetic experience then triggers a design process ending in a product that 'moves' us: 'If art rises above the sciences it is precisely because unlike these it excites sensuality, awakening deep echoes in the physical being.'[33]

The frequency with which Le Corbusier declares this effect to be the true goal of architecture is striking. Building holds things together, 'architecture ... move[s]'.[34] Or again, architecture means using materials to set up 'moving relationships'.[35] Le Corbusier has left the rhetoric of functionalism and the instrumental character of building way behind. Now the aim of all design must be 'to create proportion, poetry',[36] with proportion acting solely as a tool to bring about 'enchantment'.[37] This, then, is the goal of the cele-brated rationalist architect and his buildings – to enchant, move and overwhelm. How did this extraordinary change of heart come about?

Le Corbusier's identity card, stating his
occupation as a 'man of letters'

4·

ARCHITECTURE AND LITERATURE:
THE ARCHITECT AS 'POET'

No architect has ever promoted an image of himself as a 'poet' as
strongly as Le Corbusier. On his identity card he gave his occupa-
tion not as 'Architecte', but as 'Homme de lettres' (ill. above)[1] –
with some justification, for in the course of his life he wrote and
published more than he built. But that was not the point he was
making. In all his writings he eventually declares 'poetry' to be the
true goal of architecture. His thoughts and feelings are 'directed

toward what is the principal value of life: poetry';[2] the purpose of architecture is to 'open fields of poetry to the soul';[3] his researches have always been 'directed toward the poetry that is in the heart of man'.[4] In 1929 he ended a lecture entitled 'Les techniques sont l'assiette même du lyricisme: elles ouvret un nouveau cycle de l'architecture' ('Techniques are the very basis of poetry: They open a new cycle in architecture') with the words: 'Don't you think that my charcoal and crayon sketches encircle a fabulous poetry: the lyricism of modern times?'[5]

In 1955, as attacks on his Unité d'Habitation reached a peak, and criticism of his *Charte d'Athènes* (*Athens Charter*) and post-war urban planning in general was on the increase, Le Corbusier entered the fray once more. He published *Le Poème de l'angle droit* (The Poem of the Right-angle), a sort of picture book aimed at making his architecture and his theories comprehensible to non-specialists. Right-angles barely figure in it. In fact, there are only two: images featuring voluminous masses and a variety of 'objets à réaction poétique' appear on all the other pages. This architectural 'poem' has seven sections, 'Milieu' (Environment), 'Esprit' (Spirit), 'Chair' (Flesh), 'Fusion' (Union), 'Caractère' (Character), 'Offre' (Presentation) and 'Outil' (Instrument). Each comprises a handwritten poem and a few coloured drawings. Editions Verve published the book in a small de luxe edition, although Le Corbusier had wished for a different kind of publication, since its aim was to explain to a mass audience his view of the world and architecture.

Le Poème de l'angle droit failed to help Le Corbusier out of the corner to which some specialists and sections of the public had consigned him. His critics included the German art historian Hans Sedlmayr, who linked him with his French 18th-century predecessors such as Boulée or Ledoux, deploring the 'crystalline isolation of architecture from its surroundings' and the 'lack of organic transition between architecture and landscape'.[6] The Association pour l'Esthétique Générale in Marseilles requested twenty million francs in damages from Le Corbusier for his 'inhumane and unaesthetic' Unité d'Habitation, while others demanded its demolition.[7]

Modern architecture as poetry: Le Corbusier's promotional verse and *Le Poème de l'angle droit*

Le Corbusier sought to counter these attacks in the form of a popular, album-style publication with easily comprehensible images. *Le Poème de l'angle droit* begins with a drawing illustrating the cycle of the tides and the path of the sun. This is followed by a picture of a person standing upright against the line of the horizon. The text lauds the resulting right-angle as an anthropological constant: anyone who goes through life upright inhabits a right-angle. The 'Esprit' section celebrates mathematics as the tool of inventive people, the verse accompanied by images of a shell and Le Corbusier's Modulor man. One verse in this section is devoted to the Unité d'Habitation and its sunshades: 'sundial and solar calendar have brought architecture the *brise-soleil* installed before the panes of modern buildings'; an 'architectural symphony prepares itself under the title: "The 'Daughter of the Sun' House"; and Vignola[8] – at last – is vanquished! Thanks! Victory!'[9]

A lyrical ode to a concrete *brise-soleil* written by its designer – that was something new. The illustration accompanying the lines depicts Le Corbusier's architecture as the expression of unbridled *joie de vivre*. It juxtaposes a sectional drawing of the Unité with a naked woman with large breasts – perhaps an embodiment of the building which the poem describes as the 'Daughter of the Sun'. Thus the same apartment block that Jürgen Habermas, with the fervent urban nostalgia typical of his generation, would later attack as epitomising 'preconceived modernism' devised at the drawing-board, and as embodying the 'failure of modernism',[10] was presented by its creator as unclothed nature, as a liberation from the restrictive architectural garb favoured by society in general. Just as he explained the right-angle in anthropological rather than technological terms, so he represented his concrete building as a release of the body, a release replete with erotic promise. In this way, with sunlight striking human flesh, Le Corbusier opposed modernism's allegedly soulless concrete structures with the image of a living architectural body.

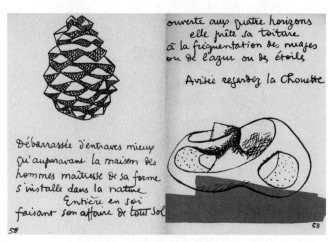

Le Corbusier, Double-page spread from *Le Poème de l'angle droit*, 1955

The following sections of *Le Poème de l'angle droit* evocatively combine seashells with naked human bodies, the figures overlapping the 'objets à réaction poétique' (ill. p. 112). An image of fingering hands appears as a literal 'embodiment' of appropriation and assimilation of the objects. Some verses embrace kitsch when stressing the importance of beach finds: 'Tenderness! Shell – the sea does not cease to wash up the flotsam and jetsam of smiling harmony onto the shore for us. The hand massages. The hand caresses. The hand strokes. The hand and the shell love one another. An absolute, sublime fulfilment suffuses these understanding things. It is the accord of time, the penetration of forms, proportion.'[11] This description of the design process as a cryptosexual act doubtless astonished even well-disposed members of the avant-garde.

A little later in the *Poème*, when a woman's body is once more combined with shells, the text states: 'Creating architecture means creating a living being,'[12] Rarely has the identity of nature and concrete modernism been invoked so directly. Indeed, *Le Poème de l'angle droit* as a whole can be seen as a move on Le Corbusier's part to 'naturise' his architecture rhetorically so as to escape criticism. For

Le Corbusier, 'Woman in front of a snail's shell',
from *Le Poème de l'angle droit*, 1955

how could anyone object to the creations of an architect–poet who evokes cosmic harmonies in his buildings and composes them in accordance with natural proportions, turning them into vehicles of nature?

Le Corbusier enjoyed great success as the propagandist of a new poetical architecture. The popular newspaper *Le Parisien* lauded him as a 'poet of construction' when Ronchamp was consecrated;[13] the critic Eduard Sekler wrote that he 'not infrequently becomes a poet';[14] and the writer Jean Guichard-Meili, contributing to the periodical *Témoignage chrétien*, recommended viewing him 'as a poet', because 'as an architect, urban planner, sculptor and author Le Corbusier has never ceased to strive for poetry in plasticity'.[15] The architectural historian Rudolf Wittkower paid tribute to him as a 'prophetic' and, 'above all, poetic mind';[16] the archi-

tectural theorist Vittorio M. Lampugnani has spoken of the 'poetic testimony of his affection for the city';[17] the architect Santiago Calatrava praises Ronchamp as a work of 'great beauty and poetry';[18] and the art historian Karen Michels notes that none of his staff equalled the 'poetic content' of his works, claiming, too, that his sketches exhibit an 'airy poetry'.[19]

By 1957 Hans Curjel was already poking fun at many critics' 'lyrical' responses to Le Corbusier's work. Writing in the periodical *Graphis* he demanded terminological clarification. Le Corbusier's 'poetry' was that 'neither of a romantic evening atmosphere nor of intoxicating passion'. Rather, it was to be understood in the Greek sense of *poēisis*, as knowledge of 'producing' or 'calling forth'. But Le Corbusier's efforts to depict Ronchamp as a *creatio ex natura* that reconciled art and nature, modern architecture and age-old needs, convinced even Curjel: 'the forms of nature, a snail's shell, stones, matter itself, became stimuli for Le Corbusier's creativity … reason and intuition formed a unity in the creative process, all antagonisms were abolished'.[20] Sigfried Giedion, the architectural historian and critic, similarly identified a victory over 'painful antagonisms' in the way that Le Corbusier's chapel amalgamated artefact and natural form and evoked archaic associations with modern means. Ronchamp, he wrote, accomplished nothing less than the resolution of the 'tragic opposition between thinking and feeling.'[21]

Pierre Charpentrat, finally, re-mythologised the chapel as a compelling natural form in its own right, as a biomorphic structure: 'At Ronchamp an *ur*-cell emerges from nothing, as uncompromising and inscrutable as those of biological structures. The idea of space appears here in its raw state, solidified in concrete, a magnificent example of immediate creation, without the intermediate stage of geometrical and architectonic elements.'[22] This, too, is a typical period piece. Striking rigorous in tone, it celebrates an 'uncompromising' form that catapulted like a meteorite into the modern era from the grey mists of time. The 'idea of space' in its 'raw state', an '*ur*-cell', 'immediate' and 'biological' in its unstoppable force: Charpentrat opposes modern civilisation with

an image of nature as immutable, compelling and insensible to human influence. The nature that interested Le Corbusier was actually quite different: it was forever inventing new forms, metamorphosing, proliferating, altering its appearance with changes in the light.

A man by the sea: discovery and invention

The sea played a major part in Le Corbusier's self-promotion as an architect–poet searching for the new on the margins of society. He wrote that he discovered the shell-based shape of his Modulor spiral during a storm at sea, while travelling from Le Havre to New York on board the cargo ship *Vernon S. Hood*. The crossing took nineteen days, he said, during the first six of which 'there was a frightful storm and for the rest of the time a strong swell ... There, to the roaring of the storm, I tried to work out a few ideas, each one arising from the last ... While the boat rolled and tossed heavily, I drew up a scale of figures.'[23] Commentators seized eagerly on such stories of how he devised the Modulor spiral amid the raging elements, how he came across the roof of Ronchamp on the beach at Long Island and so forth. And not only journalists. Specialists, too, were not slow to discover a 'Mediterranean cast'[24] to his work, a 'Mediterranean character' that made him the 'Picasso of new architecture'.[25]

No interpretative holds were barred when it came to accounts of Le Corbusier's death by drowning on the morning of 27 August, 1965 while swimming in the sea off Roquebrune at Cap Martin. Among the oddities of writing on famous people is a penchant for presenting their demise as the logical consequence and fulfilment of their life, even in the case of accidental deaths. When the philosopher Vilèm Flusser was killed in a car crash, for example, one obituary stated that he had died with 'tragic appropriateness in the de-urbanised no man's land which he had discussed and which he feared, in the disembodied metropolis of the electronic everywhere.'[26] In a memorial address for Le Corbusier on 2 September,

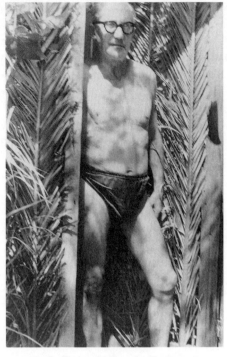

Le Corbusier photographed by Brassaï
in front of his Cabanon, undated

1965, France's Minister of Culture, André Malraux, revelled in the image of a person 'whom bathers called the old man when they saw him go down to the sea every day.'[27] Later, the architectural historian Bruno Chiambretto declared that the architect's fatal swim 'set the seal on his alliance with the Mediterranean'[28] and Jacques Lucan wrote effusively: 'on 27th August he would definitively rejoin the horizon of the sea, leaving the shore in a final search for the absolute.'[29]

Clearly, Le Corbusier's self-depiction as an 'homme de la mer' and a 'poet' met with great success as the defence strategy of a modern architect. Yet that was not the only reason for his enthusi-

asm for the sea, the beach and, indeed, for people writing about that enthusiasm. His almost obsessive preoccupation with beach finds, with his 'objets à réaction poétique', far transcended their place in flowery apologias for modern architecture: it effected a fundamental transformation in his architectural theory and in theories of design in general. Anyone exploring the background to this cannot afford to ignore one major figure. So striking are the similarities between Le Corbusier and this other beach-walker that it is tempting to see him as the architect's secret model. The figure in question is not a real person, but a character in literature, invented in 1921 by the French poet and philosopher Paul Valéry.

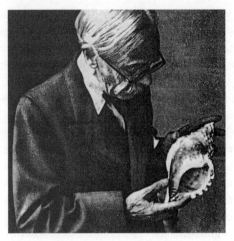

Paul Valéry inspecting a seashell

5.

LE CORBUSIER AND PAUL VALÉRY

'In stature and bearing', wrote François Valéry in 1952 in the *Atlantic Monthly*, 'my father, Paul Valéry, resembled the French foot soldier: he was short and well-proportioned, spare and lively ... He had pale eyes, not exactly blue; silver blue or grey at times, deepening to violet if he chose to gaze at you directly. He spoke quickly, without raising his voice, which was flat, with some barely perceptible traces of the Midi accent: "Speak out, will you," Degas used to say. He smoked fifty or sixty cigarettes a day; he rolled them himself, very neatly.'[1]

Paul Valéry was born in 1871 in Sète in southern France. In 1894 he moved to Paris, where he numbered André Gide and Stéphane Mallarmé among his acquaintances. Working as a press agent in London and as a private secretary he soon made a name for him-

self as a writer, especially as a poet. He ranked as a forerunner of 'poesie pure', a closed type of verse that strove for the purest construction and immanent harmony in what might be called a 'mathematised' style. As an essayist, Valéry addressed epistemological issues and theories of formal invention, especially in his *Cahiers*. It was probably his friend Auguste Perret, an architect who pioneered the use of reinforced concrete, who drew his attention to Le Corbusier.

Valéry had collected flotsam and jetsam long before Le Corbusier. The writer's son wrote: 'He liked the sea, lateen sails, the shape of hulls and anchors, sailors' knots, cordage, and the names of nautical things. The delight of swimming recalled his boyhood holidays at Genoa; he liked to swim under water, not, however, risking any great distance – he had almost drowned twice, and told of being attacked by an octopus. On the beach, he scavenged for shells and dry bones, and brought them back to Paris for his collection of valueless objects which he defended bitterly from the covetousness of his children.'[2] Valéry, too, seems to have collected such things and drawn them, not simply as a pastime. He repeatedly wrote about the sea and the objects he found on beaches, in *Le Cimetière marin* (*The Graveyard by the Sea*), *L'Idée fixe, ou Deux Hommes à la mer* (*Idée Fixe: A Dialogue by the Sea*) and other works. In 1937 he published the essay 'L'Homme et la coquille' ('Man and the Seashell') in which a mollusc forms the starting point for an outline theory of human creativity and design. Walter Benjamin wrote that Valéry had really wanted to become a navy officer.[3] Photographs show the French writer and thinker holding large shells in his hand (ill. p. 117) and the texts in his notebooks are accompanied by sketches of seashells, harbour scenes and boots.

In a letter to the editor of the periodical *Le Petit Méridional* Valéry told how he had found a strange object on the beach when he was young. 'I was fifteen or sixteen', he wrote, 'when, on the seashore not far from Maguelonne, I found a shell or a piece of bone that had been tossed about and smoothed by the sea.'[4] He remembered this object in 1921 when writing *Eupalinos ou l'Architecte* (*Eupalinos, or The Architect*). This is one of the most widely unread books on archi-

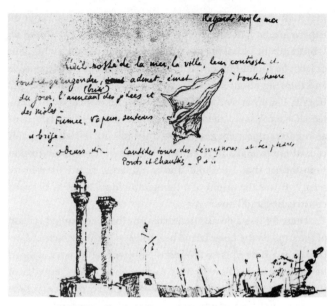

Paul Valéry, drawing of a seashell and a harbour scene
accompanying his notes to the text 'Regards sur la mer'

tects' bookshelves: few architects can say exactly what it is about.
Le Corbusier, too, possessed a copy, now in the Fondation Le Cor-
busier in Paris, but his annotations show that he actually consulted
it (ill. p. 25). What is *Eupalinos* about and why was it so important
to Le Corbusier?

Eupalinos takes the form of a Platonic dialogue, not an essay.
The text was commissioned from Valéry for a de luxe publication
of architectural ground plans and sections. This was not the first
time his thoughts had turned to architecture. In 1891 he had pub-
lished 'Paradoxe sur l'architecte' ('Paradox on the Architect'),
which was followed four fours later by 'Introduction à la méthode
de Léonard de Vinci' ('Introduction to the Method of Leonardo da
Vinci'). In *Eupalinos* two dead men discuss 'the act of constructing'.
The philosopher Socrates and his follower and friend Phaedrus are
wandering in Hades as bodiless shades. Still capable of speech,

119

they talk about architecture. Socrates tells Phaedrus about an experience he had as a young man. On the beach he found an 'objet ambigu'. Looking at the curious shape of this 'ambiguous object', he found himself faced with the choice of casting it aside and thinking about it or keeping it and developing other shapes from it – in other words, of becoming a philosopher or an architect: 'Chance', says Valéry's Socrates, 'placed in my hands the most ambiguous object imaginable. And the infinite reflections that it caused me to make were equally capable of leading me to that philosopher that I became, and to the artist that I have never been... It was the origin of a thought divided, of itself, between constructing and knowing.'[5]

There follows a description that reads like an extended version of the stroll on the Long Island beach in 1946 during which Le Corbusier, at a time of crisis, found the object that he later claimed inspired the roof at Ronchamp: "'I was walking on the very edge of the sea. I was following an endless shore... The air, deliciously rude and pure, pressing against my face and limbs, confronted me... I trod firmly the winding beach, beaten and hardened by the waves. All things around me were simple and pure: the sky, the sand, the water... I was reveling in the newborn virgin foam... It... pours round one's bare feet, bathes them, passes beyond... while the human statue, a living presence, sinks a little deeper into the sand ... This frontier between Neptune and Earth... is the scene of the most dismal and most incessant commerce. That which the sea rejects, that which the land cannot retain, the enigmatic bits of drift ... all the things, in short, that fortune delivers over to the fury of the shore, and to the fruitless litigation between wave and beach, are carried to and fro; raised, lowered; seized, lost, seized again." Phaidrus: "And it was there that you made your find?" Socrates: "Yes, there. I found one of those things cast up by the sea; a white thing of the most white pureness; polished and hard and smooth and light. It shone in the sun on the licked sand that is somber and spark-bestrewn. I took it up; I blew upon it; I rubbed it against my cloak, and its singular shape suspended all my other thoughts. Who made thee? I pondered. Thou resemblest nothing, and yet

thou art not shapeless. Art thou a sport of nature, O nameless thing ... ? ... [It was made of] the same matter as its form: matter for doubt. It was perhaps some fishbone weirdly worn by the rubbing of the fine sand under the water? ... Or was it not rather the product of a living body, which, unwittingly, labors with its own substance, and blindly forms for itself its organs and its armor, its shell ..." Phaedrus: "But tell me, what did you do with that thing in your hand?" Socrates: "I stood still for some little time. I questioned it without stopping at an answer ..." [6]

Le Corbusier marked this passage in his copy of the book. And indeed, much of it recalls his own beach finds, the rituals involved and his descriptions of the objects. There is the stroll by the sea, the physical impact of the elements (the architect's photographs showing feet sinking into wet sand almost seem like illustrations of Valéry's text), the chance encounter with an object that intrigues the finder because it cannot be identified conclusively as an artefact or a natural form, the tactile experience and the thinking about a shape in terms of its constructional and epistemological significance. Le Corbusier speaks of 'things tortured by the elements',[7] Valéry of 'things ... that fortune delivers over to the fury of the shore', that are 'carried to and fro; raised, lowered'. Both men enter into a dialogue with their finds: Valéry's Socrates asks 'Who made thee?', Le Corbusier refers to his objects as 'speaking' and 'evocative companions'.[8] Valéry's beach object is 'polished and hard and smooth and light', Le Corbusier's 'smooth as porcelain'.[9] Both call their finds 'witnesses'[10] and both are prompted by them to consider how forms arise, the role of intention and chance, and the relationship between 'constructing and knowing'.

The anti-Platonic irony of the ambiguous object

Eupalinos occupies a key place in Valéry's thinking, and it embodies an ironical approach typical of its author, using a Platonic dialogue to oppose Plato. A dematerialised Socrates – a pure idea, as it were – longs for physical experience as he walks in Hades. He

describes in minute detail the foam, the sand, the body and the ambiguous object that has an explosive effect in the context of the Platonic formal cosmos. According to Hans Blumenberg, in an essay on Valéry's 'objet ambigu' that appeared in 1964,[11] Socrates could not possibly answer his question as to who made the thing he found because the object resists any form of 'classic ontology', which necessarily 'considers the problem of the natural or artificial origin of an object to be always solvable'.[12] In Blumenberg's view *Eupalinos* was a central text not only for Valéry, but also for modern European thought as a whole, because it subjects an 'ambiguous object' to the kind of 'anti-Platonic irony'[13] that ultimately results in a different concept of the object.

The Platonic philosopher Socrates is the anti-hero in this intellectual discourse. Failing to recognise whether this 'singular object were the work of life, or of art, or ... a freak of nature',[14] he angrily throws it back into the sea and, as though fleeing from it, retreats quickly inland onto firm ground, as if fearing that the soft sand and the waves might dissolve his categories. Too late, in Hades, he realises that this was a mistake. Blumenberg notes that by enquiring into the object's maker Socrates fell victim to a 'determinative preconception' that set him on a false trail. Unable to establish the origins of the object as either human or natural, he throws it away simply because it is as it is, thereby depriving himself of the chance of 'relating to it in immediate, aesthetic' terms.[15] As construed by Valéry, the Platonic philosopher is someone who seeks to relate the world of appearances to what already exists, to known ideas, someone who recognises in things he finds only manifestations of existing *ur*-forms and who attempts to classify unfamiliar things in terms of established categories. The converse approach – which in Valéry's intellectual experiment would have made an architect of Socrates – would have led Socrates to realise that the world can be reinvented outside existing categories, that it can be rethought. Anyone who does not register the classificatory openness of the found object as a threat to their entrenched view of the world, but who is encouraged and elated by the challenge it represents, will focus not on knowing, on cognition – which is understood here as

re-cognition – but on the possibility of perceiving new, previously inconceivable forms. Blumenberg fashions this insight into a theory of aesthetic freedom when he writes that Valéry's 'aesthetically receptive subject', faced with a strange, unclassifiable form, takes pleasure 'not in the object as such or in any aspect of it, but, beyond the object, or rather by means of it, in his lack of limitation by the world of facts, in his freedom vis-à-vis the given.'[16] In Valéry's text this freedom is that of the architect, which Socrates rejects by throwing away the thing that had 'come to [him] by the will of the gods'.[17]

It is not difficult to understand why the avant-garde architect Le Corbusier was so enthusiastic about this dialogue: in it there are no unalterable givens and everything may be invented afresh. *Eupalinos* provided him with a theory that reinforced the pathos of his invocation of the new and also proposed that building need neither oppose the forms of nature nor imitate them naively, but might be approached like them.[18] Not that Valéry let his philosophical anti-hero give up quickly. In Hades Socrates is still mistrustful of building. Only *natura naturans*, he states, the nature 'produced by nature' – the shell of a mollusc, say, which grows gradually through the secretion of slowly hardening calcium – can establish a deeper connection through 'secret relations' between a thing and its surroundings. By contrast, all human products disturb the natural order by separating and dividing.[19] For example, when the artisan or architect saws up a tree so as to make a table from it he reduces a whole to a part: he sees only the boards in the tree, as it were. Because the philosopher must constantly keep the whole picture in view, says Socrates, a distinction has to be made between necessarily reductive construction and all-encompassing knowledge. At this point, the anti-Platonic irony of Valéry's dialogue comes into play when Socrates is made to recognise by a follower, Phaedrus, that there is one art that does not simply exist in opposition to nature – the art of the geometrician and the architect. Socrates is forced to admit that they establish 'another nature, against which the other artists strive, a nature more or less drawn from the first nature, but all of whose forms and beings are

123

ultimately but acts of the mind... In this essential fashion they construct worlds perfect in themselves'.[20]

Valéry's characters develop a theory of invention on the basis of a ship's hull. They cite the hull as a form not founded in the imitation of any existing thing. Phaedrus cites a shipbuilder who had sought not to reproduce a fish, but to analyse the mathematical forces governing the shape of the fish and to use this knowledge in devising the ideal shape for a boat. Copying the forms of a model thus yielded to structural analysis of those forms, to a construction arrived at in the spirit of the model but with a quite different shape. 'And whereas his rivals remained content to imitate the models then in use, and in copy after copy continued building the bark of Ulysses', says Phaedrus, the other constructor never ceased 'to fathom the unexplored regions of his art, breaking up the petrified combinations of ideas'.[21] Both men end up discussing a builder named Eupalinos, who seems like a literary blueprint for the architect Le Corbusier.

Eupalinos as a secret model: the fictional idol of a real-life architect

Phaedrus describes Eupalinos as a man with 'the power of Orpheus' who 'foretold their monumental future to the shapeless heaps of stones and beams that lay around us.' In the morning 'commands and figures' were all that remained of 'difficult meditations of the night before'. Like Le Corbusier, Valéry's Eupalinos aimed to appeal to the emotions, to use mathematical proportions to spark off 'the emotions and vibrations of the soul' that lead viewers to experience 'a sort of bliss' without knowing the cause.[22] This passage must have made a deep impression on Le Corbusier. Only one year after the publication of *Eupalinos* he wrote an essay whose title, 'Architecture, pure création de l'esprit' ('Architecture, Pure Creation of the Mind'), quotes Valéry's Socrates almost verbatim and in which he states that the architect, unlike the engineer, whose work 'cannot touch our axis', possesses a knowledge of propor-

tions and harmonies that can activate 'a resonance, a sort of sound-ing-board which begins to vibrate'.[23]

Valéry's *Eupalinos* also addresses the mathematical transforma-tion of bodies into architecture, later popularised by Le Corbusier through the evocative overlapping of buildings with women's bod-ies. The 'inexplicable grace' of a certain Hermes temple is said to result from its being a 'mathematical portrait' of a beautiful girl from Corinth: 'It faithfully reproduces the particular proportions of her body'.[24] Here too, then, and in a comparably programmatic way, formal invention begins with sensory experience. 'In one of the most beautiful passages' that Valéry wrote, said Walter Ben-jamin, 'the sea and mathematics enter into a captivating union'.[25] This combination of rules with chance forms that can only be found, not invented, would later become a central philosophical motif in Le Corbusier's writings.

Architecture and music: from Valéry to Ronchamp

Eupalinos proposes that music and architecture possess a deep kin-ship because both arts imitate nothing in the world of objects and are less physically escapable than a book or a painting: sound reaches the farthest of corners, while space is everywhere about us in a building. Theodor W. Adorno claimed that Valéry was address-ing a *coincidentia oppositorum* when he wrote: '*Composition* – which is the relation of the particular details to the whole – is much more felt and required in works of music and architecture than in the arts whose object is the reproduction of visible things.' 'It is this', says Adorno, 'that defines [Valéry's] idea of form: the return of the architectonic within the musical.'[26]

There is, however, really no need to invoke the notion of *coinci-dentia oppositorum* to understand that Valéry's and Le Corbusier's chief concern was with a total work of art that activates all the senses. Le Corbusier had originally wanted to set up loudspeakers on the hill at Ronchamp so as to flood the chapel with music, an idea that must have seemed extraordinary at the time but has since

lost much of its appeal owing to the omnipresence of canned music in supermarket parking areas, underground garages and so forth. In addition, he collaborated with the composer Iannis Xenakis on the convent of La Tourette, spacing the windows in terms of musical harmonies, the intervals between musical notes translated into centimetres. Finally, he had Edgar Varèse's *Poème eléctronique* playing in the Philips Pavilion he and Xenakis designed for the 1958 International Exhibition in Brussels. In fact, the idea of combining music, lighting effects and architecture to form a total work of art runs like a leitmotiv through Le Corbusier's work. One source of this idea was *Eupalinos*. There, Socrates and Phaedrus distinguish between buildings that are 'mute', that 'speak' and that 'sing' (the highest accolade). The latter convey the 'emotion ... of an inexhaustible accord' through the 'parallel of visible forms with the ephemeral combinations of successive sounds.'[27]

Behind the flowery language, which seeks to imitate the diction of the classic Platonic dialogue, lies the assumption that emotions can be called forth in both music and architecture by the precise calculation of intervals and proportions. In 1891, in the short 'Paradoxe sur l'architecte', Valéry had already longed to see centuries of academicism followed by a 'rebirth of architecture' in association with the 'great symphonists' Wagner and Beethoven. He returned to this idea in a later text – carefully annotated by Le Corbusier[28] – in which he wrote that music was above all the construction of 'effects and emotions' by means of exactly measured intervals between notes.

From Edgar Allen Poe, whom he studied closely, Valéry adopted the idea that poetry is above all the construction of unusual, sudden and overwhelming effects aimed at generating emotional responses, without readers (or listeners) knowing what has happened to them and why. The notion that feelings might be aroused by mathematically calculated proportions could not but interest Le Corbusier. He, too, read the works of Poe, along with T. S. Eliot's *From Poe to Valéry*.[29] Both Valéry and Le Corbusier attempted to analyse mathematical constructions and their emotional effects, and it is scarcely surprising that Valéry (as reported

by his son François) admired Wagner as a strategist 'supremely conscious of his designs, deliberate in his attacks on the sensibility of his public', but found Bach's music numbingly boring because, he said, it 'might as well go on forever'.[30]

As presented by the architect Eupalinos, Valéry's theory of architecture is in several respects 'anti-Platonic'. The design process begins not with numerical relations of everlasting validity, but with personal experience, with the memory of a very special body and the sensory perception of an exceptional form. To design, then, did not mean to produce a physical manifestation of an idea, a self-contained, ahistorical and supra-individual image of pre-existing notions. Phaedrus explains that the Platonic idea is too simple and too pure 'to explain the diversities of Beauties [and] the completely new creations.'[31] The object is defined solely by its effect on the beholder: it is beautiful when it arouses a 'kind of bliss' in a particular situation.[32] That alone establishes a view counter to Platonic essentialism and to the notion of ahistorically valid categories, which defines 'beauty' as something that resides outside experience in the 'substantiality of the true and the good'.[33]

Again taking his cue from Poe, Valéry develops an aesthetics that sees art as an 'attack' on the viewer or listener. However, this attack is less violent than it may seem. Audiences are not to be forced by cascades of minor mode tones into a mood desired by the artist; rather, their minds and sensibilities are to be prompted into inventing forms of their own. For Valéry, the work of art is a 'machine to impress the public; to arouse emotions and their corresponding images'.[34] This definition of the work of art as an activating 'machine' throws new light on Le Corbusier's frequently misunderstood notion of the modern house as a 'machine for living in'. In terms of Valéry's theory, this house would be an apparatus with fluid open spaces stimulating the occupants to discover forms of daily life different from those of convention. The house is thus a 'poetic object' in the sense that it generates new forms of life and adopts for its user the role that the 'objet à réaction poétique' had possessed for its architect at the outset of the design process.

Both become aware, in Blumenberg's words, of their 'lack of limitation by the world of facts, [their] freedom vis-à-vis the given'.[35] This theory of invention explains Valéry's interest in the 'objet ambigu', which has a curious parallel – or perhaps an imitation – in Le Corbusier's 'objet à réaction poétique'. Its intermediary, metamorphotic form, 'in the process of emerging from the border between being and non-being',[36] points up the imminent possibility of disovering a new, previously inconceivable form.

Correspondence between Valéry and Le Corbusier

Le Corbusier and Valéry may have been personally acquainted. Valéry wrote to Le Corbusier to acknowledge receipt of a copy of *Vers une Architecture* that its author had sent him (ill. opposite page):

'Monsieur,

I have often dreamt of a house in which the structure and all the qualities are those of a modern machine. Clarity, adaptability, purity of form, purity even of materials, clear and visible functions ... I find all my wishes, precisely and exactly defined, in the book you were kind enough to send me. You cannot imagine the interest with which I read it. I would have added only some pictures or diagrams – and they would have been views or plans of ships' hulls. The hulls of some great yachts are the most beautiful things produced since Antiquity. Alas, I am neither an architect, to create buildings, nor rich enough to commission them and console myself for these incurable incapacities with your book! I envy you and thank you for your package, which has moved me greatly.'[37]

The tone of this letter suggests that they had met only briefly, if at all. They could have done so in the studio of Auguste Perret. Valéry and Perret had been responsible for the October 1923 issue of the periodical *L'Architecture vivante* and some architectural historians believe that conversations with Perret influenced *Eupalinos*.[38] The reverse is more likely, that Valéry's theories influenced Perret's few remarks on architecture. For scholars have shown that Valéry produced *Eupalinos* by selecting passages from his diaries with the

Letter from Paul Valéry to Le Corbusier

help of the poet Catherine Pozzi[39] and then combining them with ideas taken from his essay 'Paradoxe sur l'architecte', which had appeared in 1891, when Perret was seventeen years old (and Le Corbusier four).

Le Corbusier obviously viewed Valéry as an authority. He even mentioned the writer's letter in an interview, embellishing the praise a little: 'One day Valéry himself wrote to me and said that one of [my] books was magnificent, adding: "That is a word that rarely escapes my pen".'[40] The fact that the influence of Valéry's thinking on Le Corbusier has not previously been examined is all the more surprising in that the architect enthused about *Eupalinos* in his *Almanach d'architecture moderne* of 1926: 'In a book with the title *Eupalinos, or The Architect Paul Valéry*, as a poet, succeeded in saying things about architecture that a professional would never be able to formulate, because [the professional's] lyre is not attuned to that tone: he has felt and expressed admirably many profound and rare things that an architect senses when he creates.'[41] The resemblances between the passage in *Eupalinos* and Le Corbusier's story of what happened on the beach at Long Island, and between Valéry's 'objet ambigu' and Le Corbusier's 'objets à réaction poétique' are clearly more than coincidental.

Annotations: the architect inscribes himself in his reading

Le Corbusier marked one passage in his copy of *Eupalinos* in the margin. In it Phaedrus describes a curved line in response to a request by Socrates that he draw something on a wall with an invisible hand, since, in the realm of the dead, they are no longer physical beings. In his *Almanach* Le Corbusier reports Phaedrus' opinion that he had traced the 'image of a caprice without a goal, without beginning or end, with no significance outside the freedom of my gesture'. The architect continues: 'Valéry is pursuing a rather disconcerting thought... One realises with astonishment that this is intended to be a person's spontaneous gesture... If I had been asked... I should probably have drawn a cross of four right-angles.'[42]

The architect also marked a page dealing with straight lines and geometry, which Valéry's Socrates praises as 'divine'. Here he wrote 'talks about geometry' in the margin. Against the key passage in which Socrates finds the object he inscribed the words 'I have found one of these things'.[43] Le Corbusier was already familiar with Valéry's story about the 'objet ambigu' and its genesis of a whole theory of architecture and design when he began collecting objects on the seashore. Shells and other beach finds do not appear in his work before he read *Eupalinos*, but not long afterwards he included them in the Pavillon de l'esprit nouveau. Could Le Corbusier have based his life as an architect on a literary model, living out Valéry's tale of the ideal architect Eupalinos? Much speaks in favour of the idea.

Building in the spirit of Valéry

Le Corbusier's thinking cannot be understood without knowing just how he read books, how he took over ideas from them and developed them. *Eupalinos* was not the only work by Valéry that he consulted. In fact, he turned to Valéry whenever he was engaged

confond peu à peu à nos fonctions et à nos puissances natives, cesse de nous être sensible en
cessant d'être *sans passé*. C'est pourquoi toute
reprise consciente d'une idée la renouvelle; modifie, enrichit, simplifie ou détruit ce qu'elle reprend;
et si même, dans ce retour, on ne trouve rien à
changer dans ce que l'on avait une fois pensé,
ce jugement qui approuve et conserve une certaine chose acquise, forme avec elle un fait qui ne
s'était pas encore produit, un événement inédit.

☆

Voici donc que je m'amusai de nouveau de
syllabes et d'images, de similitudes et de contrastes. Les formes et les mots qui conviennent
à la poésie redevenaient sensibles et fréquents
dans mon esprit, et je m'oubliais, par-ci par-là,
à attendre de lui de ces groupements remarquables de termes qui nous offrent tout à coup
un heureux composé, se réalisant de soi-même
dans le courant impur des choses mentales. Comme
une combinaison définie se précipite d'un mélange,
ainsi quelque *figure* intéressante se divise du
désordre, ou du flottant, ou du commun de notre
barbotage intérieur.

C'est un son pur qui sonne au milieu des bruits.
C'est un fragment parfaitement exécuté d'un
édifice inexistant. C'est un soupçon de diamant
qui perce une masse de « terre bleue » : instant
infiniment plus précieux que tout autre, et que
les circonstances qui l'engendrent ! Il excite un
contentement incomparable et une tentation immédiate; il fait espérer que l'on trouvera *dans son
voisinage* tout un trésor dont il est le signe et la
preuve; et cet espoir engage parfois son homme
dans un travail qui peut être sans bornes.

8

Le Corbusier's annotated copy of Paul Valéry's
'Mémoires d'un poème'

Mais tout système est une entreprise de l'esprit contre lui-même. Une œuvre exprime non *l'être* d'un auteur, mais sa *volonté de paraître*, qui choisit, ordonne, accorde, masque, exagère. C'est-à-dire qu'une intention particulière traite et travaille l'ensemble des accidents, des jeux du hasard mental, des produits d'attention et de durée consciente, qui composent l'activité réelle de la pensée; mais celle-ci ne veut pas paraître ce qu'elle est : elle veut que ce désordre d'incidents et d'actes virtuels ne compte pas, que ses contradictions, ses méprises, ses différences de lucidité et de sentiments soient résorbées. Il en résulte que la restitution d'un être pensant uniquement fondée sur l'examen des textes conduit à l'invention de monstres, d'autant plus incapables de vie que l'étude a été plus soigneusement et rigoureusement élaborée, qu'il a fallu opérer des conciliations d'opinions qui ne se sont jamais produites dans l'esprit de l'auteur, expliquer des obscurités qu'il supportait en lui, interpréter des termes dont les résonances étaient des singularités de cet esprit, impénétrables à lui-même. En somme, le système d'un Descartes n'est Descartes même que comme manifestation de son ambition essentielle et de son mode de la satisfaire. Mais en soi, il est une représentation du monde et de la connaissance qui ne pouvait absolument que vieillir comme vieillit une carte géographique. Au contraire, ni la passion de comprendre et de se soumettre par une voie toute nouvelle les mystères de la nature, ni l'étrange combinaison de l'orgueil intellectuel le plus décisionnaire et le plus convaincu de son autonomie avec les sentiments de

Le Corbusier's annotated copy of Paul Valéry's *Variété V*

in writing major texts. He read *Eupalinos* while working on *Vers une Architecture*, in which the chapter 'Architecture, pure création de l'esprit', in particular, reveals the influence of Valéry. In the late 1940s, while developing his Modulor theory of design and writing *Le Poème de l'angle droit*, he consulted Valéry's 'Une Vue de Descartes' ('A View of Descartes'), 'Mémoires d'un poème' ('Memoirs of a Poem'), *Pieces sur l'art* (*Pieces on Art*) and 'L'Homme et la coquille' ('Man and the Seashell').

Le Corbusier did not read *Eupalinos* and other theoretical works by Valéry so closely, and comment on them in such detail, as a matter of course. On the contrary, he lost no opportunity of telling people that he read little and indeed sometimes stated with a frankness bordering on rudeness that he had no time to waste on mediocre books. When the well-known art historian Elie Faure sent him a copy of his *Jardin d'Eden* he wrote back: 'I have read parts of it. Reading is for me an insoluble problem. I do battle in a life in which the past clambers over me and the future claims all my energies ... My days are taken up with everyday cares, which weaken me and do everything to reduce me to the level of normality.' Then he comes straight to the point: perhaps Faure would have the goodness to look at his paintings.[44] *Pace* such claims Le Corbusier obviously read widely during his work on *Le Modulor* and *Le Poème de l'angle droit*. In Henri Focillon's *Vie des formes* (*The Life of Forms*), for example, he marked the following passage about the hand: 'The mind guides the hand, the hand the mind ... The hand wrests touch from its passive receptivity; it prepares touch for experience and activity.'[45] Alongside these sentences he appended a reference to a part of his *Poème de l'angle droit* in which he addresses the double role of the hand as an instrument of both touch and formal invention, feeling its way in the world of existing forms before producing its own.

Such annotations are sober in comparison with those that Le Corbusier made in Valéry's books, especially *Variétés V*. Against various passages in the 'Mémoires d'un poème' he wrote 'overwhelming!!' and 'magnificent!', while in 'Une Vue de Descartes' he jotted down whole trains of thought. In the margins he noted when and

where he read the book, as on a postcard, inscribing his copy with 'On the way to and from Vienna' (where he had visited a French architectural exhibition) and the date '8–13 May, 1948'[46] – that is, before he published *Le Modulor*. How important this volume was to him emerges from a letter he wrote to his friend and patron Jean-Jacques Duval the day after his return from Austria.

Duval, born in 1912, came from a family of industrialists in Alsace and studied architecture in Zurich before working for Le Corbusier in Paris in 1934. In 1945 he arranged for his former teacher to become coordinator of the rebuilding of Saint-Dié and in 1947 commissioned him to design the Claude et Duval factory there.[47] In his letter of 14 May, 1948 to Duval Le Corbusier thanks his pupil and benefactor and writes: 'I got back from Vienna this morning, after two nights and a day in the train ... Yesterday, from dawn until well into the night, I enjoyed each and every word of "Descartes" and "Mémoires d'un poème" in Valéry's *Variétés V*: so true, and so precisely observed ... My appearances in Vienna were (I know) very close in spirit to the two well-known texts I've just mentioned'.[48]

Le Corbusier did more than simply read these two major texts by Valéry and their discussion of how artists discover or invent forms: he developed his own theory of design in response to them and indeed saw his 'appearances' in Vienna as being in the spirit of Valéry. Termed by its author an 'essay on invention', 'Mémoires d'un poème' addresses the 'ability to make' with reference to poetry.[49] In his copy Le Corbusier marked a passage on the 'happy effect' that works of art can have on 'strangers' and also the statement that intellect and poetry should not be separated.[50] Alongside Valéry's remark that 'every conscious readoption of an idea turns it into a new idea' he noted 'épatant!' (stunning).[51] He marked with bold lines the phrase 'no work is more admirable than the drama of bringing forth a work'. And he commented 'bravo!' next to Valéry's claim that he took 'far greater pleasure in methods than in results, and ends do not justify means because there is no end.'[52] Le Corbusier comments enthusiastically on all such statements in Valéry indicating that everything is in flux, variable and

not subject to eternal laws. As a reader, he resembles an excited spectator at a sports match, except that he seeks to preserve his spontaneous shouts of approval for posterity, lacing them with large numbers of exclamation marks as in a comic.

Le Corbusier identified with Valéry. When the writer states that he has given up poetry but harbours it within as a secret and a nucleus, Le Corbusier underlined 'secret' and 'nucleus' and adds 'Magnificent!'[53] Valéry published his first poems around 1890, but then for over two decades devoted himself exclusively to essays and his notebooks before returning to verse in 1917 with *La Jeune Parque* (*The Young Fate*). In 'Mémoires' he describes his decision to take up poetry again as returning 'invincibly, but by … small degrees, to a state of mind one thought had vanished forever'. Next to this Le Corbusier notes 'At sixty'.[54] This must refer not to Valéry, who was only forty-six when he returned to poetry, but to Le Corbusier himself, who was sixty when he began work on *Le Poème de l'angle droit* in 1947.[55]

Texts as beaches

In 'Une Vue de Descartes' Valéry calls Descartes, along with Poe and Pascal, part of his 'mental alphabet', not least because the philosopher insisted on thinking from the point of view of the subject, as expounded in his *Discours de la méthode* (*Discourse on Method*). Once more, the issue here is what Blumenberg terms 'anti-Platonic irony' – doubts about pre-established harmonies and truths that exist outside the subject. Valéry stresses that *Discours de la méthode* owes its importance to its description of philosophy as a mental construct proceeding from the self and not as the perception of objective, supra-individual truths.

But how can Le Corbusier's enthusiasm for Valéry's idea that artists construct on the basis of their individual experience be reconciled with his enthusiasm for the theosophists Provensal and Schuré and their belief in pre-existing universal harmonies that can be 'tuned into'? In logical terms, not at all. Typically, Le Corbusier

did not concern himself with anomalies of this kind. His theories did not add up to a self-contained manifesto. Instead, they resembled a collection of intellectual flotsam and jetsam, with the most heterogeneous fragments weaving in and out of each other in wild confision. He read texts in a correspondingly idosyncratic and unsystematic way, treating books and the ideas they contained as a quarry for thoughts of his own. In his day, production techniques meant that book pages often had to be slit open individually before they could be read. Le Corbusier would cut pages somewhere in the middle and begin annotating. Slitting open a page of Valéry's *Pièces sur l'art*, for example, he marked the phrase 'miraculeuse unité'.[56] What the author meant by this, how he arrived at it or used it, seems not to have interested Le Corbusier. The words and phrases he marked sometimes appear like the things he collected on the beach – mysterious objects, glistening enticingly, that might form the starting point for ideas or forms of his own.

Le Corbusier's idea that a 'poetic effect', a strong physical sensation, could be produced by constructions involving forms and materials arranged in mathematically precise rhythms has much in common with Valéry's notion of 'poésie pure'. Such constructions, the architect wrote, result in an 'espace indicible' (ineffable space)[57] that does not disclose the secret – that is, the structural blueprint – of its beauty. He took over the rather unusual word 'indicible' from someone who misunderstood Valéry's work comprehensively: Abbé Brémond. Shortly after Valéry published his *Pièces sur l'art*, this cleric used it as the basis for a text entitled 'Poésie et prière' (Poetry and prayer). This addressed the 'indicible' and prompted lengthy debate. Walter Benjamin later wrote indignantly: 'This is the method that, applied to Valéry's poetry, led to the well-known notion of *poésie pure*, which was certainly not coined so that some aesthete of an Abbé could hawk it around France's literary journals for months until it confessed to being identical with the notion of prayer'.[58] Le Corbusier, however, thought nothing of cobbling together a theory of his own from Valéry's term and the Abbé Brémond's misinterpretation.

qui naissent de la vie sensorielle et affective
(comme les figures que forme le sable ému par
des chocs sur une membrane tendue) et qui
jouissent de la propriété de propager les états
et les émotions, mais non celle de communiquer
les idées, ne laisse pas d'être fort difficile.

Tandis que je m'abandonnais avec d'assez
grandes jouissances à des réflexions de cette
espèce, et que je trouvais dans la poésie un
sujet de questions infinies, la même conscience
de moi-même qui m'y engageait me représen-
tait qu'une spéculation sans quelque produc-
tion d'œuvres ou d'actes qui la puissent vérifier
est chose trop douce pour ne pas devenir, si
profonde ou si ardue qu'on la poursuive en soi,
une tentation prochaine de facilité sous des
apparences abstraites. Je m'apercevais que ce
qui désormais m'intéressait dans cet art était
la quantité d'esprit qu'il me semblait pouvoir
développer, et qu'il excitait d'autant plus qu'on
se faisait de lui une idée plus approfondie. Je
ne voyais pas moins nettement que toute cette
dépense d'analyse ne pouvait prendre un sens
et une valeur que moyennant une pratique et une
production qui s'y rapportât. Mais les difficultés
d'exécution croissaient avec la précision et la
diversité des exigences que j'aimais de me figurer,
cependant que le succès de l'effort à accomplir
demeurerait nécessairement arbitraire.

Davantage, j'avais pris trop de goût à des
recherches beaucoup plus générales. La poésie
m'avait captivé; ou du moins, certaines œuvres
de poésie. Son objet me paraissait être de pro-
duire *l'enchantement*. Au plus loin de ce que fait
et veut la prose, je plaçais cette sensation de
ravissement sans référence... C'était l'éloigne-
ment de l'homme qui me ravissait. Je ne savais

Le Corbusier, annotations of Paul Valéry's

'Mémoires d'un poème'

Annotation, association, transformation:
the thought processes of an architect

Over the years Le Corbusier annotated books more and more extensively. Publications he read in the 1920s are marked faintly here and there, but by the mid-1940s he was cramming entire texts of his own between and around the lines of the books he read. Certain terms or phrases would trigger thoughts of his own. A passage in the *Variétés* in which Valéry writes that poetry, in contrast to prose, fascinates him because of its 'distance from people' makes this clear. Valéry emphasises that language in poetry need not serve a descriptive purpose but can be effective purely as material. Le Corbusier unterlined the word 'distance' and noted in the margin: 'The ditch that needs to be dug in front of an avenue so as to create distance (to keep away the rabble)'.[59] Valéry's mental distance thus becomes the physical gap of a ditch. In this way Le Corbusier frequently transformed abstract notions into concrete spaces as he read.

Elsewhere his marginal jottings mix associations with things seen or read (ill. p. 132). In Valéry's Descartes essay he noted: '9 May, 1948. The train passes through Ulm ... The cathedral'. He had clearly seen the minster in Ulm. He added: 'Terrible development = mindless repetition = crap. An artist who rebels does not do Ulm, but Nôtre Dame in Paris, because "constant repetition" of the square (all'antica) leads to the expansion of plastic effect. Ulm (triangle) is sterile (Perret's church at Raincy) ... Not everything should be derivative[,] things must be invented'.[60] This annotation is characteristic of Le Corbusier's way of thinking. He sees the front of the minster, dislikes its 'compositional development' and compares it to Nôtre Dame, the front of which is based not on a triangle, like Ulm's, but on a succession of squares.[61] Then Auguste Perret's modern church at Raincy occurs to him as an example of poor, 'derivative' form. The remark about derivation versus invention paraphrases Valéry's text, which explains how thinking and making should mean not copying existing entities, but recombining a repertory of forms in order to discover new forms. Valéry

describes how in the invention process the slow, reflective work of the intellect encroaches on the spontaneous forms of sensory and affective life like grains of sand regrouping on a stretched membrane when the membrane is tapped. Once more, Le Corbusier noted 'épatant!' (stunning) in the margin (ill. p. 137).[62] Valéry outlines two kinds of formal invention, the sudden and the gradual, as represented respectively by the lightning construct hit on by a mathematical mind and the protracted growth of a shell. A writer will suddenly discover a happy link in the uneven mental chain, a chance find that contrasts with the slow work of considered thought.[63] Le Corbusier wrote another 'bravo!' in the margin and adopted the notion of two invention tempos in 1955 when referring to design as a 'spontaneous birth', a flash of inspiration generating a basic formal idea, which is followed by the gradual growth, the 'sprouting, maturing and fermenting' of the idea in its execution.[64]

How do forms arise?
Valéry's 'L'Homme et la coquille'

Le Corbusier read Valéry's 'L'Homme et la coquille' long before he told the story about finding a crab's shell on Long Island. The essay, published with sixteen illustrations of shells by Henri Mondor in the *Nouvelle Revue française* in 1937, again begins by describing a beach find and again addresses the genesis of form. Valéry's interest is aroused first by the paradoxical identity of shell and living creature. Molluscs give birth to their own enclosure by secreting calcium that hardens into a metastable shell. The shell as a kind of secreted self fired the writer's imagination: it differed completely from materials that originated elsewhere – clay or wood, for example – and could be worked so as to imitate the shape of the shell, but not its consistency.

Here Valéry is clearly fascinated once more by a philosophical dimension that subverts traditional ontological classification, for it cannot be established where the mollusc ends and its shell begins:

Le Corbusier, annotations of Valéry's
'L'Homme et la cocquille'

to separate them would be to destroy them both. 'A seashell emanates from a mollusc',[65] writes Valéry and since 'we ... are unable to visualize a movement so slow that a perceptible result springs from an imperceptible change', all categories that the human mind conceives of as separate – 'the *energy*, the *time*, the *material*, the *connections*, and the different "orders of magnitude" between which our senses compel us to distinguish' – collapse in the face of the 'growth of the mollusc and its shell', which are locked into an inseparable unity.[66] The mollusc, he states, is 'perfect' in its identity of body and form, and it resists all categorisation.

What can be learned from such an object? Valéry approached the shell in two ways, the mathematical and the tactile. Like Le Corbusier, whose interest was aroused initially by its construction, its 'astonishing helix sculpture',[67] Valéry declared: 'The shell which I hold and turn between my fingers ... offers me a combined development of the simple themes of the helix and the spiral'. Mathematicians would 'sum up' its basic construction 'in a few signs, a numerical relation', but they too would be at a loss when 'the tube suddenly broadens, breaks, curls back, and overflows into uneven lips, often bordered, waved, or fluted', when 'the surface is incrusted with knobs or spines ... or ... swell[s],'[68] This mixture of ascertainable construction and inexplicable excrescences intrigued Valéry: 'nothing could be more deliberately planned, or speak more harmoniously to our feelings for plastic shapes, to the instinct that makes us model with our fingers something we should delight to touch, than this calcareous jewel I am caressing.'[69] In his *Poème de l'angle droit* Le Corbusier takes over this notion of tactile exploration almost verbatim when describing how the hand 'caresses' and 'kneads' a shell as though wishing to recreate it.[70] And the method of enlarging a beach find to the size of a building, as expounded by Le Corbusier in connection with the crab's shell, is also adumbrated in 'L'Homme et la coquille': 'I can conceive of no form', Valéry writes, 'that might not be larger or smaller.'[71]

It would be possible to imitate the form of a shell, Valéry writes. Comprehension of its mathematical structure might lead to the making – in clay, say – of something that looked exactly like it.

Even the inexplicable textures and markings could be reproduced. However, this reproduction would necessarily leave out of account one major aspect: time. For the shape of the shell is inseparable from the life of the mollusc: rather than being created at a stroke, it grows over a period so long that its increase in size is imperceptible. While humans must destroy material in order to produce new forms, the mollusc generates form and material simultaneously. The shell results neither from a plan nor from chance: it is the result of life itself. Perhaps, says Valéry, perfection in a work of art is 'only a sense of desiring or finding in a human work the sureness of execution, the inner necessity, the indissoluble bond between form and material that are revealed to us by the humblest of shells',[72] for the 'making of the shell is lived, not calculated.'[73]

What would be the nearest equivalent in architecture to the infinitely slow, living quality of the mollusc's shell? First of all, the fate of furnishings and fittings. Unused items are set aside and start to form a kind of domestic undergrowth in forgotten corners. Amid heaps of old bits of paper and other bric-a-brac, the undergrowth increases in density until it becomes hard to remove and almost assumes the character of a wall. The walls themselves soon become overgrown with a thick layer of kitchen utensils, clothes, books and pictures. In this way, the sediment of life forms a barely escapable shell.

Comparable 'precipitation' processes can be observed on an urban scale at crossroads in Africa where traffic jams occur frequently. Traders come and sell their wares to drivers stuck in the jams. One of them will put up tarpaulins to protect his stand. Then crates begin to pile up and shacks are erected, until eventually architecture arises that no one had planned. Or take the mud huts and shelters built into the earth in Africa and India as sun shields. Over time these 'deposits' of human life develop into villages and micro-urban systems. If the overall shape of these often randomly proliferating settlements is sometimes astonishingly geometrical, then that results from certain natural givens. A desert wind blowing constantly from the west, for instance, or the position of the sun will determine the form of each and every house.

On his travels Le Corbusier repeatedly photographed settlements of this kind – what post-modernism calls 'vernacular' architecture. They represented the antithesis of urban environments designed swiftly at the drawing board and erected equally swiftly in concrete. At Ronchamp he juxtaposed thetically both types of building, both rates of formal genesis: the gradual type, growing infinitely slowly, and the planned, geometrical type. The chapel's ground plan resembles a mollusc-style organic shape: with its curving, flowing lines, unconstrained by geometry, it appears to have been secreted by the hill, as though mud had streamed out of crevices on the slopes and solidified. On the outside Le Corbusier stages the contrast between 'calculated' form and the 'kneaded', organic variety by positioning a fountain with stereometric masses like some bulwark of mathematical order in front of the amorphously billowing west wall.

Disagreement: Valéry contra Le Corbusier

In the 1920s Le Corbusier confessed in journal articles to the deep impression *Eupalinos* had made on him. If he was so strongly influenced by Valéry's theories, why did he mention the writer less frequently later on? Le Corbusier's notes indicate that relations between the two men had become strained. In a letter of 1949 to the architect, Jean-Jacques Duval remarked wistfully that if Valéry were still alive he could be asked to say 'something good about the apartment building in Marseilles'. In the margin Le Corbusier wrote bitterly: 'Pavillon de l'Esprit nouveau / Plan Voisin / Valéry understood and saw nothing of them'.

What had happened? In 'Pensée at art française' (1939) Valéry reported that he had met a modern architect who 'wanted to convince me of the superior beauty of thoroughly modern edifices, built with thousands of feet of wonderful cement'. He had then explained to this architect 'that such masses certainly astonish the eye and present it with a striking image of geometric cliffs exposed to all the variations of daylight, and that I admire these super-

human constructions ... but will never love them ... I could not imagine anyone viewing them with growing affection, stopping and taking out their sketchbook to draw a detail, a particular solution to a problem ... that would prompt them ... to invent something of their own and give the impression of having made a discovery.'[74] This passage is doubly interesting. Firstly, it reiterates Valéry's expectation of a building that it should stimulate invention in the user, like an 'objet ambigu'. Secondly, if Le Corbusier is the promoter of tall buildings mentioned in the text, it explains the architect's bitterness. Some things tell in favour of this identification, not least the close echo of Le Corbusier's well-known definition of architecture as the play of masses in sunlight. The text will have hurt him all the more in that Valéry ends up praising the classic Parisian wrought-iron balcony as a 'charming formal invention' at the expense of the purist avant-garde. Nevertheless, Le Corbusier continued to read and annotate Valéry's writings.

6.

FROM PALISSY TO RONCHAMP:

The Prehistory of the Architect on the Beach and the Invention of a New Notion of Space

The renegade's seashell:
Bernard Palissy's spiral town

'I shall throw away this thing that I have found', Valéry wrote at the end of 'L'Homme et la coquille', 'as one throws away a cigarette stub. This seashell has *served* me, suggesting by turns what I am, what I know, and what I do not know.'[1] Seashells as promoters of knowledge, as generators of thought processes, ideas and forms, had a long history. Le Corbusier was aware of this and saw himself as continuing the tradition. Before planning the chapel at Ronchamp, for example, he closely studied the work of grotto designers, including one of the most famous, the sixteenth-century artist, engineer, potter and alchemist Bernard Palissy.[2] Investigating the possibilities of translating natural forms into built structures, Palissy had pursued an ambitious idea that could not but interest Le Corbusier: a town designed in the shape of a snail's shell.

The story of Palissy's life reads like an adventure tale.[3] Born in 1510 in the village of Lacapelle-Biron in Aquitania, he trained as a painter of glass and spent much of his time in an alchemical laboratory attempting to produce an enamel paint as white as the inside of a seashell. Devising new glazes with almost obsessive regularity, Palissy soon acquired a reputation for his vessels and sculptures. His skill as a creator of *trompe l'œil* effects was such that people were often reluctant to touch the lifelike snakes and crabs that graced his decorative plates. Although highly regarded as an artist, Palissy repeatedly ran into trouble as a result of his religious convictions. Accused of co-founding his local Protestant congregation, he was thrown into prison in Bordeaux in 1562 and was released only at the intervention of the duke of Montmorency.

Le Corbusier's copy of Marcel Gastineau's book
on Bernard Palissy (1942)

In Paris, Palissy built an artificial grotto for Catherine de Médicis in the Tuileries gardens. His technical skill as a creator of illusions on any scale, from dishes to grottoes, was exceeded only by the steadfastness of his beliefs. After surviving the massacre of St Bartholomew's Day, he returned to Paris in 1575, engaged in research and took part in scientific debates, but went into hiding in 1585, when the edict of Nemours withdrew concessions to Huguenots and banned Protestantism. The Catholic League soon disovered his whereabouts and he was imprisoned in the Bastille where he remained until his death, in 1589, refusing to convert to Catholicism. In confessional terms, then, Palissy was a rather odd source of inspiration for the design of a Catholic chapel. Yet this seems only to have encouraged Le Corbusier in his fascination with the main issues addressed by Palissy: illusionistic spaces and whether, or how, architectural invention could take its cue from natural forms.

It may not be entirely accidental that Palissy studied shells intensively. In 1563, the year after his release from prison in Bordeaux, he published a guide to increasing and maintaining personal wealth with the long-winded title *Recette veritable par laquelle tous les hommes de la France pourront apprendre à multiplier et augmenter leur thrésors*.[4] In one part of this he writes about the role shells could play in the design of towns. Here, he discloses a profound dissatisfaction with the status quo, a penchant for the visionary, an obsession with creating wholly new forms rather than simply improving details and a belief that recasting natural shapes in geometrical terms could lead to ideal architectural forms. All these aspects make the text appear like a draft of the treatises that Le Corbusier would write on the same subject almost four hundred years later.

The section of the *Recette* headed 'De la ville de Forteresse' (On the town of Forteresse) describes a crisis in his activities. Attempting to confront the 'terrible dangers of war', he had sought 'to design ... a town in which one would be safe in times of war'. Yet the devastating effect of modern artillery had made the task appear 'almost hopeless'. He had brooded over it for days, constantly walking about with his 'head bowed, for fear of seeing something that would make me forget the things I wanted to think about'.[5] Palissy reports on his desperate search for a suitable shape for the town and, in doing so, almost incidentally develops a theory of design notably different from those formulated by his contemporaries. In contrast to the Cartesian system, according to which the architect casts ideal geometrical forms 'à sa fantaisie' onto an empty surface,[6] Palissy states that formal invention can occur only through a combinatory engagement with things seen. So he considers all the towns he has seen and tries to combine their merits. The result fails to convince him. Neither does he find anything of use in the architectural theories of Vitruvius and of his own influential contemporary, and fellow Huguenot, Jacques Androuet du Cerceau.

Palissy relates vividly what followed this disappointment at the hands of knowledge and theory. He describes the path of invention

as a walk out of town into gardens and free nature. 'Head bowed [and] without greeting or looking at anybody', the inventor enters the 'labyrinth' of 'the most excellent gardens' on the lookout for something that would 'satisfy his mind' and help him to solve the problem. But the trimmed hedges, the natural world of French gardens as geometrised in accordance with the precepts of classical architecture – in short, aesthetic rules – do not get him anywhere. He then visits the seaside in search of *natura naturans* (nature that creates nature). Walking along the shore and among its rocks during his leisure hours, he discovers shells and snails, defenceless molluscs to whom 'God has given such skill that each of them knows how to make a house, constructed and ordered with a geometry and an architecture that Salomon in all his wisdom would not have known how to make anything comparable.'[7] Clambering around the rocks, he finally lights on a seashell and realises that it possesses the ideal form for a fortress town: 'You must understand that there are several fish with snouts so pointed that they would eat most sea snails if their houses were straight. But when their enemies attack them at the entrance they retreat inside, retreat into their armour and follow the line of the spiral – and in this way their enemies cannot harm them.'[8]

Palissy goes on to describe how, prompted by his find, he took a large purple-dye shellfish from Guinea or Guyana as the model for an urban design that in essence corresponded to an enlarged mollusc. His proposal consisted of a single street winding in a spiral (ill. p. 149). The inhabitants were to live in the walls lining it, which thus amounted to probably the longest line of terraced houses ever seriously envisaged. The street issued from a square at the centre of the spiral, winding round this core four times in all, at first in the shape of a square, then in that of an octagon. Palissy did not accompany his description with an explanatory diagram, arguing that he had explained the advantages of his idea sufficiently and it was therefore only just that those who wished to put it into practice should pay for the privilege.[9]

There is reason to believe that Palissy's narrative invoking the beach as a store of invention-generating shapes, like Le Corbusier's

Ground plan of Bernard Palissy's ideal fortress town

much later, forms part of an intellectual discourse and does not describe an actual occurrence. Frank Lestringant, editor of the critical edition of the *Recette*, comes to the conclusion that Palissy owed much to Androuet de Cerceau's utopian designs of 1545, which included a town in the shape of a snail's shell, even though Palissy denies this influence and relegates his rival to the ranks of those who could not help him.[10] Be that as it may, Palissy presents invention as a process in which humans analyse God's work as the greatest *mechanopoios* (machine-maker) and try to create something on the same level. The source of all innovation lies in the forms placed in the world by the highest of architects. And for Palissy, too, geometry is the key to 'translating' and adapting these natural shapes. Little more remains of the mollusc in his ideal fortress town than the basic spiral shape, with Palissy justifying the straightening of even the smallest bend by pointing out that it is more difficult to shoot at intruders in a curved street.[11]

Palissy's fortress town, like Le Corbusier's 'Musée à croissance illimitée', leaves out of account the material qualities and the surface of the mollusc. Yet Palissy had his own Ronchamp, a project in which the tactile properties of natural forms, the strange surfaces of shells and stones, come into focus. As the 'most important grotto artist' of his time,[12] he countered the geometrised nature of

his fortress design with a type of structure that evinced the maximum degree of naturisation: the grotto, the supreme architectural bluff, looks like a work of nature and even seeks to excel nature in eccentricity and bizarreness. Everything Palissy left out of his fortress town appears in the 'unnatural nature' of his artificial grottoes, which resemble human-sized snail's shells. In *Poétique de l'espace (The Poetics of Space)* Gaston Bachelard writes of them that they were inspired by the contrast between the rough exterior of shells and the smooth interior, between the dark, labyrinthine twists of their spiral shape and its sudden opening out into light. Palissy's 'spiraled house', he states, was 'a cave in the form of a coiled shell'.[13]

The enlargement theory: shelter in a monstrosity

Taking his cue from Palissy's phenomenological description of the mollusc, Bachelard develops a zoom theory strikingly similar to Le Corbusier's idea of emlarging a crab's shell to the size of a roof. 'Nature', writes Bachelard with reference to a discussion of giant shells by the geologist Armand Landrin, who had a particular interest in ethnology, 'has a very simple way of amazing us. In the case of the shell commonly known as the *Grand Bénitier* (Great Baptismal Font), we see nature dreaming an immense dream, a veritable delirium of protection, that ends in a monstrosity of protection. This mollusc "only weights 14 pounds, but the weight of each of its valves is between 500 and 600 pounds."'[14] In a comparable way Palissy enlarges the mollusc *ad libitum*. With him, it forms a model for macro and microcosmic living, defining both towns and the intimate domestic cell of the grotto. He was anxious to banish all traces of artificial origins from his works: the *trompe l'œil* of his parallel nature – his 'bluff' – must be perfect. The small 'chambers' in his grottoes hide among artificial rocks, which should be 'of masonry made with large uncut stones, in order that the outside should not seem to have been man-built.' In contrast to the rough rock of the exterior, the inside of a grotto should be covered with

several layers of enamel, so that it would 'seem to be made of one piece'.[15] A 'synthesis of house, shell and cave', the ultimate grotto envisaged by Palissy was to surpass nature with the phantasm of a shell habitable by people, its perfection residing in the unity of occupier and enclosure. 'By means of a great sum of human labour', writes Bachelard, the 'cunning architect succeeded in making a *natural* dwelling of it', a choreography of spaces and surfaces that enhances the effectiveness of natural forms. Yet it will convince as parallel nature only if it evinces a certain amount of obvious irregularity. In Palissy's words, quoted by Bachelard, the grotto must be 'twisted and humped with several skewed humps and concavities having neither appearance nor form of either the chiseler's art or of work done by human hands; and the ceiling vaults [must] be so tortuous that they ... look as though they are about to fall, for the reason that there [are] several pendant humps.'[16]

At this point at the latest, with Palissy's mention of 'dangling humps' inside the grotto, a comparison with Ronchamp suggests itself. Both structures, the Renaissance grotto and the modern pilgrimage church, employ complex technical means to generate an impression of naturalness and organic growth. And both do more than reproduce the shape of a seashell: they develop new forms from an analysis of the seashell's underlying structure, its spiral shape, the smoothness of its interior, the rough, labyrinthine textures of its exterior and the grotto-like shelter provided by its twists. Palissy's idea of design prompted by natural forms likewise transcends pure imitation (which Palissy certainly commanded, as evidenced by the strikingly real-looking animals and shells in his ceramics) to encompass *inventio* in the literal sense of 'coming upon' possibilities contained in nature but not yet exploited by anyone. For Palissy, the seashell performed the same double function as it did later in Le Corbusier's design philosophy. On the one hand, he used it as a mathematical model for innovative architecture; on the other, he 'restaged' its evocative shape and surface, and its protective qualities, in his grottoes. For him, 'invention' signified nature doubly idealised (or 'translated'), not a mental

construct founded solely in numerical ratios and systems of harmony. Le Corbusier may thus be numbered among the adherents of the theory of invention developed by Palissy.

In Horst Bredekamp's view the grotto chamber was 'a kind of outpost of what cabinets of curiosities represented on a larger scale in palace interiors'.[17] Yet grottoes can also be understood as an enlargement of things seen in cabinets of curiosities. Outside the civilised zones of architecture, in gardens, they represented a phantasmagorical parallel nature in which shells could expand onto a human scale. In this sense, the grotto was not only an 'outpost', but also an experimental experiential space that exploited the microcosmic potential of the cabinets' contents to create an independent world.

Whenever habitable shells appear in the history of architects and architecture the sense of touch plays an important part. Le Corbusier was no exception. And with reference to Palissy Bachelard writes: 'Here a man wants to live in a shell. He wants the walls that protect him to be as smoothly polished and as firm as if his sensitive flesh had to come in direct contact with them. The shell confers a daydream of purely physical intimacy. Bernard Palissy's daydream expresses the function of inhabiting in terms of touch.'[18] The identity of body and shell, which had fascinated Valéry in the mollusc, is here the focus of longing: the house becomes a 'second skin' and the limits of human identity are to some extent dissolved by the contact of flesh with wall.

In the passage just quoted Bachelard evokes the erotic charge customarily invested in shells (though nowhere near as obviously as Le Corbusier when he overlaps naked bodies with shells in *Le Poème de l'angle droit*). Countless examples of this exist throughout history. They range from Hieronymus Bosch's *Garden of Earthly Delights* (painted between 1490 and 1510 – the probable date of Palissy's birth), with its sexually engaged figures and shell-like formations, and the Baroque love poetry of a Johann von Besser ('Als zur Welt die Venus war gebracht / Sie dies, woraus sie kam, zum Frauen-Schooss gemacht')[19] to Ursula Andress's appearance as an aggressive Venus sporting only a bikini, knife and shell as she

emerges from the waves in the James Bond film *Dr. No*. Other modern instances occur in Ambrosi's futurist picture *Maternità aeronautica*, which shows aeroplanes diving into a shell-shaped lap and, not least, Henry Miller's *Tropic of Capricorn*. This features a body mutating into a house, then a grotto and, finally, a place in which the narrator can lose himself, a 'dark, subterranean labyrinth, fitted up with divans and cosy corners, rubber teeth and syringas and soft nestles.' This architectural image then shifts to a description of a fantastical natural world: 'I used to nose in like the solitary worm and bury myself in a little cranny where it was absolutely silent, and so soft and restful that I lay like a dolphin on the oyster-banks ... In the immense black grotto there was a silk-and-soap organ playing a predaceous black music.'[20] This dissolution of the boundaries between body, architecture and nature, propagated by Le Corbusier in *Le Poème de l'angle droit*, had an early forerunner in Palissy.

The threshhold as labyrinth

Gaston Bachelard describes how Palissy sought to fuse two natural dwellings into a fantastical new entity in the artificial chambers of his park grottoes. Palissy's 'fourth chamber is a synthesis of house, seashell and cave,' he writes. 'To accentuate the natural character of the chamber he had it covered with earth "so that, having planted several trees in the aforesaid earth, it would not seem to have been built". In other words, the real home of this man of the earth was subterranean. He wanted to live in the heart of a rock, or, shall we say, in the *shell of a rock*. The pendant humps fill this dwelling with a nightmare dread of being crushed, while the spiral that penetrates deep into the rock gives an impression of anguished depth ... In his daydreams Bernard Palissy was a hero of subterranean life. In his imagination he derived pleasure – so he said – from the fear manifested by a dog barking at the entrance of the cave; and the same thing was true of the hesitation, on the part of a visitor, to enter further into the tortuous labyrinth ... There's

no need of a gate, no need of an iron-trimmed door: people are afraid to come in.'[21]

This paradoxical motif of the threshhold as a kind of labyrinth erodes Western distinctions between public and private, inside and outside. Typically, European architecture has marked the divide between the public and private realms by means of a door in a wall: moving from one to the other requires opening a barrier and crossing the border it demarcates. In comparison the labyrinth is a 'soft' boundary. It has no doors. It obstructs in more subtle ways. The phenomenon of 'barrier-free barriers' is familar from shops in northern African. Wares are displayed on the street (which in the souks is often shielded from the sun by a roof and thus forms a kind of interior). Through a curtain one passes into the store, and from the store into more private areas, including, perhaps, a kitchen in which family members can sit together. The transition between public and private zones is gradual: often there is no door, just a jumble of shelves, curtains and various nooks and crannies. Nevertheless, no outsider would ever think of intruding on the private area.

While Le Corbusier was investigating shell-shaped spaces in the 1950s, a broad movement in French philosophy was addressing concepts and representations of space, along with their social and ideological implications. This ultimately led to Michel Foucault's critique of society, which included discussion of notions of space and spatially definable mechanisms of power. Previously, and even before Bachelard attacked the 'dialectics of inside and outside' in the final chapter of *Poétique de l'espace*, Jean Hyppolite had criticised the 'myth of outside and inside', stating that their formal opposition expressed 'alienation and enmity between the two'.[22] What could architects learn from this philosophical mistrust of clearly defined boundaries? Which forms could result from the idea of space that Bachelard derived from Palissy's labyrinthine spirals and be used to combat the hard, impervious walls, the unequivocal delineation of interior and exterior, that had dominated European building and urban design since Antiquity?

Detail of the east elevation of Ronchamp chapel,
showing the rectangular opening containing the statue
of the Virgin on a rotatable pedestal

A rotatable Virgin Mary

Here again Ronchamp provides an interesting answer. A close look
at the east front reveals that both the inside and the outside are
designed like an interior wall (ill. above). Both have an altar, a pul-
pit and all the niches, platforms and fittings required by the liturgy.
In this sense, there is no outside wall at all. In this wall with two
interior faces Le Corbusier installed a glass case containing the old
statue of the Madonna that forms the focus of the local cult of the
Virgin. Visible from both sides, the figure is mounted on a rotat-
able pedestal fitted with a crank. Once a year, on Assumption Day,
the crank is used to rotate the Madonna so that she gazes out into
the landscape, rather than facing into the interior of the chapel.
On this day the chapel's exterior is thus defined as an interior. The
faithful gather outside the church, not inside it; the 'interior' now
consists of the hill and the rest of the world.

This trick, easy to justify in liturgical terms, is but one example
of Le Corbusier's way of abolishing spatial hierarchies. The eleva-
tions of the Villa Savoye are another, earlier instance. Apparently
floating in the landscape on top of *pilotis*, the house is entered from
below, the visitor ascending into the living area as though climbing

to the top of a tree (ill. p. 13). In 1930 the architect described in *Précisions* how this arrangement invalidated 'all notions of "front" and "back".'[23] At Ronchamp he extended this erosion of customary distinctions to include a more open and interactive definition of inside and outside.

The shell as philosophical concept and epistemological model: Filippo Buonanni and his treatise *Ricreatione dell'occhio e della mente nell'Osservation delle Chioccole* of 1681

Bernard Palissy's treatment of the mollusc as a philosophical motif initiated a tradition that the Jesuit Filippo Buonanni sought to systematise about a century later. Little is known of Buonanni's life. Born in Rome in 1658, he was by all accounts a gifted draughtsman. He is remembered principally for his *Numismata Pontificum Romanorum* and *Gabinetto Armonico*, a collection of 150 etchings of musical instruments from around the world that appeared in 1723, the year of his death. In 1698 he was appointed administrator of Athanasius Kircher's cabinet of curiosities in the Collegio Romano and published a catalogue of the collection ten years later. Buonanni was self-taught. At the age of twenty-three he published his first major work featuring drawings. Entitled *Ricreatione dell'occhio e della mente nell'osservation delle chioccole* (Recreation of the Eye and Mind in Observing Snails), it provides one of the first systematic records of snails and molluscs (ill. p. 159). Despite many scientific errors – in the depiction of exotic snails, in particular, Buonanni gave free rein to his imagination, the results looking more like the grotesque faces on Gothic capitals than mussels – the work occupies a firm place in the history of scientific compendia and is still familiar in scientific circles. Buonanni's pioneering effort formed the basis of the names given to molluscs by Linné and later scientists.[24]

Buonanni's philosophical introduction to his compendium has been largely ignored by scholars working in the humanities. The

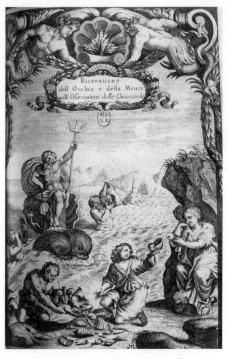

Frontispiece of Filippo Buonanni's
Ricreatione dell'occhio e della mente, Rome 1681

fact that the *Ricreatione* has been regarded exclusively as the province of historians of biology is all the more surprising in that the title of the work names its primary subject as the 'recreation of the eye and mind' and thus addresses a philosophical issue much debated in the seventeenth century. Without mentioning Buonanni, Alain Corbin describes in his study *Le Territoire du vide* (*The Lure of the Sea*) how the sea was discovered as a source of positive aesthetic experience at this time. In the late Middle Ages and in the Renaissance the seashore and the ocean had generally been viewed as repositories of antediluvian monstrosities; their vapours were considered a health hazard; and the sight of the vast, formless expanse of the sea aroused anxiety in thinkers. Gazing at the sea,

157

the narrator of Marc-Antoine de Saint-Amant's poem 'Le Contemplateur' is prompted above all to think of the 'sea of the apocalypse that "burns like spirits".'[25] However, around 1700 Corbin notes an increase in the pleasure taken in the sea.[26]

Buonanni was one of the first, and most thoughtful, advocates of the beach stroll as an aesthetic and a philosophical experience. He, too, embedded the seashore walk in a theological context. Shells found on the beach are 'of such variety, so beautiful, so graceful' that he sees in them 'true miracles of beauty', recognising in this supranatural beauty a manifestation of God in all his perfection.[27] Yet that represents almost the sum total of the theological remarks in his introduction. What follows is essentially a practical discussion of the requirements for a happy life. Buonanni emerges as an Epicurean thinker. Without an element of play, without diversions, he avers, a commendable life misses perfection: like 'music composed entirely of good notes... it will be lacking if deprived of the intervals necessary to perfect harmony'.[28]

Buonanni states that Cicero regularly escaped to the seaside to find himself again. Forsaking the battles raging in the Forum and the other tribulations of city life, he found peace by the sea, where he ceased to belong entirely to others and could be himself again.[29] Buonanni views the seaside strolls of Scipio and Laelius, both of whom took time off from the affairs of state to collect shells on the beach, in the same light.[30] The 'ricreatione' demanded by Buonanni likewise involves a break from cultural activity: the relaxation provided by reading is exceeded by that achieved through the contemplation of nature.[31] Especially in the 'miracles' of seashells, Buonanni continues, nature reveals 'a great architectural mind': for all their considerable efforts, geometricians always render the twists of the shell incorrectly, as circles.[32] Like Valéry much later, Buonanni admires the material (the 'dearest substance'), the shapes ('forms that are miracles of beauty')[33] and the colours[34] of shells. And in him, too, amazement generates endless trains of thought. Whereas Palissy had attempted to compete with these divine creations as a Promethean *alter deus in terris* (another god on earth), Buonanni the theologian accepts them as unsurpassable.[35]

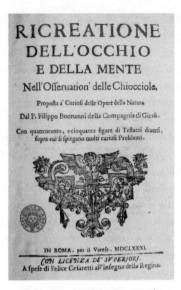

Title page of Filippo Buonanni's
Ricreatione dell'occhio e della mente, Rome 1681

He sees the seashell's spiral less as a model or a challenge to pro-
duce comparable forms than as a symbol of thought: since the
twisting form of the mollusc can activate thought with equal effort
and pleasure,[36] the beach find viewed contemplatively becomes a
divine sign for thinking itself. As a visual analogy, as a re-presen-
tation in space, it provides access to thought via the senses.[37]

Buonanni here presents thinking as a complex, interactive
process in which sensory perception and the physical apprehen-
sion of form play just as important a part as the transcendence of
these sensations in knowledge. Buonanni adduces Archimedes in
the bath to explain how sensory stimulation of thought works. The
odour of the bath oils, aimed at physical well-being, suddenly stim-
ulated Archimedes' mind as well: 'And so all in all, the recreation
of a wise man such as he, is to find enjoyment in bathing for, far
removed from any other sensual pleasure, he is free to lose himself
in geometrical considerations, awakened by the scent of oils and

ointments rubbed onto his skin by his servants.'[38] For Buonanni, indulgence of physical pleasure, the sensory experience of objects, is a prerequisite of the 'greatest joy' of all, 'to let oneself be carried by one's thoughts to wherever they are abducted by nature, which alone harbours every beauty that one could desire'.[39] The wise collect and contemplate seashells in order to become 'rich in beautiful thoughts'; the foolish display them in their hair.[40]

Buonanni's gatherer of shells combines in an unsual way pleasure with knowledge, experience of nature with cultural progress, flight from society with thirst for knowledge. The frontispiece of the *Ricreatione* shows this collector as slightly downcast, as someone who has obviously been forced to realise that no Vitruvius in the world would ever be capable of designing such a shell (ill. p. 157). Indeed, the people Buonanni mentions in his text seem beset by the kind of psychological instability associated with the melancholic. As noted above, Cicero, for example, retreats to the seaside in order to recover from the 'battles' and 'storms' of politics. Yet the recognition of Buonanni's shell seeker that nature cannot be imitated does not result in depression and apathy. Instead, it stimulates what Hartmut Böhme called the 'counter-pleasure of the mind'[41] and activates a lucid, Archimedian intelligence that will later be resurrected in aesthetically modified form in Valéry's shell contemplator.

When Buonanni posited an inextricable link between sensory and mental stimulation he anticipated the transition from 'sensation' to 'reflection' that formed part of the epistemological model presented by John Locke eight years after the *Ricreatione* in his well-known Essay *Concerning Human Understanding*. Locke's programmatic formula 'Nihil est in intellectu, quod non antea fuerit in sensu' (Nothing is in the understanding that was not earlier in the senses) helped to emphasise the significance of individual aesthetic experience over notions of inherently, ahistorically, valid ideas. In the twentieth century this dichotomy was to appear in philosophies of architectural invention as the conflict between the idea of 'poetic reaction' and the notion of the 'pure creation of the mind'.

RONCHAMP AS A
PHILOSOPHICAL CONSTRUCT

Ronchamp, as a built manifesto, demonstrates the linkage between nature, history and technology that Le Corbusier demanded in his theory of invention. The chapel's shape fuses a wide variety of influences: a crab's shell as 'objet à réaction poétique'; several historical architectural forms, including the Serapeum of the Villa Hadriana, which served as a model for the top-lighting, and Indian walls pierced for illumination, which Le Corbusier sketched on his travels and had read about in Percy Brown's book *Indian Architecture*; and, finally, contemporary technological innovations, such as aeroplane wing construction. He also combined two kinds of shaping: the organic with the cerebral, the aleatoric with the geometrical. In some places these two formal worlds confront one another thetically. The old statue of the Madonna, for instance, is placed in a rectangular box in the east elevation with the curve of the concrete roof sweeping down gently above it (ill. p. 7). Or again, the fountain, a repository of stereometric forms, stands in front of the confessional, which emerges from the wall in a gently billowing shape. This is the type of contrast that Le Corbusier had staged on the roof of the Unité d'Habitation, where the hill of the kindergarten appears as the antithesis of the square shape behind.

It would nevertheless be wrong to regard Ronchamp as composed of pairs of opposites. The chapel attempts to synthesise mathematical principles and natural phenomena in a single form. Indeed, Le Corbusier sought to overcome thinking in terms of opposites like nature/art and interior/exterior. The process of designing Ronchamp reveals as much. Operating on a give-and-take basis, the architect 'kneaded' the shape of the ground plan from the hill and 'rolled out' the ends of the west wall into two modified logarithmic spirals. As described in an earlier chapter, he

had studied Matyla Ghyka's *Le Nombre d'or* and the spirals illustrated in that volume (ill. p. 99). In December 1950, while designing Ronchamp, he also read an obscure book in which spirals feature prominently: Petrus Talemarianus's occult treatise *Architecture naturelle*. Prompted by the spirals of seashells, Talemarianus puts forward 'a golden rule based on the principles of Tantrism, Taoism, Pythagorism and the Cabbala'.[1]

A kind of synthesis comparable with this spiral-shaped geometrisation of the curving ground plan occurs in the chapel's south elevation. It recalls the thick, pierced mud walls that Le Corbusier drew on his travels. Yet far from being completely arbitrary, as Pevsner surmised,[2] the disposition of the windows is calculated down to the last detail in accordance with the Modulor system. Similarly, the billowing interior of the chapel is 4.52 metres high at its lowest point – that is, twice the height of the Modulor unit. And again, the height of the space between the two concrete skins of the roof – allegedly an enlarged crab's shell – is exactly 2.26 metres. The Modulor man would fill the space like the crab its shell. Rooted less in the physics of construction than in metaphysics, the unit of measurement testified to the architect's belief that the 'infallible mathematics of the combination' and the 'radiance of the proportions' would result in the 'aura of an ineffable space'.[3]

In designing Ronchamp Le Corbusier could refer to a whole arsenal of construction drawings (including dams and several aeroplane wings) in addition to his 'objets'. He seems to have switched constantly from one to the other, superimposing the wing construction on the crab's shell, for example, and vice versa. The architectural form emerged from this process of overlapping and interweaving technology and nature. Behind this procedure lay an almost alchemical philosophy. Although there is nothing esoteric about the building's effect, esoteric concerns lay at the heart of its genesis. As described elsewhere in this volume, Le Corbusier believed in a cosmic axis of harmony – a legacy of his early theosophical reading. The art historian Elie Faure, who in her book *Histoire de l'art* of 1927 juxtaposed a whale's skeleton with an aeroplane fuselage as examples of 'architecture naturelle', entertained

a similar notion of 'universal order' manifest in visible correspondences.[4] Le Corbusier, who was friends with Faure, wrote in the same esoterically bionic tone that this must be the 'axis on which man is organized in perfect accord with nature and probably with the universe ... If, through calculation, the airplane takes on the aspect of a fish or some object of nature, it is because it has recovered the axis'.[5] He could have put it more prosaically and said that the aeroplane has to do with aerodynamics and the fish with aquadynamics. But Le Corbusier saw greater things dawning on the horizon of his work: he was searching for 'the axis', in the way that an alchemist searches for a recipe for making gold.

To look at the roof of Ronchamp as it hovers mysteriously above the walls, held in place only here and there by the thinnest of supports and apparently about to float free of the building, is to perceive the love of aeronautics that Le Corbusier acquired at an early date (ills. pp. 23, 24). In 1923 he had written that aircraft technology had 'mobilized invention, intelligence and daring: *imagination* and *cold reason*. It is the same spirit that built the Parthenon'.[6] This broaches the second aspect of Le Corbusier's design strategy, in addition to the combination of technology and nature: feedback from historical buildings. Ronchamp brings together two essentially different historical points of reference. The position of the chapel on a hill with distant views of the horizon recalls the pictures that Le Corbusier took of the Parthenon on the first of his so-called 'oriental' journeys. In this sense Ronchamp pays homage to the ancient Greek temple enthroned above nature, a work he lauded in *Vers une Architecture* as the origin of all architectural proportion. Yet the chapel merges this Hellenic heroism with the quite different kinds of architecture that Le Corbusier drew and photographed on his later travels in southern Europe and northern Africa: Greek pantries with their ventilation shafts, Indian mud houses, African huts offering protection from sandstorms and the sun, mud huts and cave architecture modelled from and carved into rocks and steppes, apparently frozen in a strange intermediate state between natural form and constructed building. These were all examples of vernacular architecture developed in

163

response to topographical and climatic conditions which, there-
fore, impressed him as instances of 'cosmic' harmony between
dwellings and nature.

The alchemy of form:
the avant-garde's esoteric chamber of curiosities

With its technical drawings, seashells, photographs of Antiquities
and sketches of outstanding examples of anonymous non-Euro-
pean architecture, Le Corbusier's studio in some ways resembled a
sixteenth-century chamber of curiosities, in which collecting,
researching and arranging went hand in hand.[7] With the Modulor
the architect aimed to disclose an underlying mathematical struc-
ture shared by all the things he collected, from seashells and Antiq-
uities to the products of technology. The Modular was to do
nothing less than restore the 'lost unity of man and nature'.[8] With
the aid of this synthetic mathematical system Le Corbusier sought
to merge the various elements indivisibly into a single, organic-
type form. He hoped that in some mysterious way the resulting
shape would radiate the aura of everything that had gone into its
making, constituting architecture that was like a living being and
therefore prompting 'those multifarious sensations, which evoke
all that a highly cultivated man may have seen, felt and loved;
which release... vibrations he has already experienced in the drama
of life'.[9] Time and again he repeats his view that architecture lack-
ing this effect is mere construction. Addressing modern architects,
he declares: 'My house is practical. I thank you... [But you] have
not touched my heart'. Only when architects have used 'raw mate-
rials... *starting from* conditions more or less utilitarian [and have
established] certain relationships which have aroused my emo-
tions' have they created architecture.[10]

For Le Corbusier the 'machine for living in' was more than just
a practical setting promoting the smooth running of everyday
lives: it was an apparatus for generating emotion. Rather like a
physically accessible film in which the occupant plays the leading

role, this appartus was to surprise, touch, excite and arouse memories by means of skilful cutting, zooming and lighting. A love of the fictional informs even Le Corbusier's actual buildings. It thus comes as no surprise to find that the anecdotes he told about his formal inventions possess strikingly similar literary models. In his narratives the architect who knew how to collage the most diverse things, and who called himself a man of letters, amalgamated his life with the literature that influenced it until the two could not be disentangled.

Productive misunderstandings: how esotericism could prompt good design

A fundamental contradiction exists between the aesthetics propagated in Le Corbusier's early writings, underpinned mathematically and theosophically and governed by rules, and his architectural practice, schooled on the 'objet à réaction poétique' and Valéry. Can this contradiction be resolved? Should an attempt even be made to resolve this dichotomy between rationalism and esotericism, mathematics and poetry? Many commentators certainly find the logical incompatibility awkward. For admirers of Le Corbusier's architecture, his susceptibility to theosophy and other forms of esotericism is acceptable only as an irksome burden with which the Master tests them. Conversely, those devoted to the irrational notions of 'spiritual axes' and 'universal harmonies' spawned in the morass of turn-of-the-century psychological mumbo-jumbo almost invariably react negatively to Le Corbusier's architecture, apparently on the assumption that the mere appropriation of such ideas for other purposes must inevitably be unpalatable. Yet it is the very combination of the two aspects that is so intriguing: how irrational thinking gave rise to rational architecture, how absurd metaphysical constructs produced practical formal solutions. Like alchemists who revolutionised ceramics while attempting to make gold, Le Corbusier created valuable innovations on the basis of a pretty crude philosophy of the world,

just as his most interesting ideas on space arose from fragments of Valéry's theories that he misunderstood thoroughly and hacked to pieces methodologically.

Perhaps causality works differently when it comes to formal invention. Perhaps someone who genuinely believes that a window moved twenty centimetres in the wrong direction, or a space that is three centimetres too high, will put the whole structure out of joint with the great world axis takes greater pains when designing those details that ultimately determine the quality of a building. And perhaps people engaged in designing require a philosophy of the world to get their bearings in the labyrinth of potentially infinite approaches and forms: perhaps they need a philosophical base to initiate, to provide a point of entry into the process of decision-making and invention. In Le Corbusier's case, this process might be ushered in by a beach find, by Valéry's theories or by the esoteric literature of his day. Like many others, Le Corbusier had his Columbus-type moments: the methods he used to find a quick passage to the Promised Land may have been questionable, but they resulted in the discovery of a new continent.

In formal terms, Ronchamp was a novel kind of patchwork comprising topography and technology, history and nature. Its structure amalgamated visual quotations, remembered experience, things seen, historical architecture and natural shapes to produce an affective building with a surreal aura. Stirling's claim, intended as a negative criticism, that Le Corbusier had abandoned the invention of forms in favour of their adaptation and combination hit the nail on the head. The constitutive elements of Ronchamp can be pieced together from the architect's 'objets à réaction poétique' and the things he recorded in his notebooks. Thus the chapel's seemingly absolute, unprecedented modernity turns out to be a blend of the most disparate historical forms, many of them non-European. The change in philosophical attitude manifested here – a change that Stirling thinks to detect already in Le Corbusier's Jaoul houses in Paris – involved the replacement of harmonious ideas worked out at the drawing board with the aid of systems of proportion by an architecture concerned more with sur-

faces and associations and with such archaic spaces as caves and grottoes. Ronchamp is a focus of personal myths, a conglomeration of recollected forms, recorded by Le Corbusier on his trips to Africa and elsewhere or disovered in periodicals. For example, a picture in a magazine published in 1930 which he kept, shows tombs in an oriental cemetery that seem like prototypes of the characteristic towers of Ronchamp.[11] Indeed, the architecture of Ronchamp is not far from a collage.

This idea of architecture as a melting pot, as a sponge that deliberately soaked up influences from a huge variety of sources, annoyed critics who valued the kind of modern architecture represented by the Bauhaus and the International Style, with its formal purity and almost sanitised aesthetics. Some ten years after the end of the Third Reich, German writers, in particular, were quick to apply sickness metaphors when attacking the perceived formal 'contamination' of Ronchamp. The chapel, wrote the critic Rudolf Müller-Erb, was a 'monument to the most boundless subjectivism that the history of the world has ever seen in architecture' and, 'as unleashed by Ronchamp, the disease of subjectivism threatens to become a thoroughly devastating epidemic'.[12]

The modernist sponge: the principle of porosity

Tempering ideal, universally valid design systems by means of the individual, private, unique and peripheral really did form part of a new strategy at Ronchamp. It led to an aesthetic of porosity. Indeed, the principle of porosity dominates the building if 'porosity' is taken to involve ambivalence, permeability, changeability and the relaxation of strict spatial categories.

The deeply curving south elevation of Ronchamp, with its many apertures, recalls a sponge. It is porous in many respects. It softens the harshness of the smooth wall by admitting exterior space, transforming the wall from a simple separating device into a three-dimensional object. The windows are not simply holes cut in the material: instead, the wall consists of a series of spaces,

glazed at the eastern end, that in their entirety resemble honeycomb. As though entering a room, visitors can walk into the deep recessions containing windows, a feature influenced by traditional African and Indian architecture.

This transformation of the straightforward 'curtain' front into a space-encompassing, sculptural entity had already featured in a plan of 1933 by Le Corbusier for an apartment block in Algiers, in which the *brise-soleils* on the south and west fronts eliminated the paradigmatic flatness of modern elevations. At Ronchamp the exterior altar, the pulpit and the roof protrude far beyond the confines of the walls. Here too, the structural boundary between 'interior' and 'exterior' is dissolved. Such spatial fluidity reflects a new iconographical openness.

Ronchamp would be inconceivable without the repertory of architectural forms that Le Corbusier gathered on his travels in Greece, northern Africa and India. As a synthetic collage, the chapel acts like an iconographical sponge, absorbing formal quotations from foreign cultures and historical buildings along with natural shapes. Christian elements merge with heathen and Indian.

The Villa Savoye had already exhibited various gradations between 'interior' and 'exterior'. They included an entirely self-contained bedroom and a living area that was glazed completely on the side facing the roof terrace, the panes capable of being slid aside in order to transform the room into a loggia. The area opposite this had side walls with windows but no roof: was it an interior or an exterior space? Here the variety of the spaces already exceeded that of the categories available to describe them. At Ronchamp Le Corbusier went on to turn architectural norms inside out like a reversible coat, converting the interior into an exterior and vice versa. And he did so with the strikingly simple device, familiar from Romanticism and Surrealism, of formal echoes and mirrorings, as when the inside wall with the altar and pulpit is repeated on the outside or when, with a few movements of the hand, the rotatable Madonna (the focal point of the local cult of the Virgin) is made to define the exterior space as the chapel's interior.

This last breach of category, the kind of architectural freedom it embodied, may also have resulted from Le Corbusier's engagement with the twisting interior walls of seashells and molluscs in his collection. In general, his 'objets à réaction poétique' influenced Ronchamp in three ways. They sharpened his microscopic gaze as a constant source of formal inspiration: one found object was actually enlarged to wall size. Second, they provided a tactile model: the texture of a shell or bone was imitated in sprayed concrete. Finally, they offered a conceptual and structural model for the presentation of certain architectural effects: the logarithmic spiral of the mollusc, its mathematical structure as demonstrated in the Modulor system, determined the proportions of one space.

At Ronchamp Le Corbusier practised deconstruction long before the term was applied to architecture. He started not by asking how a modern variant of the classic building type 'church' might look, but by considering what constituted a church in liturgical and atmospheric terms. On the basis of these requirements he then put together an architectural mosaic from *objets trouvés*, generating a new form that fulfilled the demands far better. In destroying the conventional form he rescued its significance. That explains the special popularity of Ronchamp with the faithful.

The seashell grows, is tossed about in the sea and cracks. Its edges are smoothed by water and sand, and it breaks open. Eventually, a crab moves into the ruin. In this way seashells embody the principle of forms that react to their surroundings and are shaped by them, that are changeable and not fixed. This is the principle that governs Ronchamp's fragmentary curves and protrusions, its fractured and variously pierced forms. The chapel's appearance alters constantly depending on the time of day and the weather. On a sunny morning the sun shining through the east window, which rises to the full height of the building, dissolving the east wall optically (ill. p. 9), while on overcast evenings the atmosphere is more like that of a grotto. Moreover, the roof seems to be on the point of detaching itself from the rest of the structure. Thus, the rotatable Madonna is not the only feature that does everything in its power to dissolve the static character of the building. This kind

of architecture, existing outside antinomic notions of old and new, European and non-European, inside and outside, natural form and cultural product, would not have been possible without the conceptual model of Valéry's 'objet ambigu' and its later kindred spirit, Le Corbusier's 'objet à réaction poétique'.

8.

THE ARCHITECT ON THE BEACH
AND THE CONSEQUENCES:
A SHORT POSTSCRIPT

> Outside and inside form a division ... The dialectics
> of *here* and *there* has been promoted to the rank of an
> absolutism according to which these unfortunate
> adverbs of place are endowed with unsupervised
> powers of ontological determination.[1]
>
> Gaston Bachelard

Le Corbusier exerted an omnipresent influence on twentieth-
century architecture. It ranges from houses on *pilotis* to ribbon win-
dows and New Brutalism. Details invented by him are to be found
in millions of modern homes. Even the expressionistic styles of
an architect like Eero Saarinen or a designer like Verner Panton,
deeply affected by Pop Art and space travel euphoria, can easily
be related to the architectural language of Ronchamp. Frank O.
Gehry interpreted the idea of enlarging shells to building size lit-
erally when first designing Ron Davis's house as an inhabitable
seashell.[2] Daniel Libeskind has taken his cue equally clearly from
Le Corbusier's spirals. In 1995 he published a text entitled 'Cri-
tique of a Day's Trauma' in which he noted that seashells do not
insist on an 'either/or'.[3] The sketches he made at this time for an
extension to the Victoria and Albert Museum in London reveal
that a logarithmic spiral formed the basis of this apparently hap-
hazard structure. Even the tiles designed for the building by the
engineer Cecil Balmond were to be arranged in an upward spiral in
accordance with the Golden Section: Balmond and Libeskind

Peter Eisenman, Max Reinhardt Haus, 1992

spoke of 'fractiles', a coinage formed from 'fractal' and 'tiles'.[4] Like Ronchamp, the seemingly irregular deconstructivist form of the extension was proportioned in accordance with an invisible mathematical order centred on the logarithmic spiral.

Ronchamp has done more than offer a formal model for architecture engaging with biological forms and finds, and its influence has transcended phenotypical similarities. To look for Le Corbusier's legacy only in buildings that directly recall the Ronchamp chapel or the open, fragmented shapes of his 'objets à réaction poétique' would be to misunderstand his achievement in formalist terms. Recent architecture, in particular, has developed his particular brand of spatial thinking, grounded in found objects and defined porosity, overlapping, inversion and amalgamation, in ways that go far beyond simple formal correspondences.

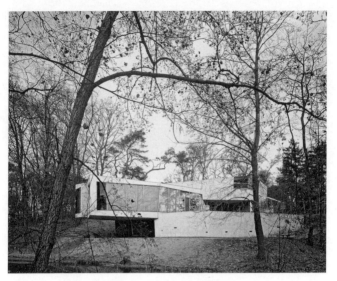

Ben van Berkel, Möbius House, 1998, exterior view

Möbius bands

Peter Eisenman's Haus Immendorf and Max Reinhardt Haus belong among the first computer-aided attempts to devise a new design practice ultimately derived from Le Corbusier's approach to found objects. Whereas Le Corbusier had searched on the beach for forms not immediately intelligible to the thinking inventor, Eisenman embarked on the design process at the computer. Entering a few basic specifications – a certain number of square metres, say, or a mathematical formula (the Möbius band in the case of Haus Immendorf) – he set in motion a process that resulted in a potentially infinite number of shapes for constructable and habitable three-dimensional objects that had little in common with conventional notions of usable buildings.[5] At end of the day Eisenman would find unaccustomed forms on the computer screen or in his printer, forms with a comprehensible structure but a genesis that could not be retraced.

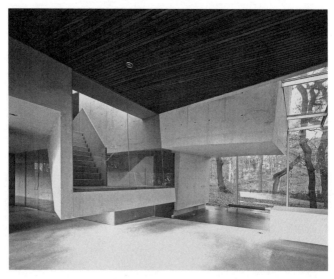

Ben van Berkel, Möbius House, interior view

The seaside strolls of a philosopher and an architect acquired a post-biological pendant in the computer – a third shaping force beside humanity and nature, an apparatus imitating in a virtual lapse of time the slow growth that interested Valéry and Le Corbusier in their beach finds. The designer searching for forms now needed only to choose between mutations, and at least in that respect he resembled his predecessor, the architect on the beach. Eisenman's Max Reinhardt Haus, likewise extracted from the endless variations of a computer programme, is a labyrinthine upended Möbius band, without beginning or end, a tall structure that turns about its axis, bends over and falls to the ground (ill. p. 172). It continues the abolition of spatial hierarchies initiated by Le Corbusier in the Villa Savoye, with its lack of distinct front and rear elevations (ill. p. 13), in his painting and in the Ronchamp chapel, with its exchangeable interior and exterior.

Eisenman's proposal was never realised, but from 1993 to 1998 Ben van Berkel, an architect who had studied the Möbius band and

hermaphrodising processes, built a house near Amsterdam that actually bears the name of the mathematical figure that gave birth to it: Möbius House. This structure, as several other houses of that time, tries to redefine the way in which the domestic home, ever since Antiquity, has been seen as a locus of privacy. In this view a dwelling is a *privatum*, built on land 'separated' from the world (from the Latin *privare*, 'to separate' or 'to deprive'). Hence the classic house is literally 'exclusive': it shuts out the world, using walls to distinguish 'here' from 'there' and discourage interaction between the two. The *privatum* brings with it anxiety: fears arise inside that the outside might intrude as an aggressor. Could this state of affairs be changed? Is a non-exclusive house conceivable? Could the desire for protection from cold and aggression – a principal *raison d'être* of building – be satisfied in a way that reduced both the emphasis on distinguishing between *privatum* and the outside world and the concomitant fear inside?

Van Berkel's Möbius House also seeks to answer these questions (ills. pp. 173, 174). Standing among trees in peaceful surroundings, it resembles something out of a dream: walls bend and dissolve; we stagger past flying doors and passages that suddenly appear from nowhere; gravity is annulled. Rarely do things come to rest in this house: tilted walls and concrete seats constantly seem to flash past like the remains of a decaying domestic culture. There are no elevations as such: the walls are forever moving away from the viewer, tying themselves in knots and interlocking. A narrow staircase leads from the vestibule to the living area. Walls fall away as though stepping aside: the house appears to be in motion. There are scarcely any partitioned spaces: the whole resembles an arena in which feelings of openness and narrowness, lightness and heaviness, are explored and firm divisions between rooms dissolved.

Van Berkel seeks to express motion in architecture. It can hardly be coincidental that many of Van Berkel's ground plans resemble racetracks seen from above or that he co-authored a major three-volume publication entitled *Move*.[6] In the second volume the image of a 'manimal', a computer-generated chimera put together from a person's, a snake's and a lion's head, figures

prominently. This creature, its name a portmanteau word combining 'man' and 'animal', denies its origins because it does not *look* assembled: in the computer animation the various shapes merge to form a new, indivisible unit, rather as Le Corbusier synthesised Indian, north African, Aegean, Early Christian, technological shapes and organic forms at Ronchamp. The manimal startles the viewer because it appears organic, but does not reveal the conditions and processes of its growth. For Van Berkel, it embodies a new way of generating form. Also in *Move* he devised a system of coordinates featuring women from Italy, Africa, Vietnam and the Far East on the X axis and faces of men from the same countries on the Y axis. Pairs were overlapped in computer images, the African man with the Chinese woman, the Italian man with the African woman and so forth. The resulting hybrids derive their aura of unfamiliarity not least from the fact that they are no longer either man or woman, but have been pixelled together exactly from elements of each to form androgynous beings – hermaphrodites of the computer age.

The illustrations in *Move* include a section through a seashell, and the spatial organisation of the Mercedes Benz Museum, which Van Berkel was to build in Stuttgart in 2005, recalls the spirals and ramps in Le Corbusier's Mundaneum and Musée à croissance illimitée. Visitors take the lift to the top floor of the Mercedes Benz Museum, where the display begins with the first cars, produced in the 1880s. In a series of steeply raked loops they then proceed down a threefold spiral. In eschewing a straightforward linear narrative and a clear spatial order, the museum owes much to Le Corbusier's precedents and gives expression to a new notion of evolution. The development of an object – in this case the motor car – is presented not as a logical, uninterrupted sequence of improvements to an original vehicle, but as a ramified process in which chance, error and constant give-and-take play a big part. Various kinds of vehicle – lorries, racing cars, small cars and such oddities as the 'Haifischflossen' (Shark Fins) – are displayed in small rooms and on platforms, all of them ultimately derived from the first motorised vehicle. Architecture here enables history to be told in a different way.

176

Two architectural narratives and two kinds of spatial experience confront one another in the Mercedes Benz Museum: the lift on the one hand and the spiral on the other. In a sense the lift is the equivalent of an aeroplane: it transports users to their destination by the shortest possible route and they see very little on the way. Twentieth-century tall buildings, which stacked floor unit on top of floor unit, were erected around lifts. Since the urbanisation of Los Angeles put an end to the romantic view of horizontal expansion cultivated in the USA after the coming of the railways and the trek westwards, 'Let's go west' was succeeded as a motto by 'Let's go up', linear horizontal expansion replaced by linear vertical expansion. Along with astronauts, architects of tall buildings were the cowboys of the twentieth century, dedicated to pushing back frontiers vertically rather than horizontally.

In the meantime, architects like Van Berkel and, especially, Rem Koolhaas have abandoned the linear romance of vertical expansion. They have countered it with tall buildings erected along spirals, structures that have levels, arms and intersections instead of storeys. In his Seattle Public Library, completed in 2004, and in nearly all his recent buildings, Koolhaas takes up the motif of ramps and spirals that plays such a major part in Le Corbusier's work. Books and reading rooms are arranged along a spiral in his design for the library of Jussieu; a spiralling passage eats its way through the cube of the Dutch embassy in Berlin like a maggot in an apple, until it reaches the public area of the building at the top, with a restaurant and fitness facility; and in Seattle, too, a spiralling ramp forms the core of the structure. This last building is essentially a vertically unwinding city, an unprecedented kind of public square folded upwards and bounded by a steel net (ill. p. 178). The glazing opens it up to the city and creates a new type of urban space, a huge livingroom-cum-plaza, with sofas and a coffee shop. Moving up the spiral, members of the public reach levels that would previously have been occupied only by private offices. The public zone and the book stacks unfold upwards as though in a vertical piazza, accompanied by computer areas and reading niches. Tall office buildings near the library – typical products of

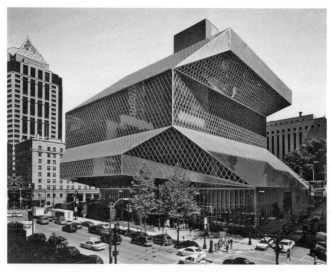

Rem Koolhaas, Seattle Public Library, 2004

Mies van der Rohe-style modernism – are organised on a strictly linear basis: the horizontal areas – that is, the streets, which here are largely given over to traffic – are defined as public, the vertical, occupied exclusively by offices, as private. Stranded like a piece of technological driftwood among the buildings, the library subverts this rigid distinction. Inside its strikingly folded shell a spiral twists upwards like a snail, drawing the public realm up with it.

Zoom, foam, cell: the deconstruction of domestic space

Le Corbusier's practice of zooming in on objects and enlarging them to the point where they were feasible as buildings likewise found later adherents. The Stuttgart engineer Werner Sobek magnifies foamed materials rather than shells. At his Institute for Lightweight Structures and Conceptual Design he works with foamed glass, foamed metal and sponge structures, while also experimenting with chemicals that thicken soapy solutions and

Rem Koolhaas, enlarged foamed material, 2005

cause them to harden. The goal is the creation of habitats from foaming liquids. It would then be necessary to transport nothing more than buckets of liquid to crisis regions, for example.

Koolhaas, too, has experimented with hugely enlarged foamed materials (ill. above). In his case the zoom effect has a social and a sculptural dimension. The latter is particularly noticeable in his experiments with magnified foam shapes. If the enlargement of sponge structures of this kind were taken to the point at which people could sit in and walk around the variously sized open 'bubbles' this would result in a new type of social space. Meeting-places and withdrawing areas would form and, with them, the concept of a labyrinthine locus that rendered questions of interior versus exterior obsolete. A structure of this kind might be a house consisting of bubble-shaped spheres open at the sides. It might be a university. Or it might be a square of the type designed by the Japanese architect Sou Fujimoto for his Huaxi Urban Nature project. This study seeks to show how city life could be condensed into a complicated set of interlocking spaces resembling a crystal enlarged to

Sou Fujimoto, Huaxi Urban Nature, 2008

the size of a tall building, rather than spreading out endlessly into the landscape in the customary form of streets lined with buildings (ill. above).

Born in 1971, Fujimoto belongs to the younger generation of Japanese architects, who have reinterpreted such Le Corbusier hallmarks as the minimalist hut organised in the shape of a spiral, the human-sized seashell and the dissolution of spatial boundaries. In his first theoretical publication Fujimoto addressed natural forms, listing the nest, the forest, the grotto and the 'guru-guru' (spiral) among ten motifs suitable for innovative architecture. He, too, has built a spiral-shaped dwelling: Final Wooden House (ill. opposite page). Erected in the Kumamoto forest in 2008, the house is a radical version of Le Corbusier's Cabanon, an eight-metre cube put together from wooden beams thirty-five centi-metres thick and stacked in a complex arrangement. The effect is as if someone had sawn a spiral into the cube, rather in the way that Gordon Matta Clark cut his 'Conical Intersects' from buildings awaiting demolition. Two people can lie, sit or stand inside Fuji-

Sou Fujimoto, Final Wooden House, Kumamoto, 2008

moto's spatially fluid wooden spiral. Customary designations like 'table', 'bed', 'chair' and 'storey' do not apply here: the protruding beams and the spaces between them replace furniture, stairs and walls. The human body fits inside the construction like a mollusc in its shell: 'You cannot move unless you twist your body', wrote the architect Toyo Ito in his review of the building.[7]

For a competition on the theme 'primitive lifestyles' Fujimoto designed ten white rectangular blocks, none more than 2.5 metres wide, that contained a kitchen, a bed and a table. Stacked like an abstract hill, they were linked by ladders – it was like climbing from one branch to the next, said Ito. The cubes encouraged new forms of family life, led in a series of separate, but connected, cells that organised communal life differently to the hall-and-room arrangement. '[I]n Fujimoto's architecture', Ito writes, 'human relationships are more open toward the exterior'. His nest-like dwellings experiment with 'defining spaces that invert interior/exterior'.[8] His House N in Oita, for instance, consists of three blocks placed one over the other (ill. p. 182). All three have openings in their walls

Sou Fujimoto, Haus N, Oita, 2008

and ceilings, some glazed, others not. In this way, the house and the garden become a continuous sequence of interior spaces: each exterior is an interior to the next exterior, and trees grow in the middle of the house as in the dream world of the children's book *Where the wild things are*.

An entire generation of architects in Japan is engaged in redefining architectural space. Ryue Nishizawa's Moriyama House in Tokyo also evinces the kind of spatial thinking that approaches the interior/exterior issue in a freer and more vibrant way (ill. opposite page). This house, too, is basically a town comprising many mini-houses. On a plot of land that would normally contain a single house Nishizawa divided up his building into ten rectangular blocks, each containing a room. The 'halls' between them are public paths. The members of the small community that lives here use the more public areas jointly, while possessing blocks of their own to which they can withdraw for privacy. The town is allowed to flow through the passages between the blocks. Like Koolhaas's library in Seattle, Nishizawa's house continues the micro-social experiment of ambiguous spaces initiated by Le Corbusier in the Villa Savoye, the monastery of La Tourrette and the chapel

Ryue Nishizawa, Moriyama House, Tokyo

at Ronchamp. What began as an aesthetic play with the dissolution of boundaries has come to embody political potential for a different kind of community, a different kind of social organisation vis-à-vis the public and the private.

All these examples of architecture existing outside rigid notions of space are hard to compare in formal terms. They have different *raisons d'être* and they resulted from different design methods. What they share is an approach that generates free formal and social spaces through spatial inversion, porosification, overlapping and amalgamation. Their foundations include the story of the architect on the beach.

NOTES

Foreword

1 von Holst 1955, n.p.

2 Fuchs 1956, n.p.

3 The planning of Saint-Joseph began in the 1940s, however construction was only completed in 1959, after Perret's death and four years after Ronchamp; see also Kidder-Smith 1964, pp. 106–9.

4 Completed in 1952; see Kidder-Smith 1964, pp. 190–95.

5 *Le Corbusier, Texte und Zeichnungen für Ronchamp*, unpaginated (p. 20).

6 Sedlmayr 1948, p. 105.

7 Le Corbusier 1965, n.p. (p. 39).

8 Abbé Ferry, in Jean Petit, *Le Livre de Ronchamp*, p. 70. Regarding Abbé Ferry, see also Daniele Pauly, *Ronchamp, lecture d'une architecture*, Paris/Strassbourg 1987, p. 135.

9 Le Corbusier, *Précisions sur un état present de l'architecture et de l'urbanisme*, Paris 1930, pp. 57 f.

10 G. Ha. (abbr.), 'Le Corbusiers Wallfahrtskapelle in den Vogesen,' in *Die Kunst und das Schöne Heim*, no. 1, 1958, pp. 138 ff.

11 James Stirling, 'Ronchamp. Le Corbusier's Chapel and the Crisis of Rationalism', reprinted in Pallazolo and Vio 1991, p. 221.

12 '... Parallels can be drawn to the mannerist period of the Renaissance', James Stirling, ibid. Later, in his career as an architect, Stirling of all people would erect a museum – the Staatsgalerie in Stuttgart, completed in 1984 – the entrance to which looks like a brightly painted homage to Ronchamp.

13 Müller-Erb 1958, pp. 361–71.

14 Ibid., p. 362. The breadth of associations evoked by the architectural form is introduced by other critics as something positive in the sense of an 'architecture parlante'. For example, Anton Henze sees in all these formal associations variations of a single image of asylum and security: 'The one image does not contradict the other. The ark and the ship, the tent and the cave, are all shelters for people on the move, refuges in a time of homelessness and uncertainty' (ibid.). Müller-Erb criticises the variety of metaphors as misleading and arbitrary, and replies to Henze as follows (p. 363): 'If Ronchamp is all these at once (and moreover per-

haps a bunker, fortress and styscraper as well), it must be an architectural monstrosity. Ship, tent, cave – 'shelters for men on the move ...' One might say this of the tent. But why of the ship and the cave?'

15 Müller-Erb 1958, p. 369.

16 Paul Doncoeur 1955, p. 95.

17 Le Corbusier 1965, p. 20.

18 *Le Parisien*, 16 July 1955, n.p.

19 *Une vase de silence, empli des bruits de la mer*; quoted from Jean-Marc Collier, 'Les Coulisses de Ronchamp' in Bradfer 1988, pp. 71ff.

20 Kidder-Smith 1964, p. 87; similarly, Boulais 1965, p. 14; more recently, Danièle Pauly, 'Objets à réacation poétique' in Lucan 1987, pp. 276f.

21 The term is often employed in contradistinction to a mechanistic avant-garde which is even etymologically somewhat sensible – ultimately the Greek *organon* means 'tool' as well as 'part of the body'. Meanwhile, the term 'organic architecture', found in connection with Gaudí's *Jugendstil* as well as with Mendelssohn's Expressionism, with Rudolf Steiner's Goetheanum and its attendant totality theory, as well as with Friedrich Kiessler's 'Endless House', a bubble-like, quasi-biological living organism that was never built, has become meaningless.

22 Ben van Berkel and Caroline Bos, *Imagination – liquid politic*, Amsterdam 1999, pp. 211ff.

23 Julia Gerlach, description of the 'Biomorph' project, taken from the website www.zeitblom.de/dl/030321_biomorph.pdf

24 Anon., in *Kultur Online*, 'Pitch Black. Biomorphe Architektur im MAK', Internet entry from 25 February 2008.

25 Werner Nachtigall and Kurt Blüchel, *Bionik. Neue Technologien nach dem Vorbild der Natur*, Stuttgart/Munich 2000, p. 146.

26 Archives, Fondation Le Corbusier Paris, Dossier Création Ronchamp.

27 Giedion 1956, p. 122

28 Valéry, *Eupalinos*, Frankfurt am Main 1990, p. 114.

29 Ibid., pp. 82f.

30 See Benjamin 1982, p. 274; Benjamin sees the relationship between tactile and visual response of key importance in the realm of architecture, see Benjamin 1969, pp. 46f.

31 Hans Blumenberg, *Ästhetische und metaphorologische Schriften*, Frankfurt am Main 2001, pp. 89f.

32 Paul Valéry, *Variétés V*, Paris 1944. Le Corbusier's personal copy, FLC 364.

33 *Art* no. 1 (2009), p. 121.

I.

The Beaches of Modernism

1 For the genesis of Gray's house and relations between her and Le Corbusier, see Adam 1987, pp. 191–92.

2 Adam 1987, p. 357.

3 Le Corbusier 1931.

4 Adam 1987, p. 191.

5 Gray's biographer Peter Adam views it in symbolic terms as 'rape'. Adam 1987, p. 311.

6 See Adam 1987, pp. 191–92: 'she had studied the terrain with its different levels and decided not to alter the topography, but to let the house embrace the natural contours. She looked at the light and studied the wind to make use of all elements.'

7 In *Vers une Architecture* Le Corbusier therefore chose the steamship as a model for the new architecture: 'A seriously-minded architect, looking at [a steamship] as an architect (i.e. a creator of organisms) ... will prefer respect for the forces of nature to a lazy respect for tradition [and] to the narrowness of commonplace conceptions he will prefer the majesty of solutions which spring from a problem that has been clearly stated.' Le Corbusier 1931, p. 103.

8 Adam 1987, p. 234.

9 Le Corbusier 1931, p. 95.

10 Adam 1987, p. 309.

11 Fondation Le Corbusier, Paris, sketchbook D14, 18.6.1950.

12 'Je n'ai pas une très belle gueule, mais puisque c'est ainsi que je vous apparais, admettons'. Le Corbusier, letter of 7 October 1955 to Lallement; Fondation Le Corbusier, Paris.

13 See, for example, Zeising 1854.

14 Le Corbusier 1947, pp. 6–7. For the Unité d'Habitation, see also Jacques Sbriglio, 'Unité d'habitation', in Lucan 1987, pp. 422ff.; Nobert Huse, 'Wohnen in der Gemeinschaft', in Huse 1976, pp. 88–97; and Ruggero Tropeanom, 'Une Unité d'habitation de grandeur conforme par Le Corbusier', in Vowinckel and Kesseler 1986, pp. 151ff.

15 Le Corbusier, in Hervé 1970, pp. 38–39.

16 Ibid., p. 62.

17 Le Corbusier 1989, p. 89.

18 For the connection between Le Corbusier's use of the hand as a symbol and Schuré's occult theosophical cosmology, see Lucan 1987, p. 468.

19 For the Modulor, see pp. 103–06.

20 For Roq and Rob, see Lucan 1987, pp. 352–53.

21 Bachelard 1969, p. 107.

22 'Donner à l'être humain sa coquille', Le Corbusier 1992, video 3.

23 Chiambretto 1987, pp. 38–39.

24 Eileen Gray, for instance, could not understand why he had erected 'just a wooden shack'. Adam 1987, p. 357.

25 Le Corbusier 1961, pp. 70–71. For the 'objets à réaction poétique', see also Lucan 1987, pp. 276–77.

26 This self-presentation was indeed odd, because the object of the journalists' visit was not to describe the architect's summer pastimes, but to find out about his proposals for relieving the housing shortage in postwar France. Anon. 1955b, pp. 74–75.

27 Anon. 1955b, pp. 74–75.

28 Ibid.

29 Le Corbusier 1967, p. 6.

30 Kidder Smith 1964, p. 87. See also Boulais 1965, p. 14.

31 Calvino 1984.

32 Le Corbusier 1935, p. 86.

33 Le Corbusier 1961, p. 70.

34 Le Corbusier, in Charbonnier 1960, p. 107.

35 Le Corbusier, in Chiambretto 1987, p. 79.

36 The list of classic found objects is Christian Kellerer's. Kellerer 1968, p. 19.

37 Cohen 2007, p. 166.

38 See Posener 1985, p. 59.

39 '[L]isse comme porcelaine'. Quoted in Petit 1970, p. 178.

40 Le Corbusier, in Petit 1970, p. 178.

41 Jencks 1973, p. 107. See also Posener 1985, p. 60.

42 Lucan 1987, pp. 278 ff.

2.

The Other Oeuvre

1 Le Corbusier, Carnets de Voyage 1907–1908; Fondation Le Corbusier, Paris, VO-I, 35-15.

2 Hervé 1970, p. 11, fig. 39.

3 Paris 2008, pp. 202–03.

4 Blumenröder 2008, p. 121 ff.

5 See Blumenröder 2008 and Baltrusaitis 1957.

6 Leon Battista Alberti, *Della pittura*, Book 2.28.

7 H. W. Janson draws attention to this in his essay 'The "Image Made by Chance" in Renaissance Thought': Janson 1961. See also Kühn 1952, pp. 32ff., and Graziosi 1956, pp. 267ff.

8 '[F]ecitque in pictura fortuna naturam'. Pliny the Elder, *Natural History*, XXXV.xxxvi.

9 See, for example, Pliny the Elder's 'De nubium imaginibus' in his *Natural History*, II.lxi.

10 Cicero, *De Divinatione*, I.xiii.23.

11 James Stirling, 'Ronchamp: Le Corbusier's Chapel and the Crisis of Rationalism', in Palazzolo and Vio 1991, p. 220.

12 Essentially, Stirling here repeated his view, expressed in connection with the Jaoul houses in Paris, that Le Corbusier's philosophical stance had undergone a change that left little room for modernist rationalism: 'it is disturbing to find little reference to the rational principles which are the basis of the modern movement'. James Stirling, 'Garches to Jaoul: Le Corbusier as Domestic Architect in 1927 and 1953', in Palazzolo and Vio 1991, p. 90.

13 Le Corbusier 1961, pp. 71–72. For the 'zoom effect' in Le Corbusier's work, see also Hilpert 1987, p. 94, and Michels 1989, p. 86.

14 Le Corbusier, in Hervé 1970, p. 11.

15 Stirling in Palazzolo and Vio 1991, p. 215.

16 Le Corbusier 1958, p. 27.

17 Le Corbusier 1992, video 2. In his conflation of various interviews Barsac does not mention the date of broadcast, what occasioned them or provide any other details.

18 Le Corbusier 1961, pp. 70–71: '[They] form the vast panoply of spokesmen who speak the language of nature. They are caressed by your hands, your eyes gaze upon them, they are evocative companions'. See also Petit 1970, p. 178.

19 Le Corbusier 1961, pp. 72, 71.

20 Ibid., pp. 70–71.

21 Le Corbusier, in Hervé 1970, p. 28.

22 A separate study would be needed to establish whether Le Corbusier was acquainted with Heidegger's criticism of the modern philosophy. Heidegger shared anti-platonic scepticism and criticism of metaphysics with Paul Valéry, and it can probably be assumed that the architect was familiar with such attitudes from the writings of the latter rather than the former.

23 Bradfer 1988, p. 61.

24 Le Corbusier 1992, video 1.

25 Ibid.

26 Le Corbusier 1961, p. 71.

27 Le Corbusier 1991, pp. 75, 77.

28 Corbin 1994, p. 104.

29 Le Corbusier 1992, video 2.

30 Bradfer 1988, p. 61.

31 Le Corbusier 1954, p. 111.

32 Giedion 1956.

33 Hilpert 1987, p. 94.

34 Letter of 6 April 1955, quoted in Bosman 1987, p. 30.

35 Boesiger 1957, p. 11.

36 Giedion 1958, p. 66.

37 Von Moos 2009, p. 47.

38 Lautréamont 2009, p. 227.

39 Le Corbusier 1989, pp. 75-76.

40 See Chapter 8, pp. 171-83.

41 Butor 1969, p. 73.

42 In Françoise de Franclieus's essay on Le Corbusier's painting, for ex-
 ample, the title appears both as *Femme rouge, homme gris et os* and as *Femme
 grise, homme rouge et os*. Françoise de Franclieu, 'Peinture', in Lucan 1987,
 p. 295.

43 The work is also known as *Grey Woman, Red Man and Bone in front of a Door*
 in the catalogue of the Heidi Weber Museum. See Weber 1999, n.p.

44 Derrida 1993, p. 17; see also pp. 128-29.

45 Kellerer 1968, p. 29.

46 Le Corbusier 1931, pp. 211, 214.

47 See Blum 1988 and, for the influence of Schuré, Nietzsche and Proven-
 sal, Turner 1977.

48 Le Corbusier 1931, p. 212.

49 Adorno 1991, pp. 89-90.

50 Colomina 1992, p. 114.

51 Breton 1987, p. 33.

52 Le Corbusier 1961, pp. 69, 71.

3.
Shell Passages

1 Ozenfant 1968, p. 103.

2 Le Corbusier 1925, p. 76. For the concept of the 'objet-type', see Banham 1960, p. 209.

3 Von Moos 1968, pp. 96–97.

4 Ibid.

5 Le Corbusier 1967, n.p.

6 For the history of cabinets of curiosities, see Bredekamp 1993, especially pp. 13-14 and 33, where the author categorises the links in the chain as 'natural form', 'Antique sculpture', 'work of art' and 'machine'.

7 Le Corbusier 1961, pp. 69–70.

8 Rudolf Steiner, a great devotee of Schuré, was among those who performed his theatrical works.

9 Le Corbusier 1961, p. 73.

10 Ibid., pp. 49, 48.

11 See Mary McLeod, in Lucan 1987, pp. 26 ff.

12 For the importance of Algerian women's bodies in Le Corbusier's painting, see von Moos 1980.

13 Fondation Le Corbusier, Paris, no. 5230.

14 Boesiger and Girsberger 1967, p. 327.

15 Le Corbusier, letter of 19 February 1930 to Christian Zervos; Fondation Le Corbusier, Paris, Dossier Musée à croissance illimitée.

16 Thilo Hilpert (1987, p. 91) claimed that the book was among Le Corbusier's 'favourite reading' and linked the ground plan of the Villa Savoye with the image of the actress Helen Wils's face in Ghyka's volume. Although the ground plan does vaguely resemble a face, Le Corbusier drew it in 1928, before publication of Ghyka's book. Thus there can be no direct connection between the two.

17 For the history of the Mundaneum, see Blum 1988, pp. 84 ff.

18 Le Corbusier and Otlet 1929, p. 31. Some authors, including Blum (1988, p. 101), mistranslate Le Corbusier's 'lac le plus suave' as the 'wildest lake', misreading 'suave' as 'sauvage'.

19 Blum 1988, p. 95.

20 For the spiral as a symbolic form, see Wagner 1990, pp. 117–18.

21 Quoted in Pehnt 1981, p. 35.

22 Wittkower, 'Le Corbusier's Modulor', in Palazzo and Vio 1991, p. 13.

23 For Ghyka's influence on the Modulor, see Dario Matteoni, 'Modulor',

in Vowinckel and Kesseler 1986, p. 27, and Wittkower, 'Le Corbusier's Modulor', in Palazzo and Vio 1991, p. 13.

24 The sequence of numbers 43-70-113-183, produced by applying the Golden Section formula (a:b = (a+b):a - that is, in the present case 113:70 = (113+70):113) - corresponds to the Fibonacci series (formula a+b, a+2b, 2a+3b, 5a+8b - that is, 43+70 = 113; 43+(2×70) = 183), as does the sequence 86-140-226, derived from the dimension 2.26 metres.

25 Le Corbusier 1967, p. 83. In this text Le Corbusier stresses that geometry is not the opposite of nature, but only its rational expression.

26 Le Corbusier 1954, p. 30.

27 Le Corbusier 1958, p. 195.

28 Ibid., pp. 207-08.

29 Le Corbusier 1965, n.p.

30 Le Corbusier 1958, pp. 296, 297.

31 Le Corbusier 1954, p. 72.

32 Le Corbusier 1931, p. 208.

33 Le Corbusier, in Hervé 1970, p. 65.

34 Ibid., p. 82.

35 Ibid., p. 98.

36 Le Corbusier 1954, p. 181.

37 Le Corbusier 1961, p. 53.

4.

Architecture and Literature: The Architect as 'Poet'

1 See Vowinckel and Kesseler 1986, p. 55.

2 Le Corbusier, in Hervé 1970, p. 16.

3 Ibid., p. 114.

4 Ibid., p. 81.

5 Le Corbusier 1991, p. 35.

6 Sedlmayr 1948, p. 98.

7 Leaflet published by the Association; Fondation Le Corbusier, Paris, 'Unité d'Habitation' file. For protests against the Unité d'Habitation, see also Le Corbusier 1992, video 3.

8 The supposedly 'bloodless academician' Giacomo da Vignola was repeatedly the target of Le Corbusier's scorn, despite the fact that he had created one of the most spectacular spiral staircases of his time in the Palazzo Farnese at Caprarola. For Le Corbusier's views on Vignola, see Lucan 1987, p. 459.

9 Le Corbusier 1989, pp. 67-68.

10 Habermas 1985, pp. 22-23.

11 Le Corbusier 1989, pp. 89.

12 Ibid., p. 136.

13 Anon. 1955a, n.p.

14 Sekler 1958, p. 228.

15 Guichard-Meili 1965, pp. 13-14.

16 Wittkower, in Palazzolo and Vio 1991, p. 19.

17 Lampugnani 1980, p. 59.

18 Calatrava, in Palazzolo and Vio 1991, p. 195.

19 Michels 1989, pp. 81 and 92-93.

20 Curjel 1957, p. 390.

21 Giedion 1958, p. 62.

22 Charpentrat 1961, p. 468.

23 Le Corbusier 1954, pp. 48, 49, 50.

24 Sekler 1958, p. 229.

25 Posener 1985, p. 52.

26 Pawley 1996, p. 215.

27 Quoted in Lucan 1987, p. 278.

28 Chiambretto 1987, p. 7.

29 Jacques Lucan, 'The Search for the Absolute', in Palazzolo and Vio 1991,
 p. 207.

5.

Le Corbusier and Paul Valéry

1 Valéry 1952, p. 39.

2 Ibid., p. 40.

3 Walter Benjamin, 'Paul Valéry', in Buchner and Köhn 1991, p. 158.

4 Quoted in Pietra 1991, p. 80.

5 Valéry 1958a, pp. 110, 111.

6 Ibid., pp. 111-16.

7 Le Corbusier, in Hervé 1970, p. 12. Le Corbusier annotated pages 87, 90
 and 100 in his copy of *Eupalinos*. See also Barcelona 2005, p. 75.

8 Le Corbusier 1961, pp. 70-71.

9 Ibid., p. 70.

10 Le Corbusier, for example, as quoted in Petit 1970, p. 178.

11 Blumenberg 1964, p. 313.

12 Ibid., p. 306.

13 Ibid., pp. 288–89.

14 Valéry 1958a, p. 116.

15 Blumenberg 1964, pp. 307–08.

16 Ibid., p. 323.

17 Valéry 1958a, p. 114.

18 Le Corbusier 1931, p. 213.

19 Valéry 1958a, p. 130.

20 Ibid., pp. 131–32.

21 Ibid., pp. 136–37.

22 Ibild., pp. 74, 70. The often emotionally charged tone used to describe the work of the architect Eupalinos will have appealed all the more strongly to Le Corbusier since it agreed with the image of the 'great initiate' with which he was familiar from Schuré and which he would also have found in the writings of Friedrich Nietzsche and John Ruskin.

23 Le Corbusier 1931, p. 203. The essay first appeared in May 1922 in the periodical *L'Esprit nouveau* and was subsequently included in *Vers une Architecture*.

24 Blumenberg 1964, p. 323.

25 Walter Benjamin, in Buchner and Köhn 1991, p. 158.

26 Adorno 1991, p. 169.

27 Valéry 1958a, pp. 87, 86.

28 See Le Corbusier's copy of Valéry 1944, pp. 90–91. Le Corbusier's copies of works by Valéry are housed in the archives of the Fondation Le Corbusier, Paris, Collection Bibliothèque personelle, V II 2.

29 Le Corbusier's library contained copies both of Eliot's book (New York, 1948; Fondation Le Corbusier J327) and of Baudelaire's translation of Poe's *Eureka* (Fondation Le Corbusier J35).

30 Valéry 1952, p. 41.

31 Valéry 1958a, p. 77.

32 Ibid., p. 74.

33 Blumenberg 1964, p. 293.

34 Valéry, 'Introduction to the Method in Leonardo', in Valéry 1977, p. 75.

35 Blumenberg 1964, p. 323.

36 Hans Paeschke, in Buchner and Köhn, p. 195.

37 Petit 1970, p. 176.

38 According to Philippe Boudon and Pierre Saddy, *Eupalinos* was 'the fruit of conversations with Perret'. Lucan 1987, p. 302.

39 Buchner and Köhn 1991, p. 33.

40 Le Corbusier 1992, video 1.

41 Le Corbusier, in Lucan 1987, p. 451.

42 Ibid., p. 451.

43 Unlike the later annotations, which are in Le Corbusier's unmistakably idiosyncratic hand, the pencil markings in *Eupalinos* cannot be attributed to him with complete certainty. It is conceivable that other people, including his wife and Pierre Jeanneret, read and marked the volume. There can be no doubt, however, that Le Corbusier consulted the book and his review of it in *Almanach d'architecture moderne* reveals how deeply it impressed him (Le Corbusier 1926, pp. 26–27). The fact that his review alludes to passages marked in his copy suggests that he was indeed responsible for the annotations.

44 Le Corbusier, letter to Elie Faure; Fondation Le Corbusier, Paris, E2–02–27.

45 Le Corbusier's copy of Focillon 1947, Fondation Le Corbusier, Paris, p. 121.

46 Le Corbusier's copy of Valéry's *Variété V*, Fondation Le Corbusier, Paris, p. 253.

47 For Duval and Le Corbusier, see Lucan 1987, p. 119.

48 Le Corbusier, letter to Duval; Fondation Le Corbusier, Paris, letter E1–20–455. Perhaps Duval had given the book to Le Corbusier, which would explain the latter's words of thanks ('Ce mot pour vous dire merci ...'). The Fondation Le Corbusier in Paris possesses a letter of 1949 from Duval to Le Corbusier in which he recommends Valéry's *Pièces sur l'art* because it has reminded him of Le Corbusier's desire for a 'synthesis of the arts'. Fondation Le Corbusier, Paris, letter E1–20–469.

49 Le Corbusier's copy of Valéry 1944, Fondation Le Corbusier, Paris, p. 107.

50 Ibid., pp. 81, 103.

51 Ibid., p. 113.

52 Ibid., pp. 89, 103.

53 Ibid., p. 108.

54 Ibid., p. 111. Valery 1958b, p. 128.

55 Le Corbusier states that he started work on *Le Poème* in 1947. Le Corbusier 1989, p. 155.

56 Le Corbusier's copy of Valéry 1934, Fondation Le Corbusier, Paris, p. 120.

57 Le Corbusier 1965, n.p.

58 Walter Benjamin, in Buchner and Köhn 1991, p. 160.

59 Le Corbusier's copy of Valéry 1944, Fondation Le Corbusier, Paris, p. 107.

60 Ibid., p. 220.

61 Or so he claimed in *Vers une Architecture* and elsewhere. See Le Corbusier 1931, p. 77.

62 Le Corbusier's copy of Valéry 1944; Fondation Le Corbusier, Paris, p. 107.

63 Ibid., p. 87.

64 Le Corbusier 1965, n.p.

65 Valéry, 'Man and the Sea Shell', in Valéry 1977, p. 124.

66 Ibid., p. 130.

67 Le Corbusier, in Petit 1970, p. 178 ('L'étonnante sculpture hélicoidale').

68 Valéry, 'Man and the Sea Shell', in Valéry 1977, pp. 113, 114, 115.

69 Ibid., p. 118.

70 Le Corbusier 1989, p. 89.

71 Valéry, 'Man and the Sea Shell', in Valéry 1977, p. 120.

72 Ibid., p. 132.

73 Ibid., p. 128.

74 Valéry 1960, p. 1052.

6.

From Palissy to Ronchamp

1 Valéry, 'Man and the Sea Shell', in Valéry 1977, p. 134.

2 Le Corbusier's reading in the late 1940s included a biography of Palissy that is among the volumes from his library preserved at the Fondation Le Corbusier, Paris (J379; J379; ill. p. 146).

3 Details of Palissy's life are taken from Boudon-Duaner 1989. On Palissy's importance as a grotto builder, see Bredekamp 1993, pp. 51ff.

4 Palissy 1996.

5 Ibid., p. 223.

6 René Descartes, 'Discours de la Méthode', in Descartes 1978, p. 122: 'des places regulières qu'un ingénieur trace à sa fantaisie dans une plaine'.

7 Palissy 1996, pp. 225, 228.

8 Ibid., p. 231.

9 Ibid., p. 238.

10 Lestrignant, in Ibid., pp. 225, n. 2 and 233, n. 4.

11 Palissy 1996, p. 235.

12 Bredekamp 1993, p. 51.

13 Bachelard 1969, p. 181.

14 Ibid., p. 122.

15 Palissy, quoted in Ibid., pp. 130, 131.

16 Bachelard 1969, p. 131.

17 Bredekamp 1993, p. 52.

18 Bachelard 1969, p. 131.

19 'When Venus was brought into the world, what she came from became the woman's womb'. Quoted in Theweleit 1983, p. 362.

20 Miller 1993, pp. 187–88.

21 Bachelard 1969, pp. 131–32.

22 Hyppolite 1956, p. 35.

23 Le Corbusier 1991, p. 48. For Le Corbusier's abolition of hierarchies among elevations in the Villa Savoye, see also Colomina 1992, pp. 73–131.

24 Dance 1986, pp. 20–21.

25 Corbin 1994, p. 20. Buonanni does not feature in Corbin's extensive list of philosophers fond of visiting the seaside.

26 Ibid., pp. 21ff.

27 Buonanni 1681, p. 19.

28 Ibid., p. 1.

29 Ibid.

30 Ibid., p. 2.

31 Ibid.

32 Ibid., p. 3.

33 Ibid., pp. 13, 19.

34 Ibid., p. 3.

35 Ibid., p. 13.

36 Ibid., p. 3.

37 Centuries later Strindberg provided an angst-ridden literary version of this philosophical motif in his short story 'The Pilot's Trials', in which the body is trapped in the object of its contemplation: 'Then he went on into the passage ... There was every possible kind of shop there ... After a while he stopped in front of a big window in which there was a whole display of shells. As the door was open he went in.' Leaving the shop, the character in the story discovers that the passage is itself a giant snail: 'The passage wasn't straight but winding, so that you could never see the end of it; and there were always fresh shops there, but no people'. Strindberg 1930, pp. 46, 50.

38 Buonanni 1681, p. 12.

39 Ibid.

40 Ibid., p. 19.

41 Böhme 1989, p. 89.

7.
Ronchamp as a Philosophical Construct

1 Talemarianus 1949, title. In *Le Modulor II* Le Corbusier describes how Monsieur Rouhier of the Vega bookshop in Paris had recommended the volume, which he then read in the Bibliothèque Mazarine, Paris (Le Corbusier 1958, p. 195). The Bibliothèque Mazarine still possesses the book, which was published by Vega in a tiny bibliophile edition and is not to be found anywhere else.
2 Pevsner 1973, p. 488.
3 Le Corbusier 1965, n.p.
4 Faure 1991, p. 38.
5 Le Corbusier 1931, pp. 211-12.
6 Ibid., p. 109.
7 Bredekamp 1993, p. 53.
8 Le Corbusier 1992, video 2.
9 Le Corbusier 1931, p. 143.
10 Ibid., p. 153.
11 These influences are described in detail in Pauly 1987a, pp. 133ff.
12 Müller-Erb 1958, p. 367.

8.
The architect on the beach and the consequences:
A short Postscript

1 Bachelard 1969, pp. 211, 212.
2 Bossière 1981, p. 16.
3 Libeskind 1995, pp. 62-63.
4 Balmond 1997, p. 59.
5 For Eisenman's design practices, see Ulrich Schwarz, 'Das Erhabene und das Groteske', in Kähler 1993, p. 122.
6 Van Berkel and Bos 1999.
7 Ito 2009, p. 7.
8 Ibid., p. 8.

BIBLIOGRAPHY

Archival material

Bibliothèque nationale de
France, Paris
• Paul Valéry, sketchbooks and
 notebooks, 1929–30, Cabinet des
 Manuscrits, VAL-106-219

Fondation Le Corbusier, Paris
• Correspondence between
 Le Corbusier and Jean-Jacques
 Duval, documents E1-20 414-645
• Correspondence between
 Le Corbusier and Elie Faure,
 documents E2-2-271

Writings and statements
by Le Corbusier

Le Corbusier 1924
 Le Corbusier, 'La leçon de la
 machine' in L'Esprit nouveau,
 no. 25, July 1924, n.p.
Le Corbusier 1925
 Le Corbusier, L'Art décorative
 d'aujourd'hui, Paris 1925
Le Corbusier 1926
 Le Corbusier, L'Almanach de
 l'architecture moderne, Paris 1926
Le Corbusier 1928
 Le Corbusier, Une maison, un
 palais, Paris 1928
Le Corbusier 1929
 Le Corbusier, Urbanisme [1925],
 trans. Frederick Etchells as The
 City of Tomorrow and its Planning,
 London 1929
Le Corbusier 1931
 Le Corbusier, Vers une Architecture
 [1923], trans. Frederick Etchells
 as Towards a New Architecture,
 London 1931
Le Corbusier 1935
 Le Corbusier, 'L'Architecture,
 à elle seule, est un support de
 lyrisme total' in Architecture d'au-
 jourd'hui, July 1935, pp. 86–87
Le Corbusier 1942
 Le Corbusier, La Maison des
 hommes, Paris 1942
Le Corbusier 1947
 Le Corbusier, 'Unité d'Habita-
 tion à Marseille' in L'Homme et
 l'architecture 11–14, 1947, n.p.
Le Corbusier 1954
 Le Corbusier, Le Modulor [1948],
 trans. Peter de Francia and Anna
 Bostock as The Modulor: A Harmo-
 nious Measure to the Human Scale
 Universally Applicable to Architecture
 and Mechanics, London 1954
Le Corbusier 1957
 Le Corbusier, Ronchamp: Les
 Carnets de la recherché patiente,
 Stuttgart 1957
Le Corbusier 1958
 Le Corbusier, Le Modulor 2 [1955],
 trans. Peter de Francia and
 Anna Bostock as Modulor 2, 1955:
 Let the User Speak Next, London
 1958

Le Corbusier 1961
Le Corbusier, *Entretien avec les
étudiants des écoles d'architecture*
[1942], trans. P. Chase as
*Le Corbusier Talks with Students
from the Schools of Architecture*,
New York 1961

Le Corbusier 1965
Le Corbusier, *Textes et dessins pour
Ronchamp*, Paris 1965

Le Corbusier 1967
Le Corbusier, *La Ville radieuse:
Eléments d'une doctrine d'urbanisme
pour l'équipment de la civilisation
machiniste* [1935], trans. Pamela
Knight, Eleanor Levieux and
Derek Coltman as *The Radiant
City: Elements of a Doctrine of
Urbanism to be used as the Basis
of our Machine-age Civilization*,
London 1967

Le Corbusier 1989
Le Corbusier, *Le Poème de l'angle
droit* [1955], repr. Paris 1989

Le Corbusier 1991
Le Corbusier, *Précisions sur un
état présent de l'architecture et de
l'urbanisme* [1930], trans. Edith
Schreiber Aujame as *Precisions
on the Present State of Architecture
and City Planning*, Cambridge,
Mass. 1991

Le Corbusier 1992
Le Corbusier par lui-même, comp.
and ed. Jacques Barsac, three-
part video documentation,
Paris 1992

Le Corbusier and Otlet 1929
Le Corbusier and Paul Otlet,
'Mundaneum' in *L'Architecture
vivante*, spring/summer 1929,
pp. 30–32

Books and articles

Adam 1987
Adam, Peter, *Eileen Gray: Architect,
Designer – A Biography*, London
1987

Adorno 1990
Adorno, Theodor W., 'Rück-
blickend auf den Surrealismus'
in *Surrealismus in Paris 1919–1939*,
Leipzig 1990, pp. 703–09

Adorno 1991
Adorno, Theodor W., *Noten zur
Literatur* [1958], trans. Shierry
Weber Nicholsen as *Notes to
Literature*, vol. 1, New York 1991

Anon. 1955a
Anon., 'Edifice sacré aux formes
révolutionnaires' in *Le Parisien*,
16 July 1955, n.p.

Anon. 1955b
Anon., 'Nos envoyés spéciaux
chez l'homme qui peut loger
tous les français: Le Corbusier'
in *Science et vie* 458, October 1955,
n.p.

Anon. 1958
[G. Ha.], 'Le Corbusiers Wall-
fahrtskapelle in den Vogesen'
in *Die Kunst und das schöne Heim* 1,
1958, n.p.

Anon. 2009
In *Art* 1, 2009, n.p.

Arvier 1965
Arvier, Pierre, 'Le Corbusier:
Poète du béton' in *Science et vie*
518, November 1965, pp. 143–55

Bachelard 1969
Bachelard, Gaston, *Poétique
de l'espace* (1957), trans. Maria
Jolas as *The Poetics of Space*,
Boston 1969

Balmond 1997
Cecil Balmond in *Arch**, vol. 138,
no. 10, 1997

Baltrusaitis 1957
Baltrusaitis, Juris, 'Pierres
images' in idem, *Aberrations:
Quatre essais sur la légende des formes*,
Paris 1957, pp. 42–77

Banham 1960
Banham, Reyner, *Theory and
Design in the First Machine Age*,
London 1960

Barcelona 2005
Le Corbusier et le livre, exh. cat.,
Collegi d'Arquitectes de
Catalunya, Barcelona 2005

Benjamin 1969
Benjamin, Walter, *Das Kunstwerk
im Zeitalter seiner technischen Repro-
duzierbarkeit*, Frankfurt am Main
1969

Benjamin 1982
Benjamin, Walter, *Das Passagen-
werk*, Frankfurt am Main 1982

Bloch 1989
Bloch, Ernst, *Das Prinzip
Hoffnung*, Frankfurt am Main
1989

Blüher 1979
Blüher, Karl, 'La fonction du
public dans la pensée de Paul
Valéry' in idem and Jürgen
Schmidt-Radefeldt, *Poétique et
communication*, Paris 1979,
pp. 105–28

Blum 1988
Blum, Elisabeth, *Le Corbusiers
Wege: Wie das Zauberwerk in Gang
gesetzt wird*, Brunswick 1988

Blumenberg 1964
Blumenberg, Hans, 'Sokrates
und das Objet ambigu' in
Franz Wiedmann, ed., *Epimeleia:

Die Sorge der Philosophie um den
Menschen*, Munich 1964,
pp. 285–323

Blumenberg 2001
Blumenberg, Hans, *Ästhetische
und metaphorologische Schriften*,
Frankfurt am Main 2001

Blumenröder 2008
Sabine Blumenröder, *Andrea
Mantegna: Die Grisaillen – Malerei,
Geschichte und antike Kunst im
Paragone des Quattrocento*, Berlin
2008

Blumenberg 1966
Blumenberg, Hans, *Die Legiti-
mität der Neuzeit*, Frankfurt am
Main 1966

Boesiger 1957
Boesiger, Willy, *Le Corbusier et
son atelier rue de Sèvres 35: Œeuvre
complet, 1952–1957*, Zurich 1957

Boesiger and Girsberger 1967
Boesiger, Willy, and Hans Girs-
berger, *Le Corbusier 1910–1965*,
Zurich 1967

Böhme 1989
Böhme, Hartmut, *Melencolia I:
Im Labyrinth der Deutung*, Frank-
furt am Main 1989

Boissière 1981
Boissière, Olivier, *Gehry, Site,
Tigerman: Trois portraits de l'artiste*,
Paris 1981

Bosman 1987
Bosman, Jos, ed., *Le Corbusier
und die Schweiz: Dokumente einer
schwierigen Beziehung*, Zurich 1987

Boudon 1971
Boudon, Philippe, *Sur l'espace
architectural: essai d'épistémologie
de l'architecture*, Paris 1971

Boudon-Duaner 1989
 Marguerite Boudon-Duaner,
 Bernard Palissy: *Le potier du roi*,
 Paris 1989
Boulais 1965
 Boulais, Fr., 'Le Corbusier et
 le sens du sacré' in *Témoignage
 chrétien*, 2 September 1965, p. 14
Bradfer 1988
 Bradfer, Françoise, *Le Corbusier:
 la modernité et après*, Louvain-la-
 Neuve 1988
Bredekamp 1991
 Bredekamp, Horst, 'Mimesis,
 grundlos' in *Kunstform* 114,
 nos. 7-8, 1991, pp. 278-87
Bredekamp 1993
 Bredekamp, Horst, *Antikensehn-
 sucht und Maschinenglauben:
 Die Geschichte der Kunstkammer
 und die Zukunft der Kunstgeschichte*,
 Berlin 1993
Breton 1987
 Breton, André, *L'amour fou*
 [1937], trans. Mary Ann Caws as
 Mad Love, Lincoln, Nebraska 1987
Breton 1962
 Breton, André, *Manifeste du
 Surréalisme*, Paris 1962
Buchner and Köhn 1991
 Buchner, Carl H., and Eckhart
 Köhn, eds., *Herausforderung der
 Moderne: Annäherungen an Paul
 Valéry*, Frankfurt am Main 1991
Buonanni 1681
 Buonanni, Filippo, *Ricreatione
 dell'occhio e della mente nell'osserva-
 tione delle chioccole, proposta a curiosi
 delle opere della natura*, Rome 1681
Butor 1969
 Butor, Michael, *Les Mots dans la
 peinture*, Geneva 1969

Calvino 1984
 Calvino, Italo, *Collezione di sabbia*,
 Milan 1984
Charbonnier 1960
 Charbonnier, G., 'Entretien avec
 Le Corbusier' in idem, *Le Mono-
 logue du peintre*, vol. 2, Paris 1960
Charpentrat 1961
 Charpentrat, Pierre, 'Architec-
 ture contemporaine au-délà
 du baroque' in *Annales, économie,
 sociétes, et civilisations* 5-6,
 1961, n.p.
Chiambretto 1987
 Chiambretto, Bruno, *Le Corbusier
 à Cap-Martin*, Paris 1987
Ciorra 1995
 Ciorra, Pippo, *Peter Eisenman:
 Bauten und Projekte*, trans. Peter
 Schiller, Stuttgart 1995
Cohen 2007
 Cohen, Jean-Louis, *Ludwig Mies
 van der Rohe*, Basle 2007
Colomina 1992
 Colomina, Beatriz, ed., *Sexuality
 and Space*, Princeton 1992
Corbin 1994
 Corbin, Alain, *La Territoire du
 vide: l'occident et le désir du rivage
 1750-1840* [1988], trans. Jocelyn
 Phelps as *The Lure of the Sea: The
 Discovery of the Seaside in the Western
 World 1750-1840*, Cambridge
 1994
Curjel 1957
 Curjel, Hans, 'Le Corbusier' in
 Graphis 73, 1957, pp. 382-90
Dance 1986
 Dance, Peter, *Collecting Shells:
 A History*, Berkeley 1986
de Maillet 1748
 de Maillet, Benoît, *Telliamed
 ou entretiens d'un philosophe indien*

avec un missionaire français,
Amsterdam 1748

Derrida 1993
Derrida, Jacques, *Mémoires
d'aveugle: L'autoportrait et autres
ruines* [1988], trans. Pascale-Anne
Brault and Michael Naas as
*Memoirs of the Blind: The Self-
portrait and other Ruins*, Chicago
and London 1993

Descartes 1978
Descartes, René, *Œuvres*, vol. 3,
Paris 1978

Doncoeur 1955
Doncoeur, Paul, 'Esthétique
moderne et art sacrée' in *Etudes*
10, 1955, pp. 89–97

Echaurren 1991
Echaurren, Roberto Matta,
'André Breton' in *Télérama*,
special Breton issue, 1991

Eisenman 1995
Eisenman, Peter, *Aura und Exzess:
Zur Überwindung der Metaphysik
der Architektur*, Vienna 1995

Faure 1934*
Faure, Elie, *Ombres solides*, Paris
1934 (FLC 409)

Faure 1991
Faure, Elie, *Histoire de l'art:
L'esprit des formes* [1927], Paris 1991

Focillon 1947*
Focillon, Henri, *La Vie des formes*,
Paris 1947 (FLC J 98)

Foucault 1970
Foucault, Michel, *Les Mots et les
choses* [1966], pub. in English as
The Order of Things, London 1970

Fuchs 1956
Fuchs, Alois, *Resümee der Jahres-
tagung der Kunstbeauftragten der
Erzdiözese Paderborn*, Paderborn
1956

Gastineau 1942*
Gastineau, Marcel, *Bernard
Palissy et la céramique*, Paris 1942
(FLC J 379)

Ghyka 1931
Ghyka, Matila C., *Le nombre d'or:
Rites et rythmes pythagoriciens dans
le développement de la civilisation
occidentale, précédé d'une lettre de
Paul Valéry*, Paris 1931

Giedion 1956
Giedion, Sigfried, 'Le Corbusier
und die Schweiz' in *Der Bund* 337,
21 July 1956, suppl. 'Bau und
Architektur', n.p.

Giedion 1958
Giedion, Sigfried, *Architektur
und Gemeinschaft* [1956], trans.
Jacqueline Tyrwhitt as *Architec-
ture, You and Me*, Cambridge,
Mass. 1958

Ginzberg 1962
Ginzberg, Robert, 'Le Cor-
busier's Humanistic Chapel at
Ronchamp' in *Rives* 18, 1962,
pp. 23ff.

Goethe 1959
Goethe, Johann Wolfgang von,
Italienische Reise, repr. Wiesbaden
1959

Graudenz and Pappritz 1965
Graudenz, Karlheinz, and Erica
Pappritz, *Etikette neu* [1956],
Munich 1965

Graziosi 1956
Paolo Graziosi, *L'arte dell'antica
età della pietra*, Florence 1956

Gresleri and Matteoni 1982
Gresleri, Giuliano, and Dario
Matteoni, *La città mondiale:
Andersen, Hébrard, Otlet, Le Cor-
busier*, Venice 1982

Guichard-Meili 1965
 Guichard-Meili, Jean, 'Le Cor-
 busier voudrait render l'homme
 heureux dans le monde des
 machines' in *Témoignage chrétien*,
 2 September 1965, pp. 13–24
Habermas 1985
 Habermas, Jürgen, *Die neue
 Unübersichtlichkeit*, Frankfurt am
 Main 1985
Heine 1979
 Heine, Heinrich, 'Die Nordsee'
 in idem, *Reisebilder*, Berlin and
 Weimar 1979
Hervé 1970
 Hervé, Lucien, *Le Corbusier:
 L'Artiste et l'écrivain*, trans.
 Haakon Chevalier as *Le Corbusier
 as Artist, as Writer*, Neuchâtel 1970
Hilpert 1987
 Hilpert, Thilo, *Le Corbusier:
 Atelier der Ideen*, Hamburg 1987
Hocke 1977
 Hocke, Gustav René, *Die Welt als
 Labyrinth: Manier und Manie in der
 europäischen Kunst*, Hamburg 1977
Huse 1976
 Huse, Norbert, *Le Corbusier*,
 Reinbeck 1976
Hyppolite 1956
 Hyppolite, Jean, in *La Psycho-
 analyse* 1, 1956, n.p.
Ito 2009
 Ito, Toyo, 'Theoretical and Sen-
 sorial Architecture: Sou Fuji-
 moto's Radical Experiments' in
 2G N50, Barcelona 2009, n.p.
Janson 1961
 H. W. Janson, 'The "Image Made
 by Chance" in Renaissance
 Thought' in *De Artibus Opuscula
 XL: Essays in Honor of Erwin*

Panofsky, 2 vols., New York 1961,
 pp. 354–66
Jencks 1973
 Jencks, Charles, *Le Corbusier and
 the Tragic View of Architecture*,
 London 1973
Jencks 1995
 Jencks, Charles, ed., *Frank O.
 Gehry: Individual Imagination
 and Cultural Conservatism*,
 London 1995
Kähler 1981
 Kähler, Gert, *Architektur als Sym-
 bolverfall: Das Dampfermotiv in der
 Baukunst*, Brunswick 1981
Kähler 1993
 Kähler, Gert, ed., *Schräge Architek-
 tur und aufrechter Gang: Dekonstruk-
 tion – Bauen in einer Welt ohne Sinn?*,
 Brunswick 1993
Kant 1991
 Kant, Immanuel, *Kritik der
 Urteilskraft*, repr. Stuttgart 1991
Karatani 1995
 Karatani, Kojin, *Architecture as
 Metaphor*, Cambridge, Mass. 1995
Kellerer 1968
 Kellerer, Christian, *Objet trouvé
 und Surrealismus: Zur Psychologie
 der modernen Kunst*, Reinbek 1968
Kidder Smith 1964
 Kidder Smith, G. E., *The New
 Churches of Europe*, London 1964
Kleihues and Lampugnani 1984
 Kleihues, Josef Paul, and Vitto-
 rio Magnano Lampugnani, eds.,
 *Das Abenteuer der Ideen: Architektur
 und Philosophie seit der industriellen
 Revolution*, Berlin 1984
Klotz 1996
 Klotz, Heinrich, ed., *Die Zweite
 Moderne: Eine Diagnose der Kunst
 der Gegenwart*, Munich 1996

Köhler 1975
 Köhler, Erich, *Sprachen der Lyrik:*
 Festschrift für Hugo Friedrich,
 Frankfurt am Main 1975
Kühn 1952
 Herbert Kühn, *Die Felsbilder*
 Europas, Stuttgart 1952
Lambert 1962*
 Lambert, Jean Claude, ed., *Paul*
 Valéry, Ecrits sur l'art, Paris 1962
 (FLC 459)
Lampugniani 1980
 Lampugniani, Vittorio M.,
 Architektur und Städtebau des
 20. Jahrhunderts, Stuttgart 1980
Lautréamont 2009
 Le Comte de Lautréamont,
 Œuvres complètes, Paris 2009
Levene 1996
 Levene, Richard, ed., *El croquis:*
 Daniel Libeskind, Madrid 1996
Libeskind 1995
 Libeskind, Daniel, *Kein Ort an*
 seiner Stelle, Dresden and Basle
 1995
Libeskind 1997a
 Libeskind, Daniel, *radix-matrix*,
 Munich and New York 1997
Libeskind 1997b
 Libeskind, Daniel, and Cecil Bal-
 mond, *Unfolding*, Rotterdam 1997
Locke 1974
 Locke, John, *Essay Concerning*
 Human Understanding, London
 1974
Lucan 1987
 Lucan, Jacques, ed., *Le Corbusier:*
 Une encyclopédie, exh. cat., Centre
 Georges Pompidou, Paris 1987
Macrae-Gibson 1989
 Macrae-Gibson, Gavin, *The Secret*
 Life of Buildings, Cambridge and
 London 1989

Michels 1989
 Michels, Karen, *Der Sinn der*
 Unordnung: Arbeitsformen im Atelier
 Le Corbusiers, Brunswick and
 Wiesbaden 1989
Miller 1993
 Miller, Henry, *Tropic of Capricorn*
 [1939], London 1993
Monnier 1986
 Monnier, Gérard, *Le Corbusier:*
 Qui suis-je?, Lyon 1986
Müller-Erb 1958
 Müller-Erb, Rudolf, 'Ronchamp,
 anlässlich einer Schrift des
 Architekten' in *Hochland* 50,
 1958, pp. 361–71
Nachtigall and Blüchel 2000
 Nachtigall, Werner, and Kurt
 Blüchel, *Bionik: Neue Technologien*
 nach dem Vorbild der Natur,
 Stuttgart and Munich 2000
Nadeau 1965
 Nadeau, Maurice, *Geschichte*
 des Surrealismus, Reinbek 1965
Ozenfant 1968
 Ozenfant, Amadée, *Mémoires*,
 Paris 1968
Palazzolo and Vio 1991
 Palazzolo, Carlo, and Riccardo
 Vio, eds., *In the Footsteps of*
 Le Corbusier, New York 1991
Palissy 1996
 Palissy, Bernard, *Recette veritable*
 par laquelle tous les hommes de la
 France pourront apprendre à multi-
 plier et augmenter leur thrésors
 [1563], ed. Frank Lestringant,
 Paris 1996
Paris 1995
 Paul Valéry et les arts, exh. cat.,
 Musée Paul Valéry, Paris 1995

Paris 2008
 Andrea Mantegna, exh. cat.,
 Musée du Louvre, Paris 2008
Pauly 1987a
 Pauly, Danièle, *Ronchamp:*
 Lecture d'une architecture,
 Strasbourg 1987
Pauly 1987b
 Pauly, Danièle, 'The Chapel
 of Ronchamp as an Example
 of Le Corbusier's Creative
 Process' in H. Allan Brooks,
 Le Corbusier: The Garland Essays,
 Princeton 1987
Pawley 1996
 Pawley, Martin, 'Architektur im
 Kampf gegen die neuen Medien'
 in *Kunstforum* 133, February–April
 1996, pp. 209–15
Pehnt 1981
 Pehnt, Wolfgang, *Die Architektur
 des Expressionismus*, Stuttgart 1981
Petit 1970
 Petit, Jean, *Le Corbusier lui-même*,
 Paris 1970
Pevsner 1973
 Pevsner, Nikolaus, *Europäische
 Architektur*, repr. Munich 1973
Pietra 1991
 Pietra, Régine, 'L'Architecte
 assassiné ou la coquille du
 philosophe' in Paul Valéry,
 Littérature modern 2, Paris and
 Geneva 1991, pp. 79–91
Posener 1985
 Posener, Julius, *Vorlesungen zur
 Geschichte der neuen Architektur*
 [1979], Aachen 1985
Pückler-Muskau 1968
 Pückler-Muskau, Hermann,
 Fürst, *Briefe eines Verstorbenen*,
 New York and London 1968

Ricken 1990
 Ricken, Herbert, *Der Architekt:
 Ein historisches Berufsbild*,
 Stuttgart 1990
Schuré 1908*
 Schuré, Edouard, *Les Grands
 Initiés*, Paris 1908 (FLC 172)
Sedlmayr 1948
 Sedlmayr, Hans, *Verlust der Mitte:
 Die bildende Kunst des 19. und 20.
 Jahrhunderts als Symptom und Sym-
 bol der Zeit*, Salzburg 1948
Sekler 1958
 Sekler, Eduard, 'Prinzipielles zur
 Architektur der Gegenwart' in
 Hochland 50, 1958, pp. 218–33
Stallmach 1989
 Stallmach, J., *In Einsfall der Gegen-
 sätze und Weisheit des Nichtwissens:
 Grundzüge der Philosophie des Niko-
 laus von Kues*, Münster 1989
Strindberg 1930
 Strindberg, August, 'The Pilot's
 Trials' in idem, *Tales* [1903],
 trans. L. J. Potts, London 1930
Talemarianus 1949
 Talemarianus, Petrus, *De l'Archi-
 tecture naturelle: Rapport du Petrus
 Talemarianus sur l'établissement,
 d'après les principes du tantrisme,
 du taoïsme, du pythagorisme et de la
 cabale, d'une 'règle d'or', servant à
 la réalisation des lois de l'harmonie
 universelle et contribuant à l'accom-
 plissement du grande œuvre*, ed.
 Alexandre Rouhier, Paris 1949
Theweleit 1983
 Theweleit, Klaus, *Männerphan-
 tasien I*, Reinbek 1983
Thomsen 1997
 Thomsen, Christian, *Sensuous
 Architecture: The Art of Erotic Build-
 ing*, Munich and New York 1997

Turner 1977
 Turner, Paul Venable, *The Education of Le Corbusier: A Study of the Development of Le Corbusier's Thought, 1900–1920*, New York and London 1977
Valéry 1923*
 Valéry, Paul, *Eupalinos*, Paris 1923 (FLC 112, copy no. 456)
Valéry 1930*
 Valéry, Paul, *Mer marines marins*, Paris 1930 (FLC 363)
Valéry 1934*
 Valéry, Paul, *Pièces sur l'art*, Paris 1934 (FLC 368)
Valéry 1944*
 Valéry, Paul, *Variété V*, Paris 1944 (FLC 364)
Valéry 1952
 Valéry, François, 'Paul Valéry' in *Atlantic Monthly* 189, no. 2, February 1952, pp. 39 ff.
Valéry 1958a
 Valéry, Paul, *Eupalinos, ou l'Architecte* [1921], trans. William McCausland Stewart (1932) as 'Eupalinos, or The Architect' in Paul Valéry, *Dialogues*, London 1958
Valéry 1958b
 Valéry, Paul, *The Art of Poetry*, trans. Denise Folliot, *The Collected Works of Paul Valéry*, ed. Jackson Mathews, vol. 7, London 1958
Valéry 1960
 Valéry, Paul, 'Pensée et art français' in *Œuvres II*, ed. Jean Hytier, Paris 1960
Valéry 1977
 Valéry, Paul, *Paul Valéry: An Anthology*, ed. Jackson Mathews, introduction by James R. Lawler, London 1977

Van Berkel and Bos 1999
 Van Berkel, Ben, and Caroline Bos, *Move*, Amsterdam 1999
von Holst 1955
 von Holst, Niels, 'Le Corbusier irrational: Die neue Wallfahrtskirche von Ronchamp' in *Frankfurter Allgemeine Zeitung*, 17 September 1955, n.p.
von Moos 1968
 von Moos, Stanislaus, *Le Corbusier: Elemente einer Synthese*, Frauenfeld and Stuttgart 1968
von Moos 1980
 von Moos, Stanislaus, 'Le Corbusier as a Painter' in *Oppositions*, nos. 19–20, 1980, n.p.
Vowinckel and Kesseler 1986
 Vowinckel, Andreas, and Thomas Kesseler, *Le Corbusier: Synthèse des arts*, Berlin 1986
Wagner 1990
 Wagner, Monika, ed., *Funkkolleg Moderne Kunst: Studienbegleitbriefe*, Weinheim and Basle 1990
Weber 1999
 Weber, Heidi, *Le Corbusier: Maler, Zeichner, Plastiker, Poet*, Apolda 1999
Zeising 1854
 Zeising, Adolf, *Neue Lehre von den Proportionen des menschlichen Körpers*, Leipzig 1854

Imprint

Project management
Karen Angne
Copy-editing
Christopher Wynne
Translation from the German
Michael Foster (all texts apart from the
foreword), Russell Stockman (foreword)
Bibliographic research
Louise Stein Plaschkes
Graphic design, typesetting and production
Gunnar Musan
Printed and bound by
Friedrich Pustet KG, Regensburg
Printed in Germany

For the works by and photos
of Le Corbusier: © FLC / VG Bild-
Kunst, Bonn 2011: pp. 8, 16, 23, 24, 25,
34 (both), 37, 39, 40, 41, 48, 49, 54 top,
70, 73, 75, 76, 79, 96, 97, 98, 101, 103, 108,
111, 112, 129, 131, 132, 137, 140, 146
for the works by Ben van Berkel:
© VG Bild-Kunst, Bonn 2011: pp. 173, 174
for the works by Rem Koolhaas:
© VG Bild-Kunst, Bonn 2011: pp. 178, 179
for the works by Mark Rothko:
© Kate Rothko-Prizel & Christopher
Rothko / VG Bild-Kunst, Bonn 2011:
pp. 82, 83

For the original German edition
Niklas Maak, *Der Architekt am Strand.
Le Corbusier und das Geheimnis der
Seeschnecke*:
© 2010 Carl Hanser Verlag, Munich

The translation of this publication
from the German has been kindly
supported by the Swiss Arts Council
Pro Helvetia.

Bibliographic information published
by the Deutsche Nationalbibliothek:
The Deutsche Nationalbibliothek lists
this publication in the Deutsche Nation-
albibliografie; detailed bibliographic
data are available in the Internet at
http://dnb.d-nb.de.

ISBN 978-3-7774-3991-4

www.hirmerverlag.de
www.hirmerpublishers.com

Picture Credits

The Publisher has made every effort
to trace all copyright owners. Individ-
uals and institutions who may not have
been contacted but claim rights to the
illustrations used are asked to contact
the Publisher.

Author's archive: pp. 13, 18 / Biblio-
thèque Nationale de Paris: pp. 157,
159, Cabinet des Manuscripts: p. 119 /
Louvre: p. 77 / Fujimoto: p. 180 / Sou
Fujimoto: pp. 181, 182 / Greg Lynn
Form: p. 20 / Niklas Maak: pp. 7, 9, 12,
155, 149 (reconstruction) / Till Nier-
mann: p. 18 top / OMA, Rem Koolhaas:
pp. 178, 179 / Mark Rothko Foundation:
pp. 82, 83 / Sanaa Architects: p. 183 /
Spacelap: p. 22 / Lars Spuybroek/NOX
Architects: p. 21 / UN Studio, Ben van
Berkel: pp. 173, 174

From Adam 1987, p. 190: p. 30 / from
Architecture d'aujourd'hui, July 1935, p. 84:
p. 93 / from Chiambretto 1987, p. 5:
p. 115; p. 41: p. 41; p. 54: p. 39; p. 59: p. 40
/ from Eisenman 1995, p. 202: p. 172 /
from Ghyka 1931, plate X, n.p.: p. 99 /
from Hervé 1970, p. 10: pp. 46, 57 top;
p. 11: p. 57 bottom; pp. 28/29: p. 61 /
from Le Corbusier 1989, p. 55: p. 2;
p. 68: p. 111; p. 93: p. 112 / from Lucan
1987, p. 214: p. 48; p. 216: p. 79; p. 266:
pp. 97, 98; p. 276: p. 50: p. 297: pp. 70,
73, 76 / from Palazzo and Vio 1991, p. 17:
p. 103; p. 54: p. 101 / from Paris 1995,
p. 108: p. 117 / from Pauly 1987a, plate 9:
p. 16 / from Petit 1970, p. 87: p. 49; p. 111:
pp. 27, 54 bottom; p. 176: p. 129; p. 198:
p. 54 top / from Science et Vie 10/1955,
p. 74: p. 42 / from von Moos 1968, p. 70:
p. 75 / from Vowinckel and Kesseler 1986,
p. 55: p. 108; p. 68: p. 37